Growing Up in
SAN FRANCISCO

Growing Up in SAN FRANCISCO

More Boomer Memories from Playland to Candlestick Park

FRANK DUNNIGAN

THE
History
PRESS

Published by The History Press
Charleston, SC
www.historypress.net

Copyright © 2016 by Frank Dunnigan
All rights reserved

First published 2016

Manufactured in the United States

ISBN 978.1.46713.570.2

Library of Congress Control Number: 2016941427

To Sister Michael Marion SNJM (now known as Sister Elise Hanrahan), who taught a class of third graders how to write clear paragraphs in 1960–1961

and

To my old friend and St. Ignatius classmate Keith Forner (1952–1977), who first taught me the art of arranging yearbook text and images back in 1968.

*There are places I remember all my life
Though some have changed, some forever…
Some have gone…and some remain.*

—*Paul McCartney & John Lennon*

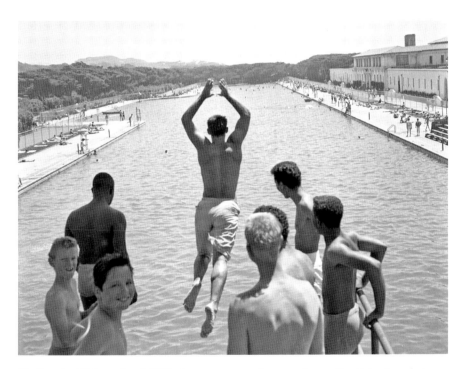

On Fourth of July weekend 1961, these young people are posing on the diving board at Fleishhacker Pool, adjacent to the zoo. *Courtesy of the* San Francisco Chronicle/Polaris.

Contents

Acknowledgements

M any individuals, both living and deceased, have contributed to the history, reminiscences and photographs included in this book. The author is indebted to each and every one of them for their contributions.

Aileen Barr
Thelma Beckerman
David Boyer
John Byrne
Cathy Nabbefeld Crain
Colette Crutcher
P. Eric Dausmann
Fred Deltorchio
Carmel Domecus
Joyce Dowling
Marc and Vicki Duffett
Mabel Ehrmann
Lee Emmett
Eric Faranda
Eric Fischer
Keith Forner
Michael Fraley
David Gallagher

Vivian Gisin
Monsignor Michael Harriman
Alvis Hendley
Rene Herrerias
Theresa Hession
Charles M. Hiller
Judy Hitzeman
Bernadette Hooper
Marci Hooper
Paul Judge
Christine Meagher Keller
Kathy Kernberger
Woody LaBounty
Megan Laddusaw
Charles and Ann Lane
Richard Lim
Keith Lynds
John A. Martini

Alan and Ruth Mildwurm
Dennis O'Rorke
Rick Prelinger
Jo Anne Quinn
David Reis
Mary Ellen (MER) Ring
Mark Roller
Paul Rosenberg
Bob and Carolyn Ross
Bernadette Ruane
Linda Moller Ruge

Bud Sandkulla
Debbie Schary
Don and June Thieler
Jeff Thomas
Jack Tillmany
Paul Totah
John Varley
Christine Vega
John and Linda Westerhouse
Marcin Wichary
Deborah Woodall

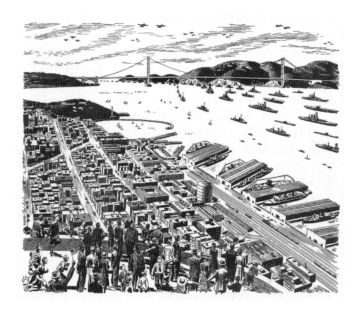

World War II and its aftermath marked the beginning of a new era for San Francisco and its residents. *Author's collection.*

1
Welcome to San Francisco

Everything in history impacts the future—or, as Shakespeare said, "The past is prologue." It is entirely fitting that the Bard's famous words are inscribed on an exterior marble wall of the National Archives in Washington, D.C.

If we are to understand the San Francisco of today, we need to realize exactly how we arrived here by analyzing historical decisions, twists of fate, family dynamics and world events that have all combined to tweak the course of our city's fortunes. Change comes slowly at first, creeping in like the fog on a summer day at Ocean Beach.

From the founding of Mission Dolores and the Presidio in 1776 until the establishment of the pueblo of Yerba Buena—the settlement predating the city of San Francisco—the area saw numerous changes, with even more to come.

By the time my great-grandfather David Dunnigan and his cousin Michael arrived in 1860, the area had already been subject to the forces of Spain and then Mexico, with an attempt by Russia to work its way in. Earlier, the Mexican War of Independence had brought about a breakup of Spain's missions, with the land being diverted into private hands. It had been just over a dozen years since gold was discovered, and San Francisco was continuing to be overrun with immigrants from around the globe—and there was a civil war brewing in the United States!

My great-grandfather arrived from his original American home in Washington, D.C., having left Ireland some ten years earlier as a youngster

By 1950, tourism had become big business and was beginning to overtake shipping, manufacturing, financial services, defense and retail as a prime industry. This gradual shift would lead to drastic changes for all of San Francisco. *Author's collection.*

during the Great Famine. Two years after arriving in San Francisco, he married a girl from "back home" and settled in the South-of-Market neighborhood, soon finding employment with the Pacific Mail Steamship Company, loading and unloading mail sacks along the San Francisco waterfront. The coming of the transcontinental railroad less than a decade later changed things significantly, since a New York letter bound for the West Coast could then be sent overland by rail. By the time his fourth and youngest child, my grandfather, was born in 1872, the shipping industry was beginning to experience a drastic upheaval, and David was no doubt feeling some level of anxiety over the changes.

His four children, including my grandfather, knew that much more was expected of them, and all of them completed high school, with my grandfather going to work for the federal government, one sister working for the San Francisco school system and two other sisters marrying well and raising families. My grandfather was ill for the last few years of his life, dying at the young age of sixty-two in 1934—at a time when San Francisco was ravaged by labor unrest.

My father and uncle were fortunate enough to attend college and be hired by the post office in the 1930s, progressing up the ranks into identical management positions in careers that lasted forty years each. At the time of their retirements in the mid-1970s, they could see significant changes coming for federal employment, many of which are still being played out today.

For baby boomers—the seventy-five million of us born between 1946 and 1964—college was mostly a given, and many of us were fortunate

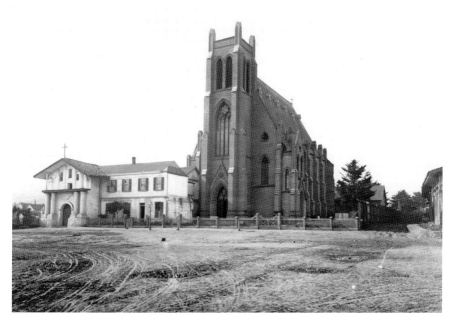

From its founding in 1776, Mission Dolores has weathered numerous changes, including a relocation to its present site in 1791 and addition of a brick basilica in 1876 (with damage to the basilica and its subsequent demolition after the 1906 earthquake), plus renovations to the Mission House and the adjacent cemetery and construction of a new basilica in 1918. The street in front of the mission was severely regraded in the late 1870s, and there are now six steps leading from the sidewalk to the entrance. The surrounding neighborhood has witnessed at least a dozen major periods of change over the past 250 years. *Courtesy of San Francisco History Center, San Francisco Public Library.*

enough to graduate without the student loan burden that weighs so heavily on many young people today. Yet it remains ironic that our own academic successes, funded heavily by our parents and other generous benefactors, have contributed to the transformation of the once-dominant blue-collar industries in San Francisco to the high-tech service industry that dominates the city in the twenty-first century.

Today, many people lament the changes that have occurred in San Francisco, as they look back at what some consider its golden past. However, we need to remember that it was hundreds of different events—tiny little threads of change—that have led us to where we are today. Change, for better or for worse, does not take place overnight.

As we embark upon this reading adventure, please keep in mind that the view from our mental tour bus, while undeniably colorful, is not always 100 percent pleasant, and it is very easy to see where all of us might wish that

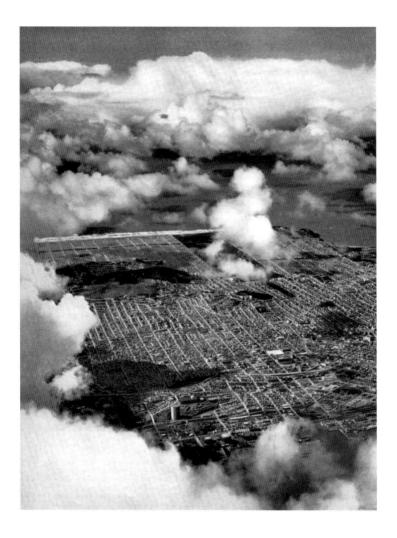

Fog drifts across a city of many neighborhoods in 1956. *Photograph by David Boyer, author's collection.*

some parts of our city's past—and perhaps certain chapters in our own personal lives as well—might have been played out differently, or perhaps not at all.

Nevertheless, it is important to see where we have been in order to judge where we are headed in the future.

With those thoughts in mind, please keep all body parts within the vehicle during our journey, hang on tightly as we go around some of the curves and breathe slowly as we view the diorama of our past lives unfolding before us when we lived in one of the world's most beautiful and fascinating cities.

2
Changing Times

A rising tide of people and prosperity
has changed many things in the City by the Golden Gate…

W ell, that line from a magazine article really sums up the problem with San Francisco in 2016—or does it? The fact of the matter is that those words were published in *National Geographic* magazine over sixty years ago, in August 1956. Indeed, from the time that my Ireland-born great-grandfather settled in San Francisco in 1860, it seems that things have continued to change on a fairly steady basis.

The wood-frame and gas-lit waterfront, teeming with ships and commerce, was a vital part of San Francisco for generations. My great-grandfather spent his entire life working as a laborer for the Pacific Mail Steamship Company, whose primary business function was transporting the U.S. mail around Cape Horn at the tip of South America to the westerly outpost of the continental United States. When he arrived from Washington, D.C., in 1860, just prior to the outbreak of the Civil War, he found a town only a dozen years removed from the gold rush. Yet when he died in 1902, the city of San Francisco had earned the nickname "Paris of the West"—suggesting that quite a bit of change had taken place during the forty years of his life as a San Franciscan.

Shortly before my great-grandfather's death, many other changes were already underway that would impact his descendants for decades to come.

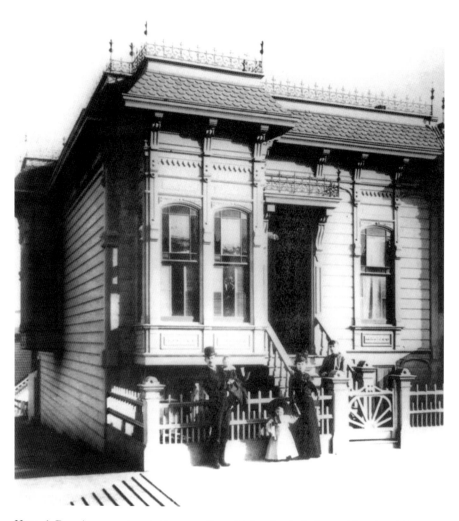

Hannah Dunnigan, age twenty-four, standing with her family in front of her sister's home at Duboce Avenue and Walter Street on Christmas Day 1891. She was still living with her elderly mother and father (then in their fifties!) and her younger brother in their longtime home in the South-of-Market neighborhood. The Great Earthquake and Fire was still almost fifteen years ahead in an unseen future. *Dunnigan Family Collection.*

Just prior to the start of the twentieth century, the Outside Lands of San Francisco were largely uninhabited and regarded by most locals as a remote area that was best suited to pursuits such as rabbit hunting, raising cabbages and chickens, burying the dead or perhaps taking a relaxing stroll. That sense of remoteness began to change dramatically on March 14, 1896, when an event took place that would change the face of San Francisco.

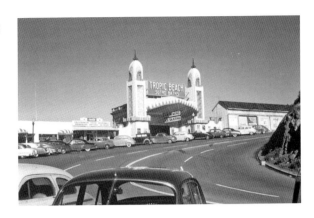

Sutro Baths opened in 1896 and went through several transformations, including the addition of ice skating. From the 1930s to the early 1950s, it boasted an elaborate art deco façade, shown here. The front of the building was later renovated with dark wood siding that remained in place from the mid-1950s until the very end in 1966. *John A. Martini Collection.*

Designed by Prussian immigrant Adolph Sutro, a large public accommodation known as Sutro Baths opened at the coastline of San Francisco, attracting residents from every part of the city.

Arriving in San Francisco from Prussia (today, part of Germany) as a young man of twenty in 1850, Adolph Sutro, educated as an engineer, earned a considerable fortune over the next two decades by devising new methods of removing water and toxic gasses from the mineshafts of Nevada's Comstock silver lode. He invested heavily in San Francisco real estate and also served as San Francisco's first German-American Jewish mayor from 1894 to 1896. In addition to his namesake baths, he built a home on a nearby hill overlooking the Pacific and also constructed the second Cliff House—an immense Victorian piece of gingerbread, also opened in 1896. By operating his own steam train to the area and charging a low fare, he was able to encourage San Franciscans to explore the farthest reaches of their city.

At the same time Sutro's was new, San Francisco was also converting many of its horse-powered streetcar lines to electricity, with the old wooden horse cars being made available to the public for very modest prices. Beginning with one Charles Stahl, a gripman on the Ellis Street line who formed a cluster of abandoned cable cars into a new home for himself and his family on 20th Avenue between J and K (now Judah and Kirkham) Streets in 1895, the Western Neighborhoods began to attract residents from older parts of San Francisco.

Other intrepid individuals followed suit, and as conversion to electricity continued, hundreds more old streetcars became available. The novel idea of a horse-car home near the beach became one of the first flights to the "suburbs" made by San Franciscans. Also in the mid-1890s, a community known as Carville began to emerge near Ocean Beach, just south of Golden

Gate Park, from what is now 44th Avenue west to the Great Highway, and from the park south to what is now Kirkham Street. Still other old horse cars formed a similar but smaller enclave near 5th Avenue and California Street known as "Carzonia."

By 1906, the city was prospering, having weathered two serious earthquakes in 1865 and 1868, plus a number of financial panics in the late nineteenth century. The earthquake and fire of that year brought about more changes than anyone could have imagined. With a substantial portion of the population homeless, new neighborhoods were about to be developed. Changes in engineering and the development of inventions such as the passenger elevator brought about a significant alteration to the city's skyline. The automobile industry, in its infancy in 1906, proved to be one of San Francisco's salvations in those dark days. The acceptance of "machines" and their increasing affordability by the masses in the coming decades changed many aspects of urban life.

As time went on, the earthquake and fire of 1906 were always collectively referred to by locals as "the Fire"—perhaps an attempt by real estate interests and everyone else to minimize the public's fear of earthquakes, for legendary fires were a rather routine part of big-city history at the time, having occurred in Chicago, Baltimore, Seattle and elsewhere. The events of that year provided a huge impetus that led many homeless San Franciscans to venture west. One of the largest refugee camps, with thousands of "earthquake cottages," was located near what is now Park Presidio Drive and California Street. Thousands more individuals sought refuge in tents located in Golden Gate Park.

As life began to resume some degree of normalcy, many people found the Richmond District a good place for a permanent new home. The inner parts of the neighborhood were in close proximity to the rapidly rebuilding downtown area by horse, streetcar or the new-fangled automobiles. Many of the earthquake shacks, removed from the camps by city ordinance in late 1907, were moved onto individual lots and remodeled into permanent homes, some of which still dot the landscape today, if you know where to look.

By 1913, there was a public outcry to clear the makeshift horse-car community near the beach, and most of these vehicles were moved to other locations and/or heavily remodeled to disguise their origins. What was left in Carville-by-the-Sea was soon abandoned, and the community essentially came to an end on the Fourth of July that year when the remaining relics were burned in a huge civic-minded bonfire.

While some parts of the Richmond District were dotted with pre-Fire Victorians, it was the post-1906 era that saw a building boom in the neighborhood—San Francisco was on the move. The introduction of the automobile aided this expansion, and many downtown streets were extended through the Western Addition and into the Richmond District to within steps of the Pacific Ocean.

Soon, businesses, schools and houses of worship began to follow residents in a gradual westward migration. The San Francisco public school system went on a building spree in the early years of the twentieth century, struggling to build schools fast enough to keep pace with the growing population of children in many different parts of the city. Areas along California, Clement, Geary, Balboa and Fulton Streets became vibrant neighborhood shopping areas, dispensing everyday necessities such as ice, coal and groceries. Public transit was extended to reach the area directly from downtown, and real estate agents often cited the transit time to Market Street as a selling point in advertisements for new homes.

Houses of worship such as Temple Emanu-El and St. Ignatius Church, burned out of their downtown locations in 1906, slowly began to move west with their congregants. Likewise, Lowell High School, St. Mary's Hospital and St. Ignatius College (now the University of San Francisco) reestablished themselves farther west, away from downtown San Francisco.

The cemeteries, however, provided a particularly difficult roadblock to westward expansion. As early as 1900, the many cemeteries located in the Richmond District (primarily Calvary, Laurel Hill, Masonic and Odd Fellows) were viewed as impediments to civic progress. The battle cry "Remove the cemeteries" had been proclaimed as early as the 1880s, yet it was not until 1902 that the Board of Supervisors enacted its first ordinance to prohibit new burials within the city—though there were numerous exceptions to this law, with Calvary Cemetery at Geary and Masonic recording its final interment as late as 1916.

In 1923, the Board of Supervisors passed a new ordinance requiring the removal of bodies from the many cemeteries in the Richmond District, and disinterment began in 1929, continuing for several more years as remains were taken to various locations across the county line in the San Mateo town of Colma.

There was initially strong opposition from the Catholic Church to the city's attempts at forcing removals from Calvary Cemetery at the corner of Geary and Masonic. That position was softened somewhat when the Jesuits at nearby USF theorized that the removal of bodies from the

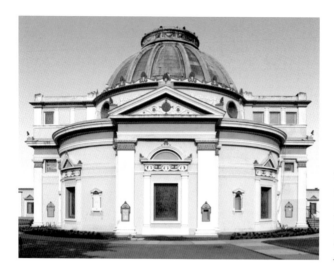

The columbarium represents the last remnant of a time when the Richmond District was filled with cemeteries. *Photograph by Alvis Hendley.*

Masonic Cemetery, adjacent to their St. Ignatius Church, would enable their college to expand. In the late 1930s, the archbishop dropped his opposition to the closure plan for cemeteries, so long as the removals were conducted in a reverent and organized fashion. Removals from Calvary commenced, with nearly forty thousand remains transferred to Holy Cross Cemetery in Colma by 1940, with removal proceeding at most of the other cemeteries as well.

Laurel Hill, the final holdout, saw thirty-five thousand removals from 1939 to 1941. Finally, after World War II, the last interments at Laurel Hill were relocated to Cypress Lawn in Colma, and the era of the cemeteries in the Richmond District was at an end.

Today, only the old columbarium, near Arguello and Geary, built for the Odd Fellows Cemetery, remains as a silent testimony to tens of thousands of San Franciscans who once regarded the neighborhood as their final "home." In an interesting twist, the building, which had fallen into disrepair, was acquired by the Neptune Society in 1980. It has been refurbished and expanded, and new inurnments now join the historic ones on a regular basis.

The era for massive housing development in the city's Western Neighborhoods was underway, and there was no turning back.

3
A Place Called Home

As the Richmond District filled with new homes and businesses, developers eventually turned their view southward to the Sunset District. Here, however, the lay of the land presented challenges. The area south of Golden Gate Park was surrounded by hills that impeded direct access, particularly by streetcar lines, still a prime mode of transportation for the masses. Recognizing this challenge, along with the incredible opportunity for San Francisco if the area could be developed, the Twin Peaks Tunnel was conceived. It was built in 1917 and opened for service in February 1918, just months before the end of World War I. Suddenly, vast new tracts of homes could be constructed, all with easy access to the downtown business district.

Henry Doelger was among those who seized the opportunity to construct affordable homes for working-class San Franciscans. Joined by other builders, including Galli, Costello, Lang and the Stoneson brothers, acre after acre of sand and scrub began to emerge as new communities, where residents were soon joined by the usual mix of merchants, religious/fraternal organizations, schools and public recreational facilities. The Sunset (Duboce) Tunnel opened in 1928, improving a difficult commute by streetcars that formerly had to wind their way around Golden Gate Park on a slow route through several neighborhoods before reaching the downtown area. The Sunset District soon emerged as one of the most vibrant and bustling communities in San Francisco, with the construction of thousands of homes before, during and after World War II.

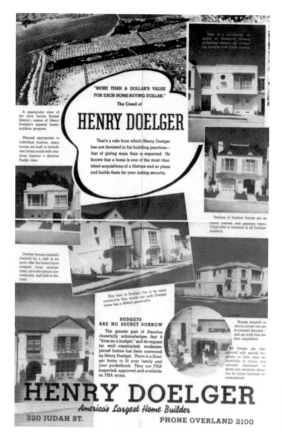

A 1939 Doelger ad shows several styles of homes then being built in the Sunset District. *Courtesy of Prelinger Library.*

As the country began to emerge from the Great Depression, many people who had been living in the Mission, North Beach or the Western Addition began thinking of a move to a new location west of Twin Peaks—less congestion, more fresh air, more room to raise a family, newer schools and space for an automobile. The expansion of streetcar service further prompted the growth of some existing residential areas such as Forest Hill, St. Francis Wood and Ingleside Terraces.

In the years just prior to and soon after World War II, the remaining open spaces south of Sigmund Stern Grove were soon filled with homes and apartments in communities such as Merced Heights, Stonestown, Parkmerced, Lakeshore and Country Club Acres.

Parkmerced, originally a planned community of low-rise garden apartments built by Metropolitan Life Insurance Company, opened in 1940. Built on the site of a former golf course, with hundreds of mature trees, it offered San Franciscans modern, fireproof structures in a garden setting—something

PARK - PRESIDIO - FULTON INTERCHANGE

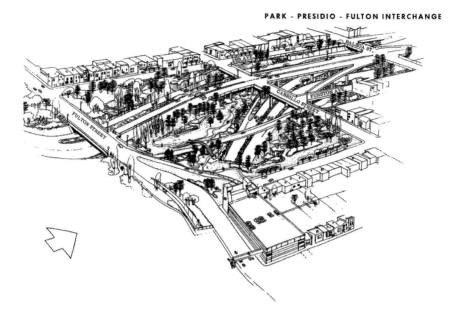

Even after San Franciscans went on record as opposing freeways, the State of California was still tinkering with plans for this nightmare installation at Fulton Street and Park Presidio Drive in the Richmond District, just north of Golden Gate Park, as late as 1964. It was never built. *Courtesy of Eric Fischer.*

unique for a city that consisted mostly of tightly built wooden structures. After the restrictions on building materials were lifted following the war, eleven new high-rise towers, with more than fifteen hundred new units, were added to the complex.

By 1950, San Francisco reached a then-record population of 815,000, and there was an overall sense of prosperity and well-being.

Stonestown, built by the Stoneson brothers, was one of this country's first shopping malls. Combined with adjacent tower and garden apartments (a community completely separate from Parkmerced), the apartments were first occupied in 1950, and the mall, anchored by the first branch store of Market Street's Emporium, opened in the second half of 1952. The adjacent areas soon filled with a collection of single-family homes.

The rise of residential development and the growth of automobile traffic in San Francisco in the post–World War II years led to the threat of freeways planned to run through many residential neighborhoods. In December 1955, a determined group of Sunset and Parkside District residents confronted the State of California's planners at a massive public meeting on the proposed

"Western Freeway"—essentially a straight-line route from San Francisco International Airport to the Golden Gate Bridge that would have wiped out thousands of homes and small businesses. Lawmakers and politicians heard the voice of the people, and though some freeways, such as the ill-fated Embarcadero, were eventually constructed, San Francisco was spared from being crisscrossed by massive spider webs of concrete and steel.

With the development of Midtown Terrace in the mid-1950s, and then Diamond Heights in the early 1960s, San Francisco was nearly completely built out. Other than some smaller in-fill projects and the city's 1960s-era redevelopment efforts in the Western Addition and elsewhere, most new home construction was beginning to take place outside the borders of San Francisco. The coming of the interstate highway system, and particularly the completion of BART in the 1970s, made suburban living a much more popular alternative for many than it had been in earlier days.

Throughout much of this history, though, there was an unfortunate stigma of both institutionalized and subtler racial discrimination present throughout the United States (including San Francisco) that limited residency in many neighborhoods solely to Caucasians. After World War II, however, old prejudices began to change, as people of many different ethnic groups chose to live in integrated communities. Various court rulings were also made that outlawed "restrictive covenants" in property deeds. Once again, San Francisco was continuing to evolve and become more welcoming to all.

One particular home in Ingleside Terraces, now an official San Francisco Landmark, is not only an excellent piece of architecture but a symbol of an era as well. A report in the files of the Landmarks Preservation Advisory Board explains:

> [The house] *is significant because of its association with two broad patterns of national and local history. When built in 1911, it was the showpiece of the first "suburban subdivision" in San Francisco, and marked an important shift in local urban design. Later, in the 1950s, it was the site of a cross burning due to its association with the residential racial integration of the city.*
>
> *The house is also significant due to its association with the lives of two owners, Joseph A. Leonard and Cecil F. Poole, both of whom were important in San Francisco history. It is particularly ironic that Leonard, a*

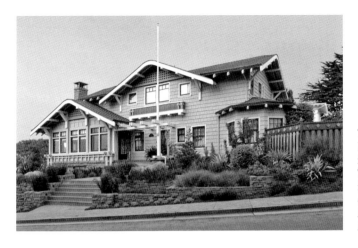

The Leonard-Poole home in Ingleside Terraces tells an interesting story of change over time. *Photograph by Alvis Hendley.*

prominent developer, was one of the first to use restrictive racial covenants as a real estate marketing tool in the city—while Poole was significant as San Francisco's first African-American District Attorney, later a federal judge, and a pioneer in furthering the status of African-Americans locally.

Over the last fifty years, San Francisco has become a much more tolerant place, particularly after the events in Ingleside Terraces and the blatant prejudice encountered by baseball star Willie Mays when he and his wife tried to purchase a home in the 1960s. Times were beginning to change, as people of many different backgrounds came together and became neighbors, friends and family to one another.

Terry Francois, San Francisco's first African American member of the Board of Supervisors, initially encountered racial discrimination when trying to purchase a home for his family on Dewey Boulevard, but he was ultimately successful. Although he died in 1989, his family continues to enjoy their West Portal–area home after more than fifty years.

Superior Court judge Joseph Kennedy, one of San Francisco's first African American judges, and his wife, Willie, lived on Mount Davidson for many years. Mrs. Kennedy was a longtime retail executive in the downtown area and later served fifteen years on the Board of Supervisors as well as on the BART Board of Directors and other civic agencies. Their residency in a predominantly Caucasian neighborhood was largely a nonissue in the 1970s.

By the dawn of the 1980s, many longtime San Franciscans were astounded to see that modest Sunset and Richmond District homes were beginning to break the price barrier of $100,000—or nearly $100 per square foot. Of course, demographers could point to several factors: a baby boom population coming of age and starting their own families, seniors living longer and healthier lives while "aging in place" and remaining in their own homes, increased immigration (often the result of various political situations in overseas countries), greater numbers of households involving only one or two persons, divorced couples with shared custody arrangements establishing separate households nearby one another and so forth. Many disparate social factors have contributed incrementally to the increase in housing prices—in addition to the rampant inflation of the late 1970s and early 1980s—all of which continued for many years.

As some of the 1950s advertising suggests, the cost of living in San Francisco has long been a challenge. Given the limited seven-mile by seven-mile geography and a local reluctance to see too many high-rise buildings outside of the downtown sector, there are constraints to expansion. As the law of supply and demand dictates, there is an inevitable upward trend in housing prices.

By the start of the new millennium, many "average" homes in San Francisco were beginning to approach the $500,000 price point. Just fifteen years later, prices of $1 million and more have become fairly routine for well-maintained homes. In fact, the San Francisco Chronicle reported that as of July 2014, $1 million was the new median price for a home in the city—half of all homes sold in the first half of that year cost more than that amount, and half of them cost less.

Clearly, that trend continues today when abandoned homes in poor condition often sell for $1 million or more in prime locations and where there is renovation potential. Where does it end? It is hard to tell, but the steady appreciation contributes to the willingness of buyers to pay top prices, even as some other longtime San Franciscans "cash out" and take their profits elsewhere.

Again, there are many factors contributing to this huge run-up, not the least of which continues to be supply and demand. In addition, many lower-paying clerical jobs at banks, insurance companies and retailers (one considered to be the backbone of the local economy) began to disappear in the 1980s and 1990s, replaced by new jobs in many sectors that offered higher income potential. Many more residents today are two-income couples with no children, and many career fields continue expanding—healthcare research

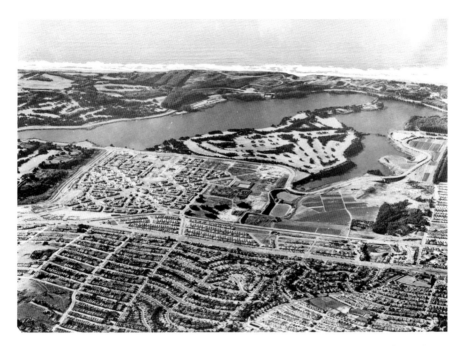

This 1948 aerial view of Lake Merced shows a very different scene from what exists today. At that time, there was no Stonestown Shopping Center/Galleria, no San Francisco State University, no Lowell or Mercy High Schools, no Lakeside Presbyterian or Temple Baptist Churches, no high-rise towers in Parkmerced, no schools or houses of worship or housing development along Brotherhood Way and thousands fewer homes throughout San Francisco and the adjacent part of Daly City that would soon become the Westlake District. Significant construction activity was about to commence in all of these areas. *Courtesy of San Francisco History Center, San Francisco Public Library.*

and high-tech, in particular—so that the household incomes of many people are rising steadily, thus giving them an increased ability to buy and remodel.

In this author's own brief three-score-plus years on this planet, the Mission District has been transformed from a blue-collar German-Irish enclave (with a heavy Scandinavian influence at its outer rim near 15th and Market Streets) to a large Hispanic community with immigrants from Mexico and Central America It is now transforming into an even more diverse community that includes all of the above, plus an incoming mix of younger, tech-savvy residents.

Likewise, Noe Valley and neighboring Eureka Valley, once home to my many Irish great-aunts and great-uncles, has been home to San Francisco's growing LGBT community (which once favored the Polk Gulch area off Van Ness Avenue) ever since the 1970s. In the years following the 1989 Loma Prieta earthquake, which caused widespread damage in the Marina

District, many yuppies (yes, that is what they were called then—young urban professionals) began to make the move from the landfill of the Marina to the more solid ground of Noe Valley, and the shopping area along 24th Street began to reflect this, with a notable increase in high-end baby strollers, boutique-style retailers and family-friendly dogs.

Row after row of railroad tracks used to fan out from Southern Pacific's old 3rd and Townsend train station, serving a community of factories and warehouses, but those began to disappear soon after San Francisco's decline as a major shipping port in the 1970s. Slowly, over the years things began to change, and suddenly the concept of Mission Bay began to emerge—now with a Major League Baseball stadium, apartment and condo complexes, restaurants, night spots, recreational facilities, shopping and an enormous expansion of the healthcare research clinics operated by the University of California.

MUNI's expanded service on the T-3rd Street line, plus the 1974 closure of the Hunters Point Naval Base and the more recent demolition of Candlestick Park (also officially known over the years as 3Com Park, San Francisco Stadium at Candlestick Point and Monster Park due to various naming rights and expirations), is continuing to bring change to the southeast corner of the city as well.

The Caucasian majority on the western half of San Francisco has long since been replaced by a predominantly Asian population, often with multiple generations living under the same roof.

Even staid old Parkmerced, my first home once I was on my own and out of college, used to have a sarcastic reputation of being "for the newly wed and the nearly dead." Today, it is a mix of recent arrivals from all over the world, students from nearby San Francisco State University (the school purchased several blocks of garden apartments nearest the campus from the Parkmerced Corporation early in this millennium) and a large mix of retirees, singles, couples and young families. A massive redevelopment project, approved by the Board of Supervisors in 2011, and affirmed following a number of legal challenges, is now underway. Over the next twenty years, the thousands of low-rise garden apartments will gradually be demolished, and replacement units, in the form of mid- and high-rise towers, will join the current eleven tower buildings as the neighborhood population nearly doubles.

As we near the end of this second decade of the new millennium, newcomers are still being welcomed, sometimes warily at first—with some media-fed examples of bad behavior in Dolores Park and other recreational locales—yet for the most part, they are drawn into the fabric of city life as San Franciscans.

4
FDR and the Knotty Pine Room

Mr. Roosevelt came home with me the other day.

Until the move, the framed full-page magazine photograph, depicting FDR at his jauntiest, had stood silent sentry on a wall above an old upright piano in one of those knotty pine downstairs rooms that were once so common in Sunset District homes. Today, such places are fading quickly from the scene, as new owners convert them into studio apartments or the latest real estate must-have: the "man-cave."

Back in the day when the firms of Charles J. O'Callaghan on Taraval Street, James Sullivan on West Portal Avenue and Julius Saxe on Noriega Street were selling Sunset real estate, a standard phrase in their advertising read simply "Knotty pine down + ½ ba," and everyone knew exactly what that meant. The phrase still evokes images of generations of happy family gatherings, New Year's Eve celebrations with noise makers and party hats, plus a console radio or an old upright piano in the background and a marvelous array of glassware for every type of drink imaginable lined up on backlit glass shelves behind a built-in wooden bar.

For nearly seventy-five years, Mr. Roosevelt watched over it all in a downstairs knotty pine room on 24th Avenue near Noriega, his place of honor having been conferred on him by the original owners, Ann and Charles, when the house was new back in the 1930s. It was their subtle little way of saying "thank you" to the man whose fiscal policies transformed them from renters into homeowners, thus ensuring their family's financial stability for generations to come.

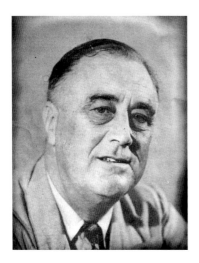

Framed image of FDR that hung in a knotty pine downstairs room on 24th Avenue for nearly seventy-five years. *Courtesy of the Charles and Ann Lane family.*

Ann and Charles were the grandparents of a St. Ignatius classmate, and I met them back in the late 1960s when their grandson and I were attending the old S.I. on Stanyan Street. They were, to use one of Ann's favorite descriptions of others, "just grand people"—old-time San Franciscans born before the Fire. Ann grew up with seven brothers and sisters on 10th Avenue near Geary, in a Victorian house that remained in her family for nearly one hundred years, until her last sister died in 1988, when it was sold and demolished by the new owners a few years later for a new structure. Ann and her siblings attended nearby Star of the Sea Academy, where one of their classmates was another Richmond District youngster who grew up to become the famous comedienne Gracie Allen.

Ann and Charles met in 1922 at a Valentine's Day party held "in one of those new flats near the police station on 24th Avenue above Taraval" and were married later that year, during the week between Christmas and New Year's. They raised two daughters in a series of apartments until the miracle of the Federal Housing Association loan enabled them to buy their first and only house just over the hill from the place where they met. Mr. Roosevelt assumed his rightful place on the wall of their knotty pine downstairs room shortly after move-in day.

Charles earned excellent wages as a union electrician, and there was no shortage of work from the time that he began installing wiring for some early SF Financial District high-rises in the 1920s, lights on the Golden Gate Bridge in the mid-1930s, through all of World War II, the boom years of the 1950s and right up until his retirement in the late 1960s. An enormous painted sign in the garage of his home remained as a souvenir from his days supervising a lighting improvement program at the old Kezar Stadium, under the auspices of Mayor Elmer Robinson, circa 1950.

Ann was a stay-at-home mom, but once the girls were older, she indulged in her love of stylish clothing by taking a part-time sales position at the old White House Department Store. It was the heyday of downtown retailing

back then, with stores open only "business" hours, along with Monday nights until 8:00 p.m., and closed on Sundays. The White House went one step further and even closed on Saturdays during the summers so that the employees could spend more time with their families during school vacations—truly a vanished age.

Ann was a wonderful cook, and she and Charley hosted parties that were legendary. They could both pour the perfect Manhattan, and they indulged their guests, even the younger ones, since we were always under their close scrutiny. Their traditional gathering was Christmas Eve, with a wonderful combination of family, friends, neighbors and everyone's co-workers. The open house began with hors d'oeuvres and a drink or two in the early evening. At about 10:30 p.m., most of the group would progress en masse to midnight mass at St. Ignatius. By 1:30 a.m., it was back to the house on 24th Avenue for a buffet of ham, turkey, salads of all sorts, baked beans, hot chocolate and glasses of champagne. The old Herman's Delicatessen at 8th and Geary was the source of much of what filled the buffet table, with desserts usually coming from the Golden Brown Bakery on Irving Street.

Ladies were always "dressed up" for the occasion, and the men generally wore coats and ties. Even as a high school student, I joined in the ritual by wearing a natty three-piece suit and a festive Christmas necktie, something that I have not done in a good long time. Chatting with older folks who were eager to share a lifetime of stories that usually began with, "I remember when…" was a great rite of initiation for this future history buff. The festivities would inevitably spill over from the living room, dining room and kitchen and into the downstairs room that held a bar, a built-in record player and an old upright piano—another disappearing relic of San Francisco homes, often a survivor of the 1906 Fire. Occasionally, the party might end before dawn, but more than once, the sun was coming up by the time the last of the guests took their leave, and everyone always had a wonderful time, enjoying the hosts' hospitality. All the while, through wars, civil unrest and economic crises, Mr. Roosevelt was quietly watching over things from his perch above the piano.

Family legend has it that about seventy-five years ago one guest indulged herself in a few too many cocktails one night and began ranting loudly against FDR and some of his economic programs, insisting to Ann and Charles, "You'll have to take that picture down or else I'm leaving." Without batting an eye, Ann promptly said to the woman, "Let me show you to the door."

As we baby boomers came along in the 1950s, those knotty pine rooms gradually evolved into rainy-day play spaces and birthday party central,

complete with cardboard cups of Arden Farms ice cream that came with tiny wooden spoons, birthday cake, pin-the-tail-on-the-donkey and lots of balloons. Lined up on benches and folding chairs at long plywood-topped tables that were covered with colorful paper tablecloths, little girls in frilly dresses and little boys in starched white shirts and clip-on bowties, we all helped each other celebrate our annual milestones, year after year.

As the 1960s drew to a close, dust slowly began gathering on all the rows of glassware behind the bar, and the revelry began to fall silent, as many old friends and family members departed for the very last time. Like many Sunset families who lacked a classic attic for storage, Ann and Charles allowed their big downstairs room to evolve into a storeroom for Christmas decorations; excess furniture; empty gift boxes from long-gone San Francisco stores like City of Paris, H. Liebes, Livingston Brothers, Nathan-Dohrmann, Ransohoff's, I. Magnin, Joseph Magnin and the ubiquitous Emporium; and stacks of old magazines, records and books that were "too good to throw away."

By 1972, ill health had begun to intrude on their lives, but Ann and Charles still celebrated their fiftieth wedding anniversary together at home. They always managed to coordinate their medical ups and downs so that just as one might need to enter the hospital for some sort of testing or treatment, the other had sufficiently recovered from his or her own health issues to assume the role of caregiver. They were there for each other until the very end, passing away less than two months apart in 1973.

After Ann and Charles died, their unmarried daughter continued to live in the house—it had been her home since she was eleven years old. She was one of those beloved maiden aunts who had risen through the ranks of Pacific Telephone into a series of comfortably secure positions before retiring in the early 1980s. Sadly, she recently joined the ranks of so many other beloved older relatives who have been waving that great generational goodbye to all the rest of us.

Now the grandchildren of Ann and Charles are confronted with the reality that their own lives have taken them in other directions, far away from 24th Avenue. As they rapidly approach their own retirements, they have reluctantly acknowledged that the old family home no longer fits into their plans. The "For Sale" sign has gone up, and generations of household memorabilia and paperwork have been sifted through, distributed, given away, shredded or simply discarded. Like many of us in the boomer generation, my friend and his sister were astounded by the amount of "stuff" that their relatives had accumulated in the house over several lifetimes.

Surprisingly, they decided to entrust me with Mr. Roosevelt. Seeing him again was like revisiting an old friend. He is now hanging on the wall of my den, and I see his reflection in the mirror each time I sit down at the computer. Even though he has left behind his beloved knotty pine room on 24th Avenue, I'm hoping that he'll enjoy life here with me.

I poured a Manhattan before dinner on the first night that he was here, and we toasted the memory of Ann and Charles and their family, who were all "just grand people." Mr. Roosevelt gazed at me from across the room, and while not forgetting his longtime Western Neighborhoods home, he seemed rather pleased to be settling in and watching over things from a slightly new perspective.

5
Along the Taraval Trail

Although I spent most of my first fifty years living in the Outside Lands, I now live outside of Outside, though I still visit pretty regularly. When I don't spend the night with family or friends, I often stay with those nice folks out at the Ocean Park Motel at 46th Avenue and Wawona. I always seem to find myself awake early and in need of coffee and the *Chronicle*. This leads to the inevitable trips up and down Taraval to see what is open at that hour.

It always seemed to me that in days gone by, Taraval was a veritable beehive of early-morning activity. Reis' Pharmacy at 18th, Zim's at 19th and the Baronial Bakery, the post office and the Overland Pharmacy near 21st, just to name a few, were active, even in the dark, early-morning hours. The familiar old yellow-panel bakery trucks with the pull-out shelves in the back would be cruising up and down the avenues with baked goods and grocery items such as orange juice, ground coffee, eggs and bread. The milk trucks from Borden and Sun Valley Dairy would be following a path, delivering to virtually all the homes on some blocks. Farther out, all the way along Taraval to the beach, were the small corner stores, their lights shining brightly. Many of those small places probably did a huge part of their business selling alcohol, tobacco, milk, bread and laundry detergent in the late-night and early-morning hours, back in the era of Ike and JFK.

There also used to be paperboys delivering the *Chronicle* (if you were in a Republican household) or the *Examiner* (if you were in a Democratic household) each morning, while those who delivered the *Progress* and the *Shopping News* were usually out and about after school. Strangely,

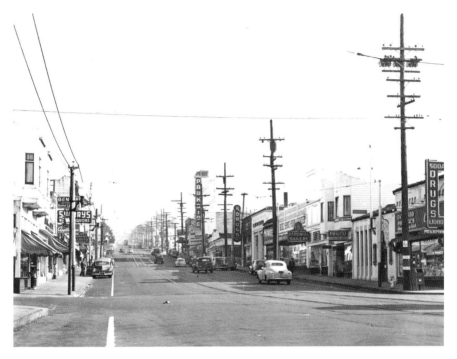

Taraval Street, looking east from 21st Avenue in the 1940s. The area retains much of its small-shop atmosphere today, though without the iconic Parkside Theatre, shown in the center distance. *Jack Tillmany Collection.*

most of those newspapers and their carriers are gone today. The big blue *Chronicle* trucks that used to rumble up and down Taraval frequently, until about ten years ago, loading up the vending stands on each corner with an inbound streetcar stop, are now few and far between, probably a reflection of a decline in readership, fewer people headed to work in the downtown area and more people opting for online news. Today, it seems that it is just those cool silver car tracks, stretching all the way out to the beach, without any early-morning signs of life in the neighborhood.

At the time of a recent visit, about 6:00 a.m., I found my way into the Tennessee Grill, an old familiar breakfast hangout from the days when Dad would want to get an early start on many family outings, from summer vacation to the annual St. Cecilia Parish picnic. The place hasn't changed much over the years since the original owners. The food is decent, down-to-earth and still reasonably priced. Service is unbelievably quick, but don't ask for "cholesterol free" eggs, because they don't have them. Toast is just white, wheat or rye, and the coffee is definitely not Starbucks. The only concession

to modern times is that there are now pink, yellow, blue and brown packets on the tables in addition to a pour-jar of plain old sugar. Ketchup still comes in a red plastic squirt bottle, as God intended.

On that foggy Monday morning not too long ago, I was sitting in the same booth that I did in 1964 and enjoying a pleasant meal, served up cheerily on the very same plastic Melmac platters from days gone by. The *Chron* was still stringing a few pitiful pages together that I could read as I ate (no more columnists, fewer comics, virtually no business news at all, very little local coverage and no high school sports, with the main focus on vague international issues and Hollywood scandals). Glancing around, I estimated that I was the youngest customer in the place by a good twenty years or so—hey, it's a great establishment that can make me feel that young again! If they would just repaint the interior in a color more cheerful than battleship gray and warm up the lighting a bit, it would crank things up a full notch or two. Once I was finished, it was time to walk off the fat and cholesterol, so I wandered a bit up and down Taraval to see the sights.

I was reminded of the early 1950s, before I started school, when Mom was still a non-driver and her usual household routine involved one or two weekly walking trips to all those long-gone merchants along Taraval. A regular shopping journey began by walking from our house on 18th Avenue down Vicente and then up 20th Avenue—a route that she selected to minimize the uphill climb. We would pass by the swings and slides of Larsen Park Playground, which would become a stopping-off point on the way home, if I behaved myself. Farther along 20th Avenue, past the older houses that had been constructed in the early days of the streetcar lines, we would wave hello to Mrs. Wolfinger, Grandma's girlhood friend, who might be sitting by her living room window or out front watering, just as she had been since the early days of St. Cecilia Parish, circa 1917. Then we would pass the side wall of the theatre on 20th, with its memorable billboard advertising 7-Up, along with the stern exhortation that I remember to this day: SHOP THE PARKSIDE.

Looking up Taraval at 20th Avenue, we could see the Parkside Sanitary Barber Shop, whose proprietor would be out there each morning winding up the barber pole with a hand crank so that a hidden mechanism in the porcelain base would spin a red-white-and-blue cylinder in a glass cage—its message being, the barber is open for business. This was something that I always enjoyed watching for reasons that I still can't fathom. I had my hair cut there for about the first fifteen years of my life, and if I didn't squirm too much, I could count on Bill the barber to open up the drawer full of Tootsie

Rolls that he kept in a desk opposite the first chair near the window. That was also the place where I learned the concept of infinity, by staring into a mirror that reflected the images of another mirror behind me—great stuff when you're five years old.

On those shopping trips, my mom's first stop was the Bank of America branch on the opposite corner. There was still etched glass in the lower six feet of the bank's tall windows facing 20th Avenue, and it added to the mystery and the allure in the mind of a six-year-old of just what mounds of currency and coin might be found at the desks within. Stepping into the lobby, there was the distinct smell of money in the air—something that is no longer present in the sanitized, air-conditioned bank buildings of today. Some of my early reading was done while standing in that lobby—Paying, Receiving, Savings, Checking, Safe Deposit, Christmas Club, Loans, Note Department and Merchant Window were just some of the signs that caught my eye. In particular, the Christmas Club sign evoked visions in my mind of Santa and his reindeer, kicking back and relaxing in recliners around a fireside with mugs of hot chocolate. How I wanted to visit that part of the bank building! Thirty years later, when Mom was about seventy, I introduced her to the miracle of the ATM one Saturday afternoon, and she had a look on her face that was about the same as if Orson Welles had walked up to her and introduced a friendly Martian.

From there, it was off to the Rite Spot Market just a few doors away for a few grocery items, then a stop at the Baronial Bakery, run by Willie Nabbefeld and his wife, Wilma, where Mom would buy half a cake for dessert or perhaps a loaf of cinnamon bread. For years, every birthday, confirmation and graduation cake in our house came from Baronial, along with plenty of Sunday-morning powdered-sugar doughnuts—we sometimes went to Adeline on West Portal for Danish pastries. In the 1950s, openings above the door emitted warm, fragrant air from the kitchen that drifted out to the street. Dad could stand there and chat with Willie endlessly, having known him from the days when Willie operated a smaller bakery on the north side of Taraval, just east of 19th Avenue, and even earlier than that, when Willie's father ran a Mission District bakery that Dad had known when he was growing up.

Then it was on to the post office. Prior to 1963, it was located right there on the south side of Taraval, just east of the Overland Pharmacy, but with the back side of the post office wrapped around behind the drugstore so that the loading docks faced 21st Avenue, thus reducing the impact on traffic on Taraval. If you look really, really closely, you can still see where

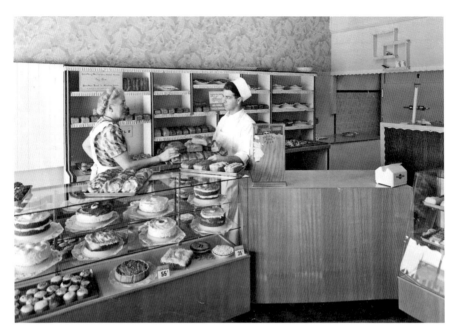

Taraval Bake Shop, late 1940s. Note the prices! *Courtesy of Cathy Nabbefeld Crain.*

the three openings for the mail trucks once were in that west-facing wall. We would always stop in to buy stamps and say hello to Dad's friend Mr. Tobin, who was the husband of the lady who would one day be my fifth grade teacher at St. Cecilia School, and if we were early enough, we'd see Leon, who would be delivering the mail to our block exactly at 1:00 p.m. every afternoon.

Next, we might stop in at the Overland Pharmacy on the corner for some toiletries and to say hello to Richard, the pharmacist. Flash-forward to 2002, and with Overland Pharmacy long gone, I found myself shopping on Taraval, picking up Mom's prescriptions at Safeway, where I was waited on once again by, yes, Richard the same pharmacist who used to work at Overland. As we talked, it also turned out that I had spent more than twenty years working alongside his widowed sister—nice people, both of them.

Moving along with the day's errands, we'd bypass the Parkside Paint Store (that was a favorite spot on Dad's list of weekend errands, and I'd get to go there with him and inhale paint fumes on Saturday) and then stop in at Ping's Hand Laundry, where Mom took her tablecloths and Dad's dress shirts. There was something very comforting about the steamy, clean smell of freshly laundered shirts, wrapped in blue paper and string and neatly

lined up on the shelves that I can't quite explain, though it remains with me to this day. In my mind's eye, I can still see Ping's elderly father, clad in a traditional silk jacket, ironing shirts by hand against the left-hand wall behind the counter. Years later, as Ping himself was about to retire, he lamented to me that the family business was not going to survive the next generation. "We worked hard so that all of the kids could have college degrees, and now no one wants to run a laundry." He sold the business to a nice Korean lady about thirty years ago, which turned out to be a wonderful opportunity for herself and her family.

I continued my walk, passing by several empty storefronts that may or may not truly be under renovation. I seem to recall that there was a radio repair shop, though that business probably dropped off considerably after the introduction of transistor radios, about 1959 or so. There was also a jewelry store where Mom liked to ooh and ah at the contents of the display window. The old Germanic-looking man behind the counter, jeweler's eye firmly in place, would always look up as we passed and smile and wave at us. Approaching the corner, I could still envision the Vogue Reweaving Studio where Mrs. Fukuhara and one other lady performed needle and thread miracles on torn sweaters, damaged tablecloths and the like. I know that they were still busily reweaving in the 1980s and 1990s when I lived at 22nd and Pacheco, but they have now vanished like all the others, swept up into the swirling foggy mists of the past.

Our next stop was at the meat counter of 22nd and Taraval Market (now Walgreens), where our Wawona Street neighbor Mr. D'Angelo worked as a butcher, and he would always offer me a slice of bologna or a hot dog. Mom enjoyed chatting with him and felt sorry that his young wife had died years earlier, leaving him alone to raise a son just a few years older than myself. Sadly, the son was killed in an accident in the summer of 1962, leaving Mr. D'Angelo all alone in their big house for another twenty-five years or so.

Then we would cross Taraval (remember, hold hands and look BOTH ways) and visit the library, where we could sit and relax for a few minutes after picking up or dropping off books. I can see that the present renovation seems to be coming along, though it is eerie to see it looking like a bombed-out shell, with parts of the building essentially open to the elements. My first memories of that place are from the fall of 1957, when Mrs. Beckerman and Mrs. McAtee, the two kindergarten teachers at Parkside School, walked the entire afternoon class, holding hands two by two, up there one drizzly autumn afternoon. We were all appropriately decked out in our yellow slickers, rain hats and galoshes (anyone else remember adults telling you that

you had to take them off in the house or else they would hurt your eyes?). Once we arrived, we were taken into the big reading room in the front, with the floor-to-ceiling windows facing Taraval.

Climbing up on the big leather chairs and sofas, with a warming fireplace along the back wall and the incredible smell of a library, it was a place of pure comfort. I still remember that the one thing I wanted for my birthday that year was a library card—ah, simpler times! The fireplace, inoperable for years by city ordinance, will likely not be returning, and I'm sure that the leather seating failed to pass inspection by some politically correct bureaucrat. Let's just hope that no one attempts to change the windows that let in that great southern exposure, since they will be the only element to warm up the place now.

I passed by the old locations of Hamill's Hardware Store and, in the next block, Parkside Appliance. Both were favorite shopping places for my parents. Mom had a pair of ceramic Dutch boy and girl figurines that she and Dad purchased at Hamill's the day they moved into their house, in September 1948. Those two statues stood sentry in the very same spots at opposite ends of the fireplace mantel, appearing in every family photo for the next fifty-four years.

As I walked east up the north side of Taraval, my imagination could still see the Parkside Theatre on the right. Without a doubt, it defined the

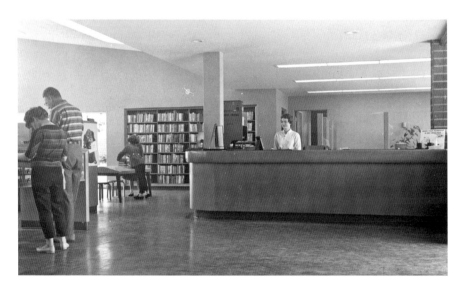

The cool, quiet interior of the Parkside Branch library in 1959 was a home away from home for many children and adults. *Courtesy of San Francisco History Center, San Francisco Public Library.*

entire community with its massive red sign rising vertically four or five stories above its low-rise neighbors and dominating the scene by turning the foggy air a crimson hue, something that could be seen most nights from our living room window on 18th Avenue, several blocks away. That old place was the site of countless summer matinees, for which schoolchildren in the neighborhood could buy ten weeks of admission for a mere dollar at the start of the summer. Those thin yellow perforated tickets were our key to freedom around 1963 or so. Whether with a group of friends or on our own (and usually meeting lots of classmates there), the tickets provided an uninterrupted afternoon away from home, and nobody worried, as long as Mom knew where you were. We faithfully paid the inflated prices at the Parkside's snack bar, though the really "wild" kids always managed to sneak in candy from the adjacent Dickinson's, which sold it for far more reasonable prices. Beginning in the late 1960s, when the building was remodeled into the Fox Parkside, it began to lose its allure, and slowly all the old trappings disappeared, from the multistory red neon sign to the ticket booth, and it finally became a nursery school, though with the iconic name Parkside School. Recent updates have totally obliterated any remaining traces of the once-grand movie palace, except for some art deco embellishments on the west wall facing 20th Avenue.

In that same block, there was a small gift shop run by a lady named Evelyn, who lived on 21st Avenue, and Mom would stop in there to buy the occasional birthday card. When I was about six, the fringe on the sleeve of my Davy Crockett jacket bumped a teacup off a shelf, and Evelyn coolly told Mom that she would have to pay for it. Not liking to be taken advantage of for an accident, Mom didn't bat an eye, but just as coolly told the woman, "I'd like the pieces gift-wrapped, please." Once home, she carefully glued it back together and placed it on a glass shelf in our living room curio cabinet, where it resided for the next forty-five years.

Just uphill from the Parkside was the Different Bakery, a place that Grandma used to visit regularly, just for its jelly roll covered in white frosting—her traditional dessert after serving a corned beef dinner to everyone at her house on 21st Avenue. It came as a surprise to me in the 1990s when Mom mentioned that her own mother had worked there for several years in the late 1930s before World War II, and it intrigued me to think that my two grandmothers had likely known one another long before my parents had gotten together.

Crossing 19th Avenue, I saw that Zim's, along with several of its replacements, are now all gone, replaced by yet another eatery that does

not open very early. The old painted sign on the south-facing wall of that building, advertising Roberts-at-the-Beach Motel, has been painted over by a new advertiser for many years now. (Roberts itself lasted for several more years before falling to the wrecker's ball in 2015.) Strange as it seems, even the gas stations along 19th Avenue are another dying breed. The Shell station is still there, alongside the 1960s apartment building where Dad's cousin Vivian used to live, but all those other ones that used to dot virtually every intersection are becoming a rare breed, indeed.

The Sunset Motel, built in the 1950s and expanded in the 1960s, is now gone, replaced by a new block of condos, and the adjacent medical building that once housed Dr. Tackney's dental office (a favorite of St. Cecilia students) now has a whole new roster of tenants. Across the street, the Gold Mirror stands out like an old friend, serving up a month's worth of vitamins with every bowl of minestrone. The place has been spruced up a bit after a runaway truck did some damage to the entrance a couple of years ago, and it will likely still be around for a good many more years. Reis' Pharmacy, now a liquor store, was at the southeast corner of 18th and Taraval, with an expansive comic book selection just inside the front door. It was the very last place that I ever saw a druggist use a mortar and pestle to mix drugs. All the work went on in a little room in the far rear corner, entered through a set of barroom-style swinging half-doors, and I remembered having to wait impatiently while Dad would lean on the counter, yakking back and forth with the owner and his brother, whom Dad had known since 1937, when he first moved to the neighborhood with his widowed mother and his own brother.

Across the street on the north side of Taraval, on the site of the present Safeway store, was Holiday Chevrolet, beginning in the early 1960s. Prior to that, it was known as Spencer Buick, but Grandma always remembered the location as the Parkside Coal Company, and an old advertisement on the wall of her garage confirmed that fact for me. Several blocks up Taraval, also on the north side and closer to today's Herbert Hoover Middle School, there was another auto dealership, Avenue Rambler. Each fall, all the boys in the neighborhood would descend, en masse, on each of these two auto showrooms to check out the new models, much to the disgust of the sales staff. The styling differences from one model year to the next were enormous back then, and although I can still identify every GM model from 1950 through the mid-1970s in a flash, I would be hard-pressed to identify most cars on the road today as a 1990, 1995, 2000, 2005, 2010 or 2015 model year. How some things have changed!

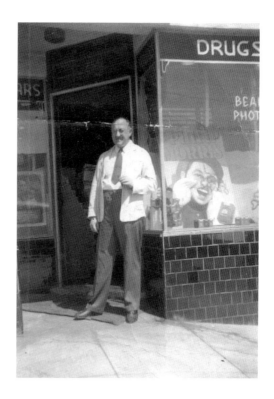

Charles Reis operated a popular pharmacy at the corner of 18th Avenue and Taraval Street from the 1930s until the 1970s. The comic book rack was just inside the door, and he allowed youngsters to read as much as they liked while their parents shopped. *Courtesy of David Reis.*

At the corner of 17th and Taraval, there was Charles J. O'Callaghan Real Estate & Insurance—his youngest son and oldest grandson were both in my class at St. Cecilia School, and one of his granddaughters just retired as assistant chief of police. For many years, he was one of the leading real estate agents in the area. His biggest competition was James Sullivan Real Estate & Insurance on West Portal, where our old family friend Theresa was the office manager. In spite of their business rivalry, O'Callaghan and Sullivan were longtime neighbors living just across the street from each other on the 2500 block of 17th Avenue, near the St. Cecilia rectory.

As I headed back to the car and drove off, I passed by the corner of 24th Avenue and Fahey's/The Dragon Lounge, which has been written about a few time on the Outside Lands site. It's nice to see a bit of the past combining with the present and future so that so many people can share in the same memories and nostalgia going forward. Wally's Ice Cream, with its red-and-white-striped awning, just kitty-corner from there, is long gone, while the police station, just up the hill, looks much the same, even after some renovations.

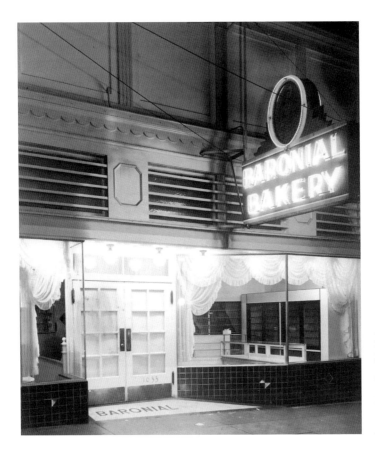

Baronial Bakery at 1033 Taraval Street served the neighborhood for decades. *Courtesy of Cathy Nabbefeld Crain.*

Those flats adjacent to the SFPD's Taraval Station, when new, were the scene of a Valentine's party back in February 1922. A friend's grandmother always recalled how she met her future husband there that night, when they discovered that they had matching halves of red construction paper hearts, passed out by the hostess to all the guests as they arrived. They were then paired up for the evening, began dating and were married that December, raising a family and living out the rest of their long lives just over the hill on 24th Avenue near Noriega.

As I passed by during my recent walk, a young couple was walking up the block, hand in hand, gazing into each other's eyes as they strolled past that row of flats—buildings that are now fully ninety-plus years old—reminding me clearly that some things in life do not change at all.

6
SCHOOL DAYS

In the not-too-distant past, nearly 25 percent of the city's population was made up of school-age children. Today, that figure has been cut in half, and there are now more registered dogs than children in San Francisco. It is little wonder, then, that education plays such a significant role when we remember the past.

The sheer number of baby boomers in the post–World War II era strained the capacity of schools everywhere, but particularly in the Archdiocese of San Francisco, whose parochial school system was impacted by a large Roman Catholic population with a traditionally larger family size. As a result, some parochial schools were forced to shut down their kindergarten operations in the 1950s in order to maintain fire department–authorized capacities in their upper grades. Consequently, thousands of children who were eventually bound for Catholic school educations experienced the warm embrace of kindergarten in the arms of the San Francisco Unified School District.

Particularly in the growing Western Neighborhoods of the city, elementary schools were constantly expanding in the 1950s. A new concept, "home schools," sprang up in the public school system, in which small facilities housing only the lower grades were constructed quickly to deal with the onslaught of larger and larger classes of baby boomers—with an understanding that many of these families might likely migrate to the suburbs prior to the time their children reached the upper grades and/or high school. Two of the home schools in the Sunset District were Juan

SAN FRANCISCO UNIFIED SCHOOL DISTRICT
PROGRESS REPORT
for
GRADES ONE AND TWO

Pupil _Frank Dunnigan_
Teacher _Mrs. M. Ehrmann_
School _PARKSIDE SCHOOL_
Principal _Amy E. Wisecarver_
Grade _L.1ST_ Term Ending _June 13,_ 19 _58_

ASSIGNMENT FOR NEXT TERM

Frank Dunnigan is assigned to the _H. 1ST_ Grade for the _Fall_ Term, 19 _58_.

NOTE TO PARENT OR GUARDIAN

San Francisco is proud of her public schools as shown by the active public interest and support. The high standards reflect close home-school relationships and co-operation. Parents are welcome in the schools at all times; and in the case of conferences with teachers, time is saved by making such arrangements with the principal.

In the sound and sympathetic preparation of your child for the future, there is no substitute for your close interest and participation in the work of the school.

Harold Spears
Superintendent of Schools

Left: Report cards issued by the San Francisco Unified School District have long carried the message about home and school working together. _Author's collection._

Below: While many newer school buildings are architecturally uninspiring, Francis Scott Key, on 43rd Avenue in the Outer Sunset District, was designed in a classic art deco style and included a winged Pegasus above the entrance. Following recent renovations, the school has one of the largest special education programs in the district. _Photograph by Michael Fraley._

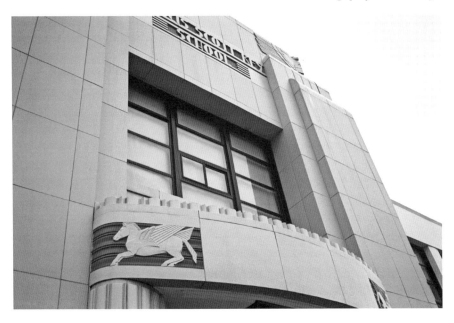

Crespi at 24th Avenue and Quintara and Noriega Home School at 44th Avenue and Noriega.

Likewise, the Catholic schools were expanding, too. St. Cecilia School, built in 1930 at 18th Avenue and Vicente Street, originally had just eight classrooms but was doubled in size in 1948 to include two classes at each grade level, plus both morning and afternoon kindergarten sessions. St. Gabriel, at 40th Avenue and Ulloa Street, opened in 1948 and soon expanded to three classes at each grade level—the largest Catholic elementary school west of Chicago at that time. Many Catholic parishes in San Francisco were building or expanding elementary schools in the years after World War II.

Large public high schools dotted the city landscape in those days, including Balboa, Commerce (closed after 1950, with the school building becoming administrative offices and the one-time football field of the champion Bulldogs now the site of the 1980 Louise M. Davies Symphony Hall), Galileo, Lincoln, Lowell, Mission, Polytechnic (closed after 1972, with the school building demolished and the site converted to housing) and Washington.

Between 1925 and 1968, Poly won thirty-nine city championships in high school sports, including thirteen football titles. From 1942 to 1961, under the legendary head coach Milt Axt, the Parrots won forty-five

St. Cecilia School at 18th Avenue and Vicente Street was built in 1930 with eight classrooms. A 1948 expansion doubled the school's capacity, and today it is the largest Catholic elementary school in San Francisco. A new church building was constructed in 1956 on the sandlot in the foreground, plus a new multipurpose facility in 1999–2000. *Courtesy of Monsignor Michael D. Harriman, parish archives.*

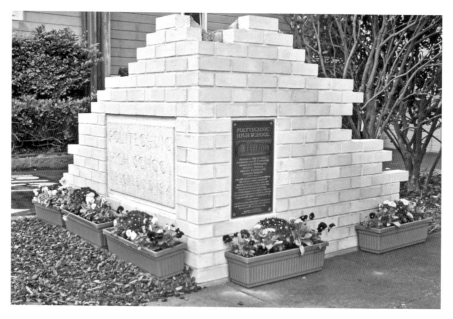

After Poly closed in 1973, the building was eventually demolished. While individual classes no longer hold reunions, the very active alumni association now sponsors all-class gatherings. In 2014, the group held a centennial rededication of the cornerstone in a replica of the original building's exterior wall. *Courtesy of Bob and Carolyn Ross.*

straight games—never once losing to their crosstown archrival, Lowell High School.

In 1962, Lowell, then located at Hayes and Masonic for fifty years, followed the city's population to a location west of Twin Peaks, opening a new campus on the shores of Lake Merced.

For nearly a decade, from the mid-1930s through World War II, San Francisco's Catholic high schools banded together to conduct joint commencement exercises—a practice largely forgotten today. Reading over the list serves as another quiet reminder that many of these schools are no longer with us today.

While the San Francisco Unified School District actually has its own published dress code (recently updated for the first time since 1997 to eliminate a district-wide ban on head coverings), Catholic school students continue to have far less wardrobe latitude than their public school counterparts. In particular, girls attending San Francisco's Catholic girls' high schools still have very clear uniform requirements.

Each August, the annual buying begins. Many girls visited the old Sue Mills store on upper Market Street (now relocated but in business since Harry

The Archdiocesan School Board
and
The Senior Classes
of the
Catholic High Schools of San Francisco
cordially invite you to be present at the
General Commencement Exercises
Civic Auditorium
on Sunday afternoon, the twentieth of June
Nineteen hundred and forty-three
at three-thirty o'clock

His Excellency
The Most Reverend John J. Mitty, D. D.
Archbishop of San Francisco
Presiding

Boys and Girls Catholic High Schools
of San Francisco

St. Vincent High School
Notre Dame des Victoires High School
St. Peter's Academy
St. Rose Academy
Immaculate Conception Academy
Star of the Sea Academy
Notre Dame High School
Academy of the Sacred Heart
St. Joseph's High School
St. John's Ursuline High School
St. Paul's High School
St. Brigid High School
The Academy of the Presentation
Sacred Heart College High School
St. Peter's High School
St. James High School
St. Ignatius High School

From the Depression through World War II, Catholic high schools joined together to hold a single, consolidated graduation ceremony each year. Many of these once-popular Catholic high schools from 1943 have closed or merged in recent times. *Courtesy of Bernadette Ruane Hooper.*

Truman was in the White House) or the downtown City of Paris department store. Most San Franciscans could spot the herringbone patterns a mile away—tan for St. Rose versus gray for Convent of the Sacred Heart—and easily tell the difference between Presentation's and Mercy's plaid patterns, while Star of the Sea's solid dark-brown skirt also stood out in a crowd. Although there was very little that a student could do to customize her school's specialized look, there were some options that permitted a bit of fashion consciousness.

Having completed a highly unscientific poll of Catholic school alums, all with vast experience, we now take a look back at some fashions that once dominated local high school corridors.

MERCY GRAD, 1974

Yes—Sue Mills—it was more of a warehouse than a store, not nearly as nice as what my brother found at Bruce Bary in Stonestown. In 1970, we also had a uniform sale day at Mercy. Even though my mother had already taken me downtown for essentials, I recall buying another sweater that day. The sweaters were color/style-coded: cranberry cardigan for frosh, cranberry V-neck for sophomores, blue cardigan for juniors and blue V-neck for the seniors. We also had a uniform bolero jacket in cranberry, but it was not mandatory. Also at Mercy, we were one of the first classes who wore knee-high stockings and loafers instead of the old saddle shoes. MOST girls rolled their skirts after school—how else were we going to get SI [St. Ignatius] *boys to take us to a dance or game? When I was shopping at Stonestown earlier this year, I noticed that the girls are still following this same proud tradition as they leave the campus—sometimes I forgot to unroll mine before my dad came home, and he was NOT amused!* [Author's note: One day, while driving along 19th Avenue, circa 1989, with my own mother and her sister—then both in their seventies—in the car, we saw several Mercy students rolling up their skirts before crossing 19th Avenue to Stonestown. My aunt commented that she and Mom used to do the very same thing when leaving school at St. Peter's Academy in the Mission District in the 1930s, before walking home along 24th Street—some things never change!]

STAR OF THE SEA GRAD, 1972

I don't have many memories of purchasing uniforms, but I do remember that I loved my uniform—it gave me a sense of community and belonging. I think it was a San Francisco thing, as I always enjoyed seeing other uniforms and making the neighborhood connections. In high school, because we were aware of fashion trends, I remember how important hair accessories and purses became—since that was the only form of expression we had. I paid a lot of attention to both, making sure that they made a statement.

ST. ROSE GRAD, 1966

We had brown herringbone skirts and jackets from City of Paris, and we had to buy two skirts, because at some time in the past, St. Rose students were invited to welcome General Eisenhower at the airport. Some moms had washed their daughters' wool skirts, and they shrank. Short skirts—scandalous! So after that, there was a two-skirt minimum. I loved the freedom of a uniform—no decisions to be made in the morning, and our non-uniform clothes remained nice because we had the uniform for everyday use. When I hit college, it was a pain to have to think about what to wear first thing each day.

St. Rose Academy operated on Pine Street from 1905 to 1990, the last link to an old South-of-Market parish founded in the 1870s. The school survived the 1906 earthquake and was out of danger from the subsequent fires. However, it suffered severe damage from the Loma Prieta earthquake in 1989 and was closed down in 1990, with the building later demolished. Though gone for more than twenty-five years, the school still has an active alumnae association. *Artwork by Joyce Dowling, Marci Hooper Collection.*

CONVENT OF THE SACRED HEART GRAD, 1971

I liked uniforms because they were the great equalizer—no matter what you had at home, we were all the same in the classroom. It was also a good feeling to know that I could get ready every morning in far less time than my public school friends, because my wardrobe choices were predetermined.

We had a herringbone blue skirt with a single inverted pleat in the front, along with a vest-like top and a white blouse and black loafers. There was also the "dress uniform" that consisted of a white jacket and skirt with a white blouse trimmed in red plus a red tie. These were worn for First Friday Mass plus assemblies.

PRESENTATION GRAD, 1970

Our uniforms were pleated plaid skirts, white blouses and navy blue sweaters, plus navy-blue-on-white saddle shoes with white ankle socks. It was easy to spot our schoolmates on MUNI, which helped us to get to know others before and after school hours. "Free dress" days were tricky—old play clothes vs. dress-up.

For guys attending St. Ignatius, Sacred Heart or Riordan, there were no uniform requirements, though there was a basic pattern of gray/dark green/khaki pants, button-down collar shirts (with enough starch to give them a brick-like firmness—the choice of students and *never* a school requirement) and V-neck wool sweaters. Some sartorial splendor crept in from time to time in the 1960s: Madras shirts, knit snow caps and mufflers during cold weather, Derby brand jackets, always yellow, tan or navy blue—no parent would allow their son to wear a black one because that hinted at gang activity.

For boys just entering high school, it was a given that the late summer shopping trip to Bruce Bary would be conducted under the close scrutiny of one's own mother. Being seen in public with either parent was an ordinary embarrassment for most fourteen-year-olds, but the situation became immeasurably worse when trying on pants. Many mothers seemed to have a rather obsessive need to put their hands into the waistband and tug at it in order to determine whether or not there was a proper fit. The usual teenage male retaliation for this embarrassing maternal behavior was to chat up every schoolmate who happened to be in the store at the time—even those you weren't particularly friendly with—about any and all topics until every mother involved was fed up with the delay and resolved that her son was old enough to shop on his own from that point on.

Just as girls expressed individuality with purses, guys often did so with footwear. At St. Ignatius in the 1960s and early 1970s, the rule was

In 1965, St. Ignatius made plans to depart its decades-old home on Stanyan Street for an expanded campus in the Sunset District. Pictured here is the kickoff publicity photo of the fundraising drive; the "new school" opened in 1969. *Courtesy of St. Ignatius College Preparatory.*

simple—no athletic or other "non-polishable" shoes. There were some school years when black wingtips were popular, and by the following September, everyone was wearing burgundy penny loafers, while in 1968, the trend was heavily in favor of brown-on-brown saddle shoes. What everyone at SI wanted to wear were Clark's desert boots, made with a soft, unfinished tan leather and a thick crepe sole—very comfortable. They were forbidden, however, because they were non-polishable. Miraculously, in 1969, the Clark's Boot Company produced a yellow-tan polished version with a side buckle, and these became an instant hit on 37th Avenue.

Similar to Mercy's sweaters, SI also had distinctive school jackets, with the colors red and blue alternating for each class. The class of 1969 was blue, and the class of 1970 was red. I remember once asking an elderly Jesuit why the colors alternated from one year to the next, and without batting an eye, he replied, "Makes it easier for the police and witnesses to narrow down the guilty ones in a lineup."

SI's dress code became far more specific following the school's transition to coeducation—something that occurred a full twenty-five years ago. Today, all students must wear knit polo shirts or button-down collar shirts. Sweaters or jackets may be worn, as long as the shirt collar remains visible. Pants must still not be denim, but to-the-knee shorts are now permitted on both male and female students, and girls have the added option of wearing a knee-length skirt if they wish. The old rule about "non-polishable" shoes is gone, replaced with a simple "shoes must be worn at all times." One new rule, in keeping with the times, is "No visible tattoos."

St. Ignatius, founded in 1855, relocated to its sixth site, in the middle of the Sunset District, in 1969 and has since expanded considerably. The school, fully coeducational for more than twenty-five years, has nearly twenty thousand graduates. *Courtesy of St. Ignatius College Preparatory.*

Both guys and girls have always had some latitude in hairstyles—though never enough. While girls' schools did not tolerate students dyeing their hair in the 1960s, it was a rare girl, having light brown hair, who did not help Mother Nature just a bit with the occasional bucket of lemon juice, peroxide or Clorox—even though the nuns were constantly on the lookout for anyone who suddenly became "too blonde."

In SI's Stanyan Street days, hair had to be "short, neat and conservative," even though those terms were defined only in the mind of the Jesuit beholder, with students subject to frequent impromptu personal reminders about the need for a haircut, shave or shorter sideburns, often in the hallways between classes. SI's hair rules today remain generalized (though with prohibitions against "extreme" or "distracting" styles or colors) along with the summary, "Hair must be clean, combed, and neatly styled. Inappropriate hair styles will be left to the discretion of the Deans." Lime-green spiked Mohawks are still out, I guess.

One Facebook user recently posted his own recollections about a 1957 grooming crisis at Lincoln High School that came about because of Yul

Brynner's role in the movie *The King and I*, noting that Herb Caen had mentioned it in his column:

> *Jeff Amos of 2222 48th Avenue, a low-junior student at Lincoln High, marched into Paul's Barber Shop at 46th & Taraval Wednesday and ordered: "A Yul Brynner, please!" He got it. Paul clipped all his hair off and then shaved the top. "Ahhhh," said Jeff, a red-hot Brynner fan, as he surveyed himself in the mirror. But the next morning—"Ughhhh," said Dr. J.B. Hill, principal of Lincoln High. He promptly ordered Jeff to stay out of school until his hair grows back, because he's afraid the idea might become contagious. "But I have a math test tomorrow," wailed Jeff. "You can come in for that," decided Dr. Hill, "but you'll have to wear a hat."*

Oh, right—a hat is going to be really inconspicuous! It's amazing how something like hair has been a cause of so many adolescent as well as adult crises over the decades. Trust me, it will change color on its own over the course of time—and then just fall out.

I wonder if retirement homes will have dress codes when we get there?

School Safety Patrols of traffic girls/boys from both public and private schools gather at the polo field in Golden Gate Park for their 45th Annual Review, accompanied by school bands, in 1968. *Courtesy of Western Neighborhoods Project.*

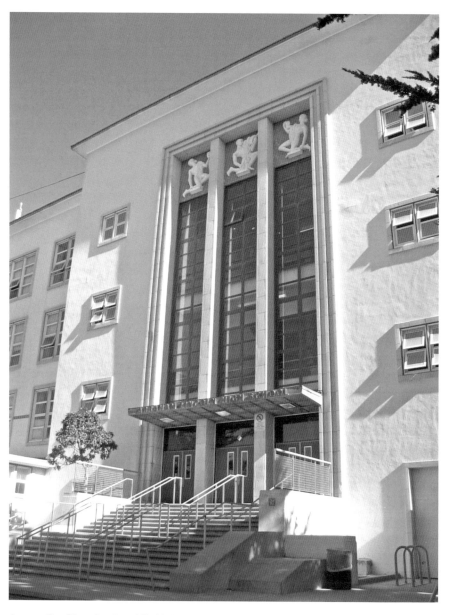

Among San Francisco's public high schools, Abraham Lincoln, a California Distinguished School, is one of the most competitive for admissions in recent years. *Photograph by Woody LaBounty.*

7
THE GRAND ERA OF PHILANTHROPY

M uch is written today about the perceived evils of capitalism and the extreme wealth of the rich and famous. San Franciscans, perhaps, are able to demonstrate a certain level of tolerance for such matters because of a long history of local philanthropy from institutions such as the Chinese Six Companies, Jewish Family and Children's Services, Catholic Charities, American Red Cross, United Way, Salvation Army and many other organizations that have been funded by both large and small donations alike.

In addition to organized charities, some very wealthy individuals have plunged billions of their own dollars into the San Francisco community, sometimes in magnificent ways, and often right here in our very own Western Neighborhoods.

Author's note: This listing most certainly does NOT purport to be all-inclusive of the many generous donors to worthy causes. In fact, most organizations will confirm that their all-time most generous gifts have often come from those known only as "Anonymous." The following is but a snapshot of the positive impact that some generous contributors have made on the daily lives of all San Franciscans.

ANDREW CARNEGIE

Born in Scotland in 1835, Andrew Carnegie moved with his family to Alleghany, New York, when he was thirteen years old. In a classic rags-to-

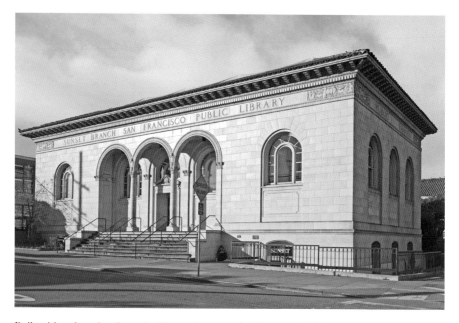

Built with a donation from the Carnegie estate, the library at 18th Avenue and Irving Street has served the community since 1918, when it became the eighth branch in the system. It has recently undergone a detailed renovation. *Photograph by Alvis Hendley.*

riches story, he rose from a telegraph and messenger boy earning $2.50 a week in Pennsylvania to this country's preeminent steel and railroad magnate. In the final twenty years of his life, he became a philanthropist, giving away more than $350 million (nearly $5 billion in today's money) for the establishment of free libraries throughout the United States that were open to all. San Francisco's current Sunset and Richmond branches of the San Francisco Public Library are just 2 of the 144 California libraries established with Carnegie funds—some others include the old San Francisco Main, Chinatown, Golden Gate Valley, Mission, Noe Valley and Presidio branches.

MICHAEL DE YOUNG

Born in St. Louis in 1849, Michael de Young moved with his family to San Francisco as a young child. Along with his brother Charles (1845–1880), he founded a newspaper in 1865 that became the *San Francisco Chronicle*. Having

helped to assemble a gem collection for the Midwinter Exposition of 1894 in Golden Gate Park, he also donated pieces from his own art collection to San Francisco's first public museum, which was named in his honor. De Young ensured that the museum retained free admission throughout his lifetime and for many years after.

HERBERT AND MORTIMER FLEISHHACKER

The Fleishhacker brothers, born in San Francisco, were involved in banking as well as investing in early hydroelectric power plants that were eventually acquired by PG&E. Herbert, a parks department commissioner, spearheaded the drive for a public swimming pool, contributing much of the $1.5 million cost from his own pocket. Filled with six million gallons of heated ocean water and with enough room for ten thousand people, the incredible pool—150 feet wide by 1,000 feet long—required that lifeguards use rowboats. Opening in 1925, it was packed with fun-seekers for decades—at an admission price of just $0.10. Sadly, the pool was closed

The Mother's Building at the zoo was donated by the Fleishhacker brothers and was a much-appreciated amenity for countless mothers and their small children for decades. Although it is no longer in service, plans are underway for its restoration. *Photograph by Lee Emmett, John Varley Collection.*

in 1971 and has been replaced with a parking lot. The old bathhouse remained vacant for decades but burned to the ground in December 2012 and was subsequently demolished, except for the ornate entryway, which will be preserved as a memorial. Herbert contributed heavily to the establishment of the adjacent zoo, named in his honor for decades, and he and his brother Mortimer also donated a personal $50,000 for construction of the Mother's Building at the zoo, in honor of their own mother, Delia Fleishhacker. The zoo remained a free attraction until 1970. Mortimer spent thirty years as a regent of the University of California and was also an active benefactor of the San Francisco Opera, the San Francisco Symphony and the Museum of Modern Art. The Fleishhacker Foundation, today run by third- and fourth-generation descendants of this family, manages more than $13 million in assets and makes regular distributions in two categories: arts and education.

HAAS FAMILY

Among the descendants of Levi Strauss and Rosalie Meyer Stern, Walter Haas and his wife, Evelyn, established the Hass Foundation in 1953, and it has since awarded nearly $400 million in grants to support fundamental rights for all people. As far back as the 1950s, Walter and his brother Peter ensured that racial equality and decent working conditions were business standards in the company's manufacturing plants—one of the first large clothing manufacturers to do so. The foundation has also donated generously to the Graduate School of Business at UC-Berkeley (where the Haas School of Business was named in honor of the family). Other significant donations have been made to nonprofit groups supporting the *Chronicle*'s Season of Sharing Fund, LGBT rights and Hunters Point Boys & Girls Club, as well as the massive transformation of Crissy Field into a premier urban park.

JAMES DUVAL PHELAN

Born in San Francisco in 1861 of Irish immigrant parents who became wealthy during the gold rush, Phelan graduated from St. Ignatius College (now USF) and law school at the University of California at Berkeley and became a successful banker and real estate investor. He was elected mayor

The University of San Francisco (USF) campus is adjacent to St. Ignatius Church, which celebrated its centenary in 2014. The school began as St. Ignatius College, and the present campus developed over the decades of the past century with the generous support of U.S. senator James D. Phelan and many others, expanding from a "streetcar college" to an international university today. *Photograph by Michael Fraley.*

of San Francisco, serving from 1897 to 1902, and later was chair of the Red Cross relief efforts following the 1906 earthquake and fire. He was elected U.S. senator from California in 1914 and served until 1921. Upon his death in 1930, his country estate, Villa Montalvo, in Saratoga, was given to the people of Santa Clara County as a performing arts center, and the Phelan Award, an annual series of scholarships to young writers and artists, was funded in perpetuity in his will. He provided $100,000 toward the construction of St. Ignatius High School on Stanyan Street and also gave generously to USF, with Phelan Hall, the first campus residence hall, named for him.

Alma de Bretteville Spreckels

One of the first natives of the Sunset District to become widely known (she was born somewhere in the sand dunes between Junipero Serra Boulevard

and the shores of Lake Merced in 1881), Alma had a poor childhood, often helping her mother in a small family-owned bakery. She attended art school and posed as a model for the 1903 Dewey Monument in Union Square before she met and married sugar heir Adolph Spreckels in 1908—when he was her senior by twenty-four years—and it has been said that this helped to coin the phrase "sugar daddy." Taking her place in San Francisco society, she acquired many works of art for display at the 1915 Panama-Pacific Exposition. Following the end of the fair, she funded the construction of the Palace of the Legion of Honor in Lincoln Park as a permanent home for her donated collectibles. She also engaged in other charitable work, benefiting a museum in Washington State as well as providing significant funding to the Salvation Army for the establishment of its local thrift shops.

IGNATZ AND SIGMUND STEINHART

Sigmund Steinhart was born in Bavaria in 1833. Arriving in San Francisco as a teenager in 1850, he became a dry goods wholesaler and, later, a stockbroker. Never married, Sigmund lived with his banker brother Ignatz and his family, and both brothers donated large sums to charity. In his 1910 obituary, it was noted that Sigmund "was known for his magnificence to the poor." One of his charities was the Pacific Hebrew Orphanage and Home Society, which later established the Homewood Orphanage on Ocean Avenue in the Ingleside neighborhood. Ignatz and his family also donated large sums to charity, including a gift of $250,000 to the California Academy of Arts & Sciences in 1916 to build the Steinhart Aquarium in Golden Gate Park, which offered free admission for decades.

ROSALIE MEYER STERN

In 1931, Rosalie Meyer Stern wished to create an appropriate memorial for her late husband, Sigmund, who happened to be a nephew of clothing manufacturer Levi Strauss. Based on a recommendation from park superintendent John McLaren, she was shown a eucalyptus grove located in a natural amphitheater near 19th Avenue and Sloat Boulevard. Paying $50,000 to the owner for some thirty-three acres, Mrs. Stern then donated

the land to San Francisco to be used "solely and exclusively for recreational purposes." Free summer concerts, established in 1938 and funded by her family's descendants, continue to draw up to twenty thousand attendees on Sunday afternoons.

Adolph Sutro

Born in Germany in 1830, Sutro came to San Francisco as a young man and soon became a successful silver miner. He encouraged public recreation by opening the grounds of his home to visitors and later constructing the nearby Sutro Baths and rebuilding the Cliff House. Sutro kept the admission price low and even subsidized a new transit system, the Ferries and Cliff House Railroad, to bring tens of thousands of visitors to the Lands End area each week from downtown. Sutro's nearby home was donated to the city upon his death but was torn down in 1939, though the grounds remain a public park. His vast library collection, which survived the 1906 fire because of his mansion's remote location, now forms the Sutro Library, which is housed on the fifth floor of the SFSU library, having been located in a stand-alone building near Stonestown and a ground-floor location at the USF library for many decades prior. A home built by his grandson on property near Mount Davidson marked the first permanent home of broadcast television in San Francisco, and it was demolished for construction of a regional transmission facility, Sutro Tower, which was completed in 1972.

Ben Swig

Born in Massachusetts in 1893, Swig and his family settled in San Francisco after World War II, and he expanded his real estate operations to include the Fairmont Hotel, the Mills building and other San Francisco commercial properties. Before his death in 1980, he donated much of his wealth to various Jewish, Catholic and secular colleges and universities—Swig Residence Hall at Santa Clara University is named for him—as well as funding many Girls' and Boys' Club operations.

ZELLERBACH FAMILY

From a small family charity founded by matriarch Jennie Zellerbach in 1956, the fund has grown from sound investments and a further contribution from Mrs. Zellerbach's trust following her death in 1965. In addition to a $1 million gift to the University of California at Berkeley in the 1960s (for which Zellerbach Hall is named), the foundation has distributed over $70 million in charitable support to many local nonprofits.

Those who have benefited from recent wealth seem to be following in the steps of their predecessors in helping the local community. Bill and Melinda Gates of Microsoft fame have established a foundation with an asset endowment of more than $40 billion to provide worldwide support organizations that work to improve the health and education of children, with much of the funding going to UC Medical Center on Parnassus Avenue. Marc Benioff, founder of Salesforce.com, and his wife, Lynne, made two separate $100 million donations in 2014 to support childhood healthcare at UC-Med—the largest of the hospital's donations to date.

Finally, among the youngest of the recent crop of techies are Mark Zuckerberg and his wife, Priscilla Chan, who have pledged $1.1 billion to the Silicon Valley Community Foundation over the next five years. The recent announcement included the stipulation that the first $5 million will go directly to financially needy school districts in San Francisco and East Palo Alto—all of this over and above a 2015 donation of $75 million to San Francisco General Hospital.

Of course, philanthropy isn't always easy. The long-widowed Mrs. Spreckels and the daughters of Michael H. de Young traveled in the same social circles but were not known to be particularly friendly toward each other. When questioned about this, one of the de Young daughters stated politely that things had never been cordial between them "ever since her husband shot my Daddy." Indeed, history records the fact that Adolph Spreckels fired a nonfatal gunshot at Michael de Young in 1884 because of an unflattering newspaper article about Spreckels's business dealings that was published in the de Young–owned *San Francisco Chronicle*. The fact that the de Young Museum and the Legion of Honor Museum merged many years ago into a single entity—now known as the Fine Arts Museums of San Francisco—is yet another small irony in the long history of our unique hometown.

Then and now, it is good to see that many people have the right idea about appropriate uses of immense wealth. In the words of an ancient Chinese proverb:

> *The family that perseveres in good works will surely have an abundance of blessings.*

8
Fun and Games

Prior to the electronics age—say, the era before transistor radios—young and old alike had dozens of activities to occupy their leisure hours. It was a time of simple pleasures, and in the immortal words spoken by the mother of some of my cousins, "If you can swim, sing, dance and play cards, you'll always have fun." Here are just a few of the frequent activities enjoyed by many of us in the past:

BACKYARD ADVENTURES. Most San Francisco homes used to have at least a small patch of lush, green outdoor space. In the past, it was always a place for kids to explore, grown-ups to putter or relax and a safe haven for the family pet. Sadly, too many of these spots have long since been cemented over and are about as hospitable as the average prison cell.

BASEBALL. Once the San Francisco Giants made Candlestick Park their home in 1960, local kids knew the routes and schedules of MUNI's "Ballpark Express" buses. A crosstown adventure with a friend was a bargain outing on a Saturday, and most parents had no concerns—"just be home before the streetlights come on."

BOARD GAMES. Every family had a well-worn Monopoly game (the author's version is now fifty-seven years old). Some also had Scrabble, Bingo or one of the newer 1960s boxed games: Candy Land, Chutes & Ladders, Mouse Trap, LIFE, Lie Detector and many others. In a well-stocked neighborhood, rainy days were never a problem for kids of any age.

Excitement hit a peak in 1962 when the San Francisco Giants went to the World Series for the first time. *Author's collection.*

Rene Herrerias, *right*, from 18th Avenue in the Parkside District, was a member of the USF Championship basketball team in 1949–50. *Author's collection.*

BOWLING. San Francisco once had a bowling alley in virtually every neighborhood, but this activity has declined to just a handful of spots in recent times.

CARDS. Whether it was solitaire or Go Fish as youngsters, Hearts as teens, a men's poker or pinochle group, a ladies' bridge party, Grandma's canasta club or marathon gin rummy games, we were much more of a card-playing society in the past.

COLLEGE SPORTS. City College, San Francisco State and USF all had loyal followers attending their games. News accounts confirm that the public's exuberance for the victorious 1949–50 USF basketball team rivaled today's enthusiasm for a World Series or a Super Bowl championship.

CRAFT PROJECTS. Construction paper, blunt-end scissors, cellophane tape, Elmer's glue, a hole punch, pinking shears, glitter and sequins were generally kept in an old shoebox in the linen closet as every family's kit for "rainy day projects." It is a rare child who did not make paper daisy chains from old gum wrappers, decorate pinecones that had been picked up in Golden Gate Park or cut up old Christmas cards to make new gift tags.

DOWNTOWN SHOPPING. It was a real rite of passage when parents would allow a youngster to ride public transit all the way downtown alone—usually by age eleven or twelve—though any parent permitting such a thing today would likely be answering to Child Protective Services. The standard destinations were usually the Emporium, with its vast toy department at the back of the fourth floor, or Woolworth's just across the street. Armed with a MUNI "car ticket" and a spare quarter for a slice of Woolworth pizza and a Coke, this was often a full Saturday adventure.

EATING OUT. Dining out is one activity from the past that remains popular among San Franciscans today. As the retiree community grows ever larger with an influx of baby boomers, many local restaurants find themselves crowded even at lunchtime.

HIGH SCHOOL SPORTS. Whether as participants or spectators, high school sports teams used to be a much bigger draw when the city had a larger

Above: Market Street presented a blaze of lights from theatres, stores and restaurants for decades until various ordinances began to restrict commercial neon signage and theatres began to experience a decline in patrons. *Jack Tillmany Collection.*

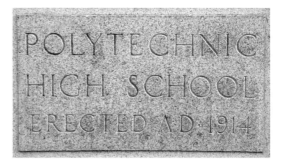

Right, middle: Retirees have long gathered for lunch on a regular basis, such as this trio of baby boomer historians in 2011. Their restaurant of choice opened when all three were mere lads. *Photograph by John Byrne.*

Right, bottom: Polytechnic High School was a presence on Frederick Street as well as on the football field in nearby Kezar Stadium for decades prior to its closure in 1972. *Courtesy of Bob and Carolyn Ross.*

school-age population. It was a rare Thanksgiving Day that did not see Kezar Stadium filled to capacity by young and old alike for the city's high school football championship game—frequently pitting Lowell and Polytechnic against one another.

ICE FOLLIES. The Shipstad and Johnson's show booked a summer-long engagement at Winterland each year from the 1930s through the late 1960s. This was an activity favored by moms, grandmas and maiden aunts, while many dads took a different approach: "Why don't I just drop all of you off in front of Winterland and then just pick you up in a couple of hours when it's over?"

LIBRARIES. Not just places for homework research, neighborhood libraries were also meeting sites for the entire neighborhood. Checking out books, sitting in the large reading rooms (some, like the Parkside Branch, with a large operating fireplace to ward off the chill on foggy summer days) or bumping into friends were all regular activities in

Until the late 1960s, Shipstad and Johnson's *Ice Follies* was booked for an annual summer-long engagement at Winterland Auditorium. *Courtesy of a private collector.*

San Francisco. With more people in the workforce for much of the day, plus restricted hours (most San Francisco branch libraries used to be open Monday through Friday from 9:00 a.m. to 9:00 p.m.), this is a forgotten activity for many people today.

MARIN TOWN & COUNTRY CLUB. Warm weather and recreational pursuits of all kinds lay just thirty minutes north of foggy San Francisco in the Marin County town of Fairfax. Day-rate admission was fifty cents for years, and even carless city kids could hop on a Greyhound bus at 7th and Market Streets (less than one dollar for a round-trip ticket) and be dropped off a block or so from the entrance. Sadly, the resort closed after the 1972 season, and the future of the parcel, nearly a half century later, remains the subject of contentious local debate.

MOVIE THEATRES. When San Francisco had a movie theatre in virtually every single neighborhood—plus a huge cluster of them on both Market and Mission Streets—spending a weekend or summer afternoon "at the show" was a standard feature when growing up. Bargain matinee tickets could often be purchased in advance for fifteen cents, and with an extra quarter for snacks, most kids were happily out of their mothers' hair for several hours.

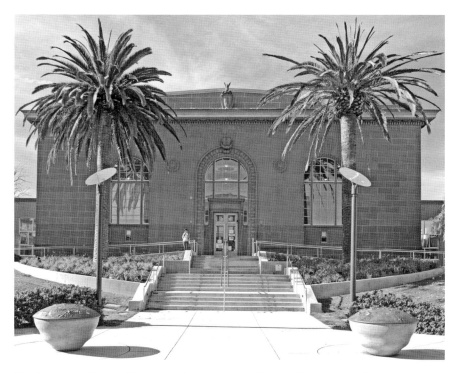

The Richmond Branch library on 9th Avenue near Clement Street is one of several branches now open seven days a week. *Photograph by Alvis Hendley.*

A series of colorful billboards once graced the San Francisco landscape, reminding residents that during the foggy summer months of summer, sun and fun were just thirty minutes north in the town of Fairfax. *Photograph by John A. Martini.*

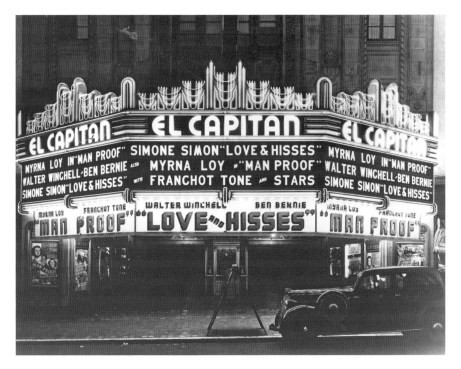

Above: The marquee of one of San Francisco's largest movie palaces, Mission Street's El Capitan, went dark for the last time in 1957. *Jack Tillmany Collection.*

Left: The interior of a classic MUNI streetcar with green-and-cream exterior. The image of the dark green leather seats with metal backs is a memorable sight to thousands of former passengers. *Author's collection.*

MUNI. Riding MUNI just for recreation was a great activity at a time when a fifty-cent "car ticket" entitled the bearer to ten rides. As early as 1962, when a friend of mine was taking Bar Mitzvah lessons after school at Temple Sherith Israel at California and Webster, he and I could get to his appointment, riding all over town for a single punch, while taking in the sights and sounds of San Francisco along the way.

MUSEUMS. In an era when admittance was free, places like the Steinhart Aquarium, the Morrison Planetarium, the de Young Museum and the Palace of the Legion of Honor were all great places to spend time and learn some new things.

Outdoor Play. Everyone knew that playing on the sidewalk or the asphalt on your own street was the best form of instantly available fun. Growing up on 18th Avenue near Vicente in the 1950s, there were nearly forty kids on that one block (including a few slightly older siblings) who were on the lookout every day for the first one of us to wander out of the house, thus getting some sort of playtime activity underway.

Playland-at-the-Beach. Until its demise in 1972, Playland was a great place for all. Strangely, photographs from earlier times show mostly an adult crowd, with the women in dresses, men in suits and everyone wearing hats. By the 1960s, though, kids were there in droves on weekends and during school breaks. Getting there was easy, with several MUNI lines terminating nearby, including the ever-popular "5-McAllister—Playland." A handful of dimes and a group of friends—each one with a block of pink popcorn and a paper tube of cotton candy—formed lasting memories for thousands of us for decades.

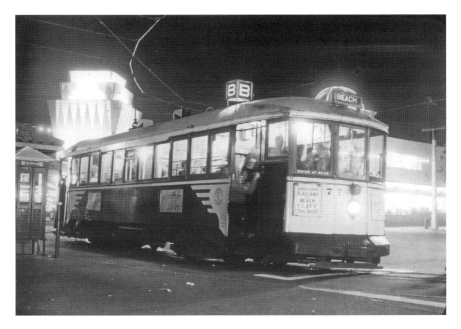

The last nighttime run of the B-Geary streetcar line at Playland, December 1956. Motor coaches were about to replace the rails in order to provide better service. Today, urban planners are once again trying to improve transit service along Geary by...bringing back the streetcars. *Jack Tillmany Collection.*

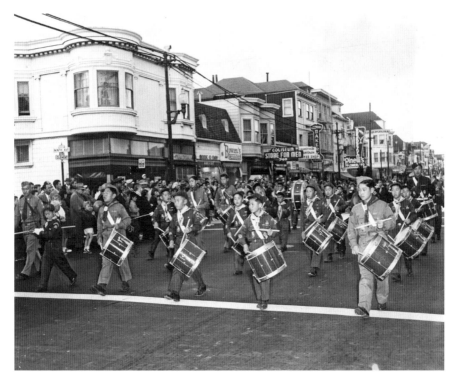

Scouting was once a popular activity for young people, such as this group marching along Clement Street near 9ᵗʰ Avenue in the 1950s. *Courtesy of San Francisco History Center, San Francisco Public Library.*

SCOUTING. Whether Cub Scouts, Brownies, Camp Fire Girls, Girl or Boy Scouts, young people had plenty of opportunities for organized afterschool activities. These programs also promoted good citizenship and were well attended for decades. Other than at a Girl Scout cookie sales event, when was the last time you saw a girl in the traditional green uniform—or a Boy Scout in the traditional navy blue uniform with yellow trim?

SWIMMING. The granddaddy of them all was Fleishhacker Pool on Sloat Boulevard, where one thin dime would purchase access to dressing rooms, a fresh towel and an afternoon of fun and frolic in six million gallons of somewhat heated seawater. After years of underfunding and deferred maintenance, the pool was showing deterioration when a storm damaged the piping system in January 1971. With prohibitive repair costs, the city converted it to fresh water, but there were serious problems and the pool was closed by the end of that year. Throughout the 1950s and 1960s, the City

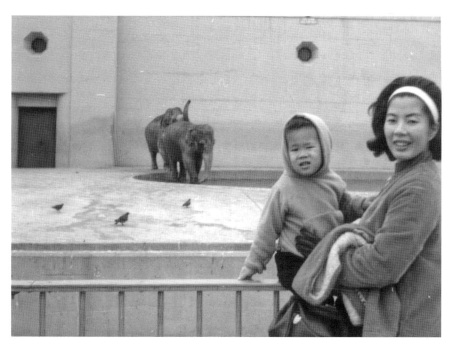

Mother and son visiting the WPA-built Pachyderm House at the Zoo, circa 1960. *Richard Lim photo.*

and County of San Francisco was also building many neighborhood pools throughout the community.

Zoo. Until 1970, the zoo was a completely free public amenity, thanks to the generosity of the Fleishhacker family. That year, a modest admission charge was instituted—now a nineteen-dollar adult admission price with a three-dollar discount with proof of current San Francisco residency—for a form of recreation that had been free for generations.

9
On the Road Again

The summer of 2011 marked the fiftieth anniversary of our family's one (and only) lengthy car trip—to Disneyland, where else? So in honor of that momentous occasion, which was replicated by every one of our San Francisco neighbors at one time or another, let's take a look back at just what it was like.

For most 1960s families with kids, there was never a question of *if* we were going to go south to visit Disneyland, but just a question of when. I probably began lobbying my parents in earnest in late 1959 when I was in the second grade, and those efforts finally paid off eighteen months later, in July 1961. This was the first of only two times throughout the 1950s and 1960s that Mom and Dad decided to alter our usual summer vacation and go somewhere other than Marin Town & Country Club.

For that first trip, Dad decided to drive, taking our family's new Dodge Dart down Highway 101. Armed with AAA maps that the auto club highlighted with a yellow marker (the folks at AAA then bound the narrow pages into a spiral booklet about four inches wide by eleven inches long), it was easy to follow directions. Along with thousands of other families, these low-tech navigational aids assisted the driver (generally a dad), the navigator (generally a mom) and the bunch of restless kids in the backseats of all those cars to understand just where they were and how far there was to go.

Dad always bought his gasoline in fixed amounts, probably to make his mileage calculations easier. I can still hear him leaning out the window and saying, "Ten gallons of ethyl," just after driving over the rubber hose that

evoked a loud DING in the office. This practice of ten-gallon purchases also guaranteed that restroom breaks on this trip would be as frequent as needed, with no emergency stops required. In retrospect, I now understand that my dad and a few thousand others actually coined the phrase that became the title of newscaster Al Roker's autobiography—*Don't Make Me Stop This Car!*—a familiar command to all of us former backseat-riding baby boomers.

Thinking back to that July day now, I can truly attest to the fact that there is no heat in the world quite like Bradley, California, that summer, when the thermometer at the Flying A gas station read 115 degrees (no car air conditioning in those days). Fortunately, Mom had stocked the Coleman ice chest in the backseat with our lunch and several extra bottles of 7-Up for just such an occurrence. Windows down, heads hanging out for the breeze, we were so excited and relieved to reach the fog of Pismo Beach just a short time later, as Highway 101 meandered its way toward the coast as it did back then.

Like many "modern" motels of the time, the place we stayed that first night had "Magic Fingers" vibrators on the beds, along with a wall-mounted push-button coffeemaker (then cutting-edge modern) in the bathroom. Needless to say, armed with a supply of quarters, I managed to test both devices multiple times during our overnight visit, with Mom and Dad thoroughly caffeinated and vibrated by the end of our overnight stay.

Our first stop the next morning was Marineland, the granddaddy of all marine-themed adventure parks. Located on the Palos Verdes Peninsula in Los Angeles County, it was a must-see destination for families with kids from the mid-1950s until about 1987. Its peak years were the late 1950s and early 1960s, before the opening of Northern California's Marine World (in Redwood City in 1968 and then Vallejo in 1986). It was a combination of aquarium/circus show/feeding zoo, and there were thousands of people there the day we visited, yet we managed to spot two different families of my grammar school classmates.

Throughout the trip, our daily meals were always eaten in restaurants attached to the motels where we were staying—places like Denny's, International House of Pancakes, Sambo's or any establishment with the words "Waffle Shop" or "Family Restaurant" as part of its name. Mom correctly theorized that such places always had clean restrooms plus menu selections that were not too exotic for kids who might be picky eaters.

Following a brief one-day visit with the performing dolphins and porpoises, it was off to spend a couple of days on the Southern California

beaches before finally reaching Disneyland. Mom ran into a childhood friend from San Francisco on the beach at Santa Barbara, Dad bumped into an old navy buddy later that day and one night, I saw one of my own St. Cecilia School classmates having dinner with her parents at a seafood restaurant in Santa Monica. Even then, it amazed me that for all its population, California could be such a small place.

Finally, it was time for the big event. Spotting the Matterhorn from the freeway sent every backseat-riding kid into an absolute frenzy—"WE'RE HERE, WE'RE HERE" could literally be heard from thousands of vehicles navigating Highway 101's Harbor Boulevard exit and the streets of Anaheim each day. Disneyland was only six years old then, much smaller than today's site. Even so, the rides were still a definite step up from our usual Playland-at-the-Beach entertainment, though still light-years away from the high-tech wizardry that exists down there today.

Mom had read somewhere that kids and parents should have some sort of distinctive clothing or headgear—in case they became separated in Disneyland, it would be easier to spot one another. So on that first day, we stopped at the Mad Hatter, one of the shops just inside the park, where we were all outfitted with peacock blue alpine hats that were accessorized with a twelve-inch-tall white feather—our family plus a couple of hundred others, from the looks of things that summer.

Once in the park, kids quickly learned the lingo of the A-B-C-D-E tickets. The A ticket was for something pretty dorky like the Main Street Cinema. The B ticket was a bit better—attractions like the now-gone Motor Boat Cruise where passengers could steer (even though the boats were guided along on an underwater rail). The C ticket was for things like the Tomorrowland Autopia (once a narrow curving track, but with a guide rail added around 1964 to control over-adventurous ten-year-olds and others). The D ticket gave access to the now-gone Skyway from Fantasyland to Tomorrowland or TWA's iconic Flight to the Moon, while the coveted E ticket was the best of all—things like the Submarine Voyage, Jungle Cruise, Matterhorn Bobsleds and the Monorail. In later years, E tickets also covered It's a Small World (with its hauntingly sweet theme song sung in ultra-soprano), Space Mountain and many others.

The few remaining tickets I have are in a booklet from the mid-1970s visit that shows a face value of $10.55 ("only $4.75 for Magic Kingdom Club members") back at a time when every large employer offered Magic Kingdom Club discount cards. Those single tickets disappeared in 1982, to be replaced by full-day fixed-price passes, and I shudder to report that

Disneyland GOOD FOR "E" ADULT ADMISSION
CHOICE OF ONE

| TOMORROWLAND | AMERICA SINGS
MONORAIL to Disneyland Hotel & Return
SUBMARINE VOYAGE |
| FANTASYLAND | IT'S A SMALL WORLD
MATTERHORN BOBSLEDS |
| BEAR COUNTRY | COUNTRY BEAR JAMBOREE |
| NEW ORLEANS SQUARE | HAUNTED MANSION
PIRATES OF THE CARIBBEAN |
| ADVENTURELAND | ENCHANTED TIKI ROOM
JUNGLE CRUISE |

F229456 or any other 'E' attraction E COUPON

The Disneyland E-ticket has come to mean "the best, the ultimate." It was certainly that way for thousands of youngsters hoping for a summer vacation visit to the park in its early decades. *Author's collection.*

today's online discounted price for a one-day, single-park adult pass is now approaching a wallet-busting $100 per person.

After many hours of waiting in lines and whooshing through rides like the Matterhorn Bobsleds (then the most "scary" of all the attractions), we headed back to the hotel for an afternoon dip in the pool and, at Mom's insistence, a one-hour nap. About 5:00 p.m., we would be off to dinner at nearby Knott's Berry Farm, where fried chicken with gravy and biscuits plus boysenberry pie à la mode were the staples. Like the Disneyland of that era, Knott's was also a much lower tech operation in 1961, featuring mule rides and panning for gold—I still have a tiny plastic bottle, the water long gone, with a few teeny, tiny flecks rattling around. Then it was back to Disneyland at night—the absolute best time to be in the park, with cooler weather, shorter lines and the guarantee of a relaxing frozen treat at the now-gone Carnation Ice Cream Parlor on Main Street or the Tahitian Terrace in Adventureland. There were nightly fireworks shows, but these were nothing like the spectacular events that were to come with the Main Street Electrical Parade of the 1980s and 1990s.

By the second morning, Mom and Dad decided that room service for breakfast was the order of the day—and an easy way to avoid the local

eateries and the crowds of families that had a few too many rambunctious kids. Over breakfast, the daily drill began—which new rides would we go on that day, and which rides did we all want to go on for a second time? The ticket book concept ensured that at some point, even the lackluster attractions that used an A ticket, such as the Main Street Horse Cars, would be visited by most families.

Armed with the Kodak eight-millimeter movie camera in Mom's oversized tote bag, plus Sea & Ski lotion, Life Savers, Wash & Dry ("the miracle moist towelette"), Kleenex, Band-Aids and enough assorted other items to stock a small convenience store, we set forth to await the park's opening in the crowd along Main Street. Throughout the day, it was still line after line, but we never complained—it was Disneyland after all, and there was always something to see, even when waiting. By the end of that day, we were tiring somewhat, and a quick dinner at a nearby air-conditioned restaurant was just fine with everyone.

Finally, on the last day there, it seemed that every kid went into a wild buying frenzy of souvenir items from the shops on Main Street, and I was no exception. I still have a lapel pin, and I occasionally drink my morning coffee from a Donald Duck mug with my name on it. Best of all, there was the leather beaded belt with ADVENTURELAND spelled out across the back, which will be very handy once again, just as soon as I get back to having a twenty-eight-inch waist.

Cramming the car's trunk full of suitcases and a variety of shopping bags from our weeks on the road was no small task, and we began to resemble the Ricardos and the Mertzes packing their car for the trip from New York City to Los Angeles. Dad still favored Highway 101 over the coast highway, and we were rewarded with cooler weather on our trip home than what we had on the way down. After endless games of Auto Bingo and family sing-a-longs (plus reading the Burma-Shave signs—even then, they were about to disappear into roadside history), we finally reached 19th Avenue for the last leg of the ride home.

Then, for the next few years, it was back to our family standard vacation—Marin Town & Country Club—until Mom raised the idea of a return visit to Disneyland a few years later. It turned out that she herself had seen an episode of *Wonderful World of Disney* when she veered away from the *Ed Sullivan Show* one Sunday night and apparently liked many of the new attractions that were being shown, so I didn't have to do any persuading that second time around.

We made our second visit in June 1964, when Dad decided that it was high time for a family train ride. On the Sunday morning of our departure,

Grandma and Aunt Margaret picked us up at home and dropped us off at the old Southern Pacific station at 3rd and Townsend (an intersection and a neighborhood that is barely recognizable to anyone who has not seen it in the last five years or so; for a present-day look at the same intersection, Google "747-3rd Street, San Francisco" and then scroll slightly left for today's view from that spot).

Onto the *Coast Daylight*, and we were off—breakfast in the dining car in San Mateo County, lunch somewhere deep in the Central Valley and dinner just before arriving at Union Station in Los Angeles. This was still the era of white linen service, heavy silver utensils and thick china plates with the railroad's logo emblazoned at the top. I must say that Dad was right—more than fifty years later, I still relish the entire day that we spent zipping southward on those steel rails that Arlo Guthrie would sing about several years later.

That year, we stayed at the Biltmore Hotel in downtown Los Angeles and had dinner with a couple of Dad's cousins whom we had never met before. It was my first lesson in genealogy, which led to a lifelong fascination with the subject. We also rode on the old *Angel's Flight* cable car that climbed one of the downtown hills and explored Olvera Street, the Farmers Market and Grauman's Chinese Theater. (Mom apparently didn't approve of whatever they were showing at the time, and it was years later, traveling on my own, that I had the pleasure of experiencing the film *Titanic* on that enormous screen—with such a great sound system that you could literally feel that magnificent ship go down.) Then after a few days, it was off to Anaheim, with a list of the latest attractions firmly in hand.

By that year, Disneyland had expanded its offerings to include the Enchanted Tiki Room, Swiss Family Robinson Tree House, Haunted Mansion and Flying Saucers—round pods that, filled with one child, floated on a field of pressurized air (but only for a year or so before they disappeared). The Skyway was still running then, with new rectangular rather than round baskets (now, sadly, it is a feature that has been discontinued). Along with the Monorail, I began to think that Mr. Disney had mastered the whole idea of transportation better than San Francisco's MUNI—and I hold that opinion even more strongly today.

Future attractions like General Electric's Carousel of Progress, Monsanto's Adventure Thru Inner Space and the People Mover were all added later. My personal all-time favorite, Pirates of the Caribbean, was still a bit of pixie dust in Mr. Disney's imagination at that time, and the blockbuster draws like

Star Tours, Mickey's Toon Town and Disney's California Adventure were yet to be dreamed.

Knott's, too, had expanded somewhat by 1964, but the big thrill was taking one of the new public tours up at Universal Studios. Far smaller than today's rendition, the tour involved simply boarding a tram and being given a glimpse into a Hollywood back lot and soundstages. The visit was quite an eye-opener for this twelve-year-old, who could never again attend a movie or watch television without declaring with a voice of authority, "I know how they did that…" at every scene of a bloody barroom brawl, collapsing bridge, rock avalanche, parting waters or fiery inferno. The sets from the infamous Bates Motel, the *Leave It to Beaver* house, the streets of Andy Griffith's Mayberry and Quentin McHale's PT-73 were all designed to involve family members of every age, and Universal did the job very well.

Too soon to imagine, it was back on the train for the ride home to San Francisco. Leaving downtown L.A. in the morning, then racing through a sunbaked Central Valley at midday, we were finishing up our dinner on the outskirts of San Jose and about to return home to a classic foggy summer evening in the Parkside.

For me, though, the travel bug had bitten, and after just a few more years, I was off on adventures of my own—travels that would eventually take me far beyond our Parkside District neighborhood.

10

Dinner on the Table

From the time of the gold rush, even up to the current millennium, San Franciscans have had a penchant for dining out. How could it be otherwise with virtually all of the world's culinary versions within easy walking distance of so many people?

Growing up, most of us were raised on mom-cooking, with meatloaf or a mac-and-cheese casserole often getting star billing, with tuna casserole or fried fish Friday night staples in Catholic households. Yet for most of us growing up in San Francisco, there was an early exposure to the "Big Three" of foreign cuisines—Chinese, Mexican and Italian—since they dominated the dining-out landscape of the mid-twentieth century.

Today, youngsters will grow up knowing and appreciating Turkish, Indian, Vietnamese, Filipino, Thai, Cuban, Peruvian and dozens of other culinary delights from around the globe, whether at home or in neighborhood dining spots.

In a city as large and diverse as San Francisco, restaurants are notorious as businesses that come and go regularly. Everything from a bad Yelp review to fickle public tastes to parking hassles can doom the best dining venue. Sometimes political considerations enter into the equation—such as the drastic decline in German-themed restaurants and hofbrau establishments immediately after the commencement of World War I.

Likewise, drinking establishments have a history of being wildly popular and then suddenly fading from the scene as something new comes along. Those operating in residential areas, though, seem to have

Left: The politics of World War I brought about a decline in restaurants that featured singing, as this was widely regarded as a German custom, in an era of anti-German sentiment. *Author's collection.*

Below: Some San Franciscans also enjoy pre- or post-meal visits to one of the many spots that dot every neighborhood. The West Portal area has been a shopping and dining destination on the western half of San Francisco for nearly one hundred years, with the Philosophers Club one of its many popular local establishments. *Photograph by Michael Fraley.*

a better chance of long-term survival. Virtually everyone has a favorite local spot close to home.

As new restaurants open daily, others fade from the scene. Many of us grew up in an era of dressing up to go out to a dining establishment with linen tablecloths, low lights and sometimes formally clad headwaiters. These seem to have disappeared from the scene, as dining out has taken on a far more relaxed atmosphere in recent years.

Restaurants with cuisines from overseas can be notoriously competitive. Once largely limited to the Chinatown neighborhood, such establishments can now be found virtually across San Francisco, specializing in specific food types from various regions of the vast country. The local culinary scene has seen a gradual shift over the years from Cantonese cuisine to more far-ranging dishes, including Hunan, Shandong and Sichuan.

Changes in immigration patterns have also brought many more varieties of Indian, Pakistani and other regional foods from various regions of the subcontinent and many parts of Southeast Asia to San Francisco diners.

Local tastes also evolve over time, with the mild flavors of some ethnic foods now seeming bland to more sophisticated palates. Dining out in

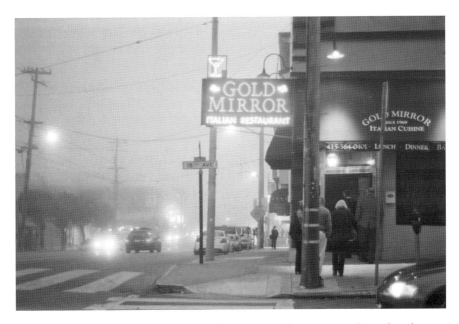

It is a typically foggy night in the Parkside District, as regular patrons—often referred to as the "born and raised"—enjoy dinner at the Gold Mirror at 18th Avenue and Taraval Street. Opened at this location in 1954, the same family has been operating the popular spot since 1969. *Photograph by Michael Fraley.*

the city continues to evolve day by day, just as the food served to today's youngsters is also evolving from what many of us knew while growing up in the 1950s.

The following are just a couple of the San Francisco–based recipes from years gone by that produce instant requests for a written copy whenever I make one of them.

Bardelli's "Fried" Zucchini

Bardelli's was a popular San Francisco bar and restaurant since the days before World War I. It was a half block up the O'Farrell Street hill from Macy's, and it became a regular gathering place after work, since it was on the way to the Mason & O'Farrell Garage, where many of us parked. This version is a dead ringer for the original, only without the deep-frying and the excess fat and calories. The flavor is true to the original, and the dish is highly reminiscent of many an after-work Saturday night dinner that I enjoyed with friends back in the 1970s.

4 medium zucchini
2 eggs
½ cup seasoned bread crumbs
½ cup grated Parmesan (*not* fat-free!)
Salt
Pepper

Trim ends from zucchini and slice in half, lengthwise. Cut each half into four equal strips. Scramble eggs in a wide dish and mix dry ingredients in another wide dish. Dip each zucchini strip in the egg and then in the bread crumb mixture. Place on prepared cookie sheet. Lightly spritz the laid-out zucchini strips with nonstick cooking spray. Bake in a preheated 425-degree oven for about 15 minutes. Turn each piece over with tongs, and bake for an additional 10 minutes. Serve piping hot.

Yield: 32 pieces

BETTY MOLLER'S GIN FIZZ

For years, my friend Linda's mother, Betty Moller, enjoyed entertaining friends, relatives, neighbors and co-workers at holiday brunches. (She despised the idea of going out to a restaurant on a holiday—"Lousy food and lousy service, all at the same time," she insisted.) Betty would deputize all of us teenagers (this was 1968, and I was sixteen years old at the time) into various kitchen patrol chores for her brunches. I somehow found myself assigned to blender duty, and I caught on quickly. Betty had been searching for the perfect and simplest gin fizz recipe for years and had already acquired a cabinet full of exotic ingredients such as rosewater, citric acid, powdered egg whites and other items she labeled as "kooky." She came across this recipe and directed me to "start mixing." I've been doing so now for nearly fifty years. When our families get together for any holiday brunch, Linda and I will have one of these and remember her mother and all the good times we shared at her family's home on 27th Avenue. Note that this can be made nonalcoholic by substituting an equal amount of water in place of the gin.

 6-ounce can frozen lemonade concentrate
 6 ounces half-and-half
 6 ounces inexpensive gin
 Ice

Place equal portions of the first three ingredients into a blender, using the empty lemonade can to measure the half-and-half and gin. Fill blender with about 12 ice cubes. Blend until smooth, about 2 minutes. Serve immediately. Recipe easily doubles, triples and so forth, but be sure not to over-fill the blender jar.

Yield: 6 servings

TAMALE PIE

There's no agreement in our family as to the origin of this dish. Mom and her sister Margaret were sure that the recipe came from their own mother, but it has been printed in many old newspaper articles and cookbooks. It seems to have been around since the 1930s, and one thing is for sure—it's always present on my family's buffet table, and it has a particular affinity with cold slices of turkey and ham. This is also a dish that can be prepared in advance and keeps well, improving with age. I've reduced the amount of oil and eliminated the added tablespoon of salt that was called for in the original, but you should use a bit of added salt to your own liking. Note that the baking and the standing time are crucial to the success of this dish!

1 pound ground chuck
1 large onion, chopped
2 cloves garlic, minced fine
¼ cup salad oil
2 cans Del Monte Tomato Sauce
2 sauce cans water
1 can cream-style corn
1 tablespoon Grandma's Chili Powder
1 egg
½ cup milk
1 cup yellow cornmeal
1 can extra-large pitted olives
1 cup grated Parmesan cheese
Salt to taste

Brown the meat, onion and garlic in the oil in a large, heavy pot. Add the tomato sauce, water, corn and chili powder and stir well. In a medium covered jar, mix the egg and the milk. Add cornmeal and shake well to mix thoroughly. Add this to the contents of the pot and simmer for about 15 minutes, stirring often. Add olives and cheese and mix thoroughly. Salt to taste. Pour into a prepared casserole dish and bake uncovered in a 350-degree oven for about 45 minutes or until hot and bubbling. Let stand for 10 minutes before serving.

Yield: 8 to 10 servings

Pink Icebox Cake

*Mom got this one from her mother, Kitty Westerhouse, and made it regularly in the 1950s and 1960s. She then let it slide for a long time until a young friend heard her mention it when she was well past eighty. He was a budding pastry chef at the time and asked if she could show him how to make one. That got her back into action, and she made one easily. This is a great warm-weather treat—usually served from Mother's Day through Labor Day. Be sure to buy the exact ingredients—sugar wafers (**not** vanilla wafers) and evaporated milk (**not** sweetened condensed milk). Make this your own springtime tradition.*

- 1 small package raspberry or strawberry Jell-O
- 1¼ cups boiling water
- ¼ cup lemon juice (juice of 2 lemons)
- ½ cup sugar
- 1 large can Pet or Carnation evaporated milk (very cold)
- 2 inner packages Nabisco sugar wafers (not vanilla wafers), crushed
- 1 small basket fresh strawberries, sliced
- 2 containers whipping cream (½ pint each), whipped with a little sugar and vanilla

Dissolve Jell-O in the boiling water. Add lemon juice and sugar, mix well. Let cool. When Jell-O mixture thickens slightly, add it to the canned milk, whipped stiff. Beat again to combine thoroughly. In a deep cake pan with a removable bottom, place a layer of sugar wafer crumbs, then add about half of the Jell-O mixture, then the remainder of the crumbs. Then layer the sliced strawberries and one of the half pints of cream, whipped stiff with a little sugar and vanilla. Add the remainder of the Jell-O mixture, cover with waxed paper and refrigerate overnight.

When ready to serve, whip the second half pint of whipping cream with a little sugar and vanilla so that it is slightly stiff. Remove the cake from the pan, leaving the metal bottom in place. Frost the cake with the whipped cream and serve immediately.

Yield: 8 servings

11
Rites of Passage

From the beginnings of life, through the adolescent and the adult years, to the very end, there are steps along the way where we pause to come together in order to reflect on life's changes.

For many, a church christening marks an early rite of passage in a religious community. Among Chinese families, a "red-egg-and-ginger" party welcomes the newborn infant, and Jewish families hold a circumcision or a naming ceremony during the first week of a baby's life.

Within many Christian denominations, first communion and confirmation mark additional religious steps on the road to adulthood within the community.

Bat and Bar Mitzvahs celebrated in a synagogue setting represent a thirteenth birthday and the beginning of adult responsibilities for daughters and sons in observant Jewish families. Likewise, the quinceañera celebration in many Hispanic communities marks both the secular and the religious transition to womanhood for young girls.

School graduation ceremonies, held everywhere from a middle school stage to a house of worship and the grand expanses of San Francisco's Civic Auditorium, have marked additional steps along the path to employment and full adulthood for millions of residents over the years.

Marriage still represents one of life's major milestones in our society. San Francisco offers thousands of public and private venues for ceremonies marking the transition from single to couple lifestyles, as well as the receptions that often follow the ceremony. From a modest gathering of friends at home—a highly

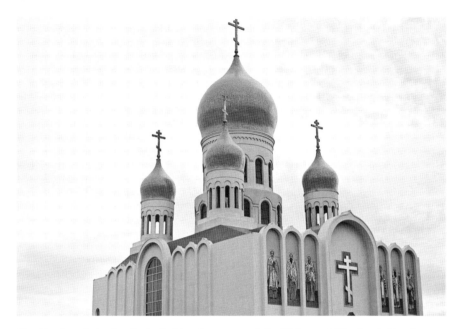

The Russian Orthodox Cathedral has been part of the Richmond District skyline since its construction in 1965. It is currently undergoing a first-ever renovation. *Photograph by Michael Fraley.*

popular reception site until recent times—to grand events held in restaurants or other rented venues, we still celebrate the joy of a new couple.

Finally, there are end-of-life rituals—differing within various religious and ethnic groups—but all meant to pay respect to the departed while consoling loved ones left behind.

Funeral services can run the gamut from a quiet cremation and scattering of ashes in a favorite spot to traditional Judeo-Christian religious ceremonies, Irish wakes, Masonic funerals, elaborate events in the Chinese community that often involve marching bands and everything in between.

Many families have a traditional provider for such services whenever the need arises; however, this is yet another factor of daily life that has been changing considerably in San Francisco during recent years.

It's not too often that a family business manages to thrive for three full generations, while still making meaningful contributions to the community. Sometimes a company will fail to keep pace with changing times (buggy-whip manufacturing or telephone answering services, as examples), while in other cases, operations may be moved to another country for the

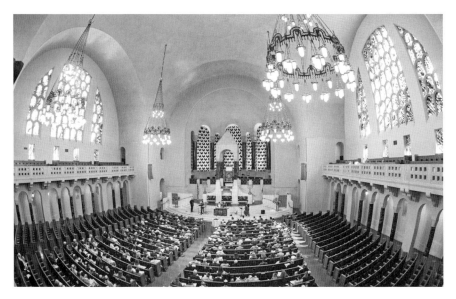

The baroque interior of Temple Emanu-El on Lake Street has been the congregation's spiritual home since the 1920s. *Courtesy of Keith Lynds Photography.*

purposes of reducing taxes and production costs (such as manufacturers of everything from clothing to food products and automobiles).

However, one business, owned by a family with deep roots in the western neighborhoods of San Francisco, has been in place for ninety-two years now, quietly serving the needs of the community—Arthur J. Sullivan Funeral Directors. But if you wish to avail yourself of their services, it is too late, as the location was set to close in March 2016, with its upper Market Street space to be replaced by a condo-retail complex.

Please do not blame changing times, though—it is not a story involving techie takeovers or unscrupulous landlords. The current generation of Sullivans—brothers Arthur III and Jim—are both well past the usual age for retirement, and the younger generations of the family are not interested in taking over daily management duties.

The business began in the years just after the end of World War I, when the original Arthur J. Sullivan, who lived with his family near the southeastern corner of Golden Gate Park, went into business with his brother Alfred at 2254 Market Street, with the sign reading "Arthur J. Sullivan, Undertakers." Over time, the original Arthur took over the business on his own, and the sign morphed into the industry's new standard moniker, "Funeral Directors."

In that era, death was, sadly, a regular visitor to most households. The lack of antibiotics and preventative medical treatments and diagnostic testing

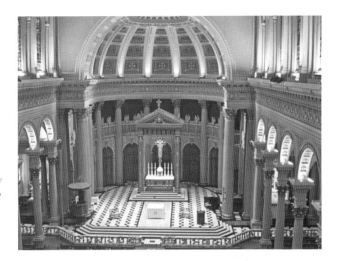

St. Ignatius Church
on the USF campus
celebrated its centenary
in 2014 and is now also
a parish of the San
Francisco Archdiocese.
*Photograph by Michael
Fraley.*

took many San Franciscans to an early grave. Childbirth was the largest
single cause of death among otherwise healthy young women. Today—
when anyone who dies at less than age ninety is said to have "gone too
soon"—it is difficult to imagine the frequency of funerals involving younger
people who were often in the prime of their lives.

San Francisco was dotted with funeral establishments in the 1920s, with
more than fifty listings in each annual edition of the city directory for that
era. Services were just beginning to be held outside the home, and various
establishments were striving to provide a "homey" atmosphere for pre-
funeral visitation and the service itself if the family was not planning to have
a church service.

This was also a time when the automobile was a comparative rarity in
many households, so undertaking parlors tended to be conveniently located
in virtually every San Francisco neighborhood in order to provide easy
access for mourners. (These businesses were also located with easy access
to neighborhood bars—often on the opposite corner—but that's a story for
another time.) Many firms in the 1920s had horse-drawn hearses, and the
public transit system even offered electric streetcars specifically for funerals
that ran to the Colma cemeteries via Mission Street and the center median
of El Camino Real. Firms like Sullivan's were among the first to introduce
that new amenity—the automobile—for transporting both the casket and
the mourners.

In the old days, this was a trade that maintained a regular clientele,
with families returning again and again to the same firm in times of need.
Jewish families generally sought out the services of Sinai Memorial Chapel,

Newlyweds in the courtyard of Temple Emanu-El on Lake Street in December 1975. Today they are grandparents, nearing retirement. *Author's collection.*

while most Italian families gravitated to Valente-Marini-Perata. The once-large San Francisco Irish community had split loyalties, with many favoring the old firm of Carew & English, located for years at Masonic and Golden Gate Avenues. The Mission District was home to several establishments—Duggan's, Driscoll's, Reilly Company/Goodwin & Scannell—while the Richmond District had McAvoy & O'Hara at 10th Avenue and Geary Boulevard. Sunset District residents of an earlier era might choose from Hogan & Sullivan on 9th Avenue or Currivan's Chapel of the Sunset on Irving Street. Arthur J. Sullivan, with its central location on Market Street, was known to many people citywide.

Gradually, consolidations began to occur, and many firms vanished over time. Some of those still in business, such as Halsted & Co. on Sutter Street, are an amalgam of many different firms with deep roots in San Francisco's history. A sign at Halsted's indicates that its firm has absorbed N. Gray (a gold rush–era coffin maker that survived well into the twentieth century), Carew & English, Gantner-Felder-Kenny (previously at Market and Duboce Streets), Gantner-Maison-Domergue, H.F. Suhr Company, Godeau Funeral Home, Martin & Brown Funeral Directors and Quock Fook Sang Mortuary. Some of the Halsted records go back to N. Gray's services, with transactions dating from the 1850s.

Even into the relatively modern 1950s and 1960s, funerals were often enormous events because many individuals died at relatively young ages, still in their working years and with many friends and relatives still living in San Francisco. Sullivan's experienced congestion in its small parking lot in those

days, and the family member in charge at the time, Arthur J. Sullivan Jr., a lifelong Sunset District resident, wisely purchased a dilapidated old structure facing 16th Street, had it demolished and created a larger lot to accommodate the constant stream of cars bringing mourners to the establishment each day and night for "visitation."

During the onset of the AIDS epidemic in the early 1980s, Sullivan's was recognized by the San Francisco Department of Health as being one of the only funeral establishments that would provide funeral services to victims. The Sullivan family has long been known for possessing generous quantities of both common sense and compassion.

In 1986, second-generation family member Arthur Jr. passed away, and his wife, Catherine, took over the helm, overseeing the work of her two sons, Arthur III and Jim (one living in the Parkside and the other near West Portal). The business changed with the times, as the brothers noted that more and more local residents were opting for simpler funerals, often with cremation instead of open-casket viewing. Changing migration patterns, particularly among their largely Irish-Catholic clientele, meant that many families who once availed themselves of Sullivan's services were no longer residing locally. Nearly a decade ago, Sullivan's completed a merger agreement with Duggan's Serra Mortuary, another firm with deep roots in the San Francisco community, thus setting the groundwork for the current transition.

It's interesting to note that within the western neighborhoods of San Francisco, many mothers of baby boomers used to share a wry expression among themselves that defined their personal wishes for remaining at home and aging in place as they grew older. Most widows, dozens and dozens of them, regularly announced to family and friends—this writer's own mother included—that "the only person who will ever get me out of my house is Arthur J. Sullivan—and that will be feet-first." We boomers generally tried to abide by such strongly held wishes.

Now, the final two Sullivan brothers are about to embark on well-deserved retirements, and the Duggan family, with its younger generations still moving into management positions within their family-owned firm, will be taking over completely. The Market Street building is slated to become retail space, while the large adjacent parking area will see the construction of housing units.

I'll likely wander through that new space whenever some future retailer sets up shop, just for a final look at the spot where our family once said goodbye to so many loved ones.

Thanks again to the Sullivan family for ninety-two years of loyal service to San Francisco.

12
WORKIN' NINE TO FIVE

W hat was your very first "real" job in San Francisco?
 Not mowing lawns or watching your neighbor's kids or delivering the *Shopping News,* not the summer you spent scooping ice cream at Shaw's on West Portal or dipping frozen bananas into chocolate sauce at Playland or selling baby turtles to the tourists at Fisherman's Wharf—but your very first full-time, pay-the-rent and buy-the-groceries job you had as a young adult?

By the early 1970s, both shipping and manufacturing were on the decline in San Francisco, and the service industry was beginning to boom. For many of us, our first job was in a downtown office of faceless co-workers, lined up at desks stretching out, row after row into infinity, surrounded by walls of filing cabinets. We might have been processing payments, answering telephone inquiries, typing forms, responding to customer complaints or simply filing endless streams of index cards or paper forms.

For some of us, when computers were still a backroom operation, we might have spent our days researching data on microfilm (updated daily) of computer printouts. The whirring of film back and forth in the readers, along with the constant ringing of telephones, clattering of typewriters and mechanical adding machines, plus the often-deafening slamming of steel file cabinet drawers, was often far louder than the piped-in music that some offices began introducing at the time.

The banks—Bank of America, Wells Fargo, Crocker, United California, Hibernia and Security-Pacific—were among San Francisco's biggest

Top: Bank of Italy, founded in San Francisco in 1904, renamed itself Bank of America in 1930. It grew to be the country's largest bank and employed thousands of local residents in its downtown administrative offices and large branch network. Here, employees attend a staff meeting prior to the start of the business in the 1940s. A 1998 merger with an East Coast bank saw the Bank of America name go with the merged institution's new corporate offices in North Carolina. *Courtesy of San Francisco History Center, San Francisco Public Library.*

Bottom: Large retail stores such as Emporium represented stable employment for thousands of local residents, particularly women. Here, the store's employees are attending a 1940s staff meeting on the main floor prior to store opening. *Courtesy of San Francisco History Center, San Francisco Public Library.*

employers back in the 1960s and 1970s, and they employed tens of thousands of us. Fresh out of high school or college, and with no bad work habits, these institutions were willing to take a chance on young grads to deal with the rapid growth of their branches and data centers, as baby boomers came of age and computers were just beginning to be introduced into the workplace.

For many others, in that long-ago era before online commerce and stores like Costco, Walmart and Target came onto the scene, much of the city's retail life revolved around department stores such as the Emporium on Market Street. Founded in 1896, the store had achieved a solid ninety-nine-year run when it finally breathed its last in 1995. For decades, downtown shopping was a regular destination for household basics, including January and August "white sales" on linens, birthday gifting and holiday events such

as roof rides at the Emporium. It was only after World War II that stores began to open suburban branches, thereby diluting the whole experience of "getting dressed up to go downtown."

Utility companies such as AT&T, PT&T and PG&E were considered to be bastions of solid employment and secure retirement for generations of relatives and family friends, and these businesses offered solid career opportunities to women and minorities long before some other firms did so. The job of telephone operator was a highly marketable skill that could be used at any number of large businesses, operating a PBX (private branch exchange) or switchboard.

Likewise, San Francisco was home base to multiple insurance companies— the Equitable, Royal Globe, Fireman's Fund and others—that also employed tens of thousands of residents to sell their products, collect payments, respond to customer inquiries and process claims. All of them offered entry-level positions that could lead to steady career progression.

Government work—at the federal, state or local level—has long been regarded as a smooth career path, with steadily rising wages, excellent benefits and a predictable retirement income from a stable source—the taxpayer. Particularly in San Francisco, with its large numbers of school-age children—well over 10 percent of the population back in the 1950s and 1960s—schoolteachers, librarians and support staff were constantly in demand and well compensated in both salary and benefits.

Today, telephone call centers serve most types of businesses, clustering employees into row after row of cubicles, often with scant training, and frequently located on a remote continent in another hemisphere. Pay is often low, and success rates vary widely by institution, with frequent staff turnover. The negative similarity to the old factory assembly line remains an inevitable comparison.

Likewise, retailers have replaced professionally trained sales staffs with a handful of "cashiers" whose only job is to take payments and move customers out the door (often just after they have strong-armed that particular individual into opening a new credit card account). As I learned this past Christmas, wrapping a customer's purchase is no longer a free amenity because of bizarre local ordinances regarding the use of bags—the sweater I purchased at one large department store was thrust into my hand, along with the accompanying receipt, for me to lug around under my arm for the rest of the day.

Where have all the good jobs and the accompanying steady pay and benefits gone? Today, Bank of America is headquartered in Charlotte, North Carolina, while several of the products that I once serviced for it in seventeen

years of employment (travelers' cheques, Visa/Mastercard and stock transfer/bond registration) are businesses that B of A has since divested. Many of the operations that used to take place in downtown office buildings (555 California, 550 Montgomery, 55 Hawthorne, 1455 Market, 1 Powell, 1 South Van Ness—was there a conscious pattern of numerology in the bank's selection of office sites?) were long ago moved to remote locations such as Concord, while the credit card operation was shifted to Phoenix in the 1980s. Likewise, Wells Fargo, though still with a headquarters in San Francisco, conducts many of its operations out of Minnesota and South Dakota. Crocker, UCB, Hibernia and Security-Pacific are ancient names, sometimes represented by a dusty, abandoned building, following multiple mergers and acquisitions.

Retailers like the Emporium, Roos-Atkins, I. Magnin, Joseph Magnin and many others are long gone, and even the popular Williams-Sonoma Call Center where I once taught the intricacies of catalogue sales and customer service operations to classrooms full of enthusiastic new hires in the mid-1990s long ago abandoned San Francisco in favor of Las Vegas, Oklahoma City and other locales, with an extensive warehouse operation in Memphis, Tennessee.

The San Francisco Unified School District, famous for its series of pink-slip layoff notices that began in the late 1970s, has certainly lost its luster as a premier employer, and the daily challenges encountered in today's classrooms are no longer offset by present-day salaries and benefits.

Even positions in the healthcare industry have changed drastically. Insurance programs and advances in medicine have both contributed to shorter hospital stays, and many rehabilitation facilities are no longer located in San Francisco. In addition, many maintenance jobs have disappeared over time, with the introduction of single-use, disposable sterile implements.

A few high school and college classmates of mine went to work for the airlines—as flight attendants, customer service agents, maintenance crews or pilots. However, deregulation and countless mergers have undermined their lives, pensions and employee benefits considerably over the last forty years.

Having graduated from St. Ignatius, further education was a given, and virtually all of my 250 high school classmates were college-bound. Many knew that they were headed for careers in medicine or law, and their choices were straightforward, but many of us remained "undeclared" college majors for a long time. Almost without exception, though, those who opted for positions with the SFPD or the SFFD—with or without a four-year degree—seem to have achieved economic stability and comfortable retirements long before the rest of us.

Nursing schools, present in many local hospitals, trained thousands for a lifelong profession, such as these graduates from the Children's Hospital Class of 1954. *Courtesy of San Francisco History Center, San Francisco Public Library.*

Opening a small business used to be popular in San Francisco. Just figure out what was needed in a neighborhood—hardware store, shoe repair, deli—and you were soon ready to begin raking in the money. Now, if the competition from big chains does not sink your plans, the regulations and permit process will likely do so. The City of San Francisco's website for small businesses advises that a minimum of *five* licenses or permits are now required to open something as simple as a sandwich shop—even more if the place plans to offer seating or sell alcoholic beverages. Many people give up before even reading to the end of the website.

Today, tech skills are highly prized and are often more important than academic achievements. Of course, the ultimate challenge today, after landing a job in San Francisco, is finding a place to live that is an easy commute to work.

That, however, remains a topic for future discussion.

13
Home Sweet Home

When recalling the past, most of us will invariably begin to recall what life was like when we were finally out on our own, out of school and away from our parents' homes for the first time.

Hang on for some interesting then-and-now comparisons.

In the immediate post–World War II era, many of our parents were able to marry and purchase homes for themselves prior to raising families. Yes, there were some financial pressures back then, but there was still a great deal of open space in San Francisco, so the law of supply and demand worked in favor of first-time home buyers back then.

Even as late as the mid-1970s, San Francisco rents were moderate enough that many young people could afford a place of their own. Back then, many downtown office workers seemed to gravitate to the west side of San Francisco when looking for a place to live. The Marina was a place for older Italian families, Noe Valley was still a blue-collar enclave and today's newly trending areas—South Beach, the Mission, the Excelsior, Bernal Heights, Dogpatch—weren't even on the radar of most people. The whole notion of employer-sponsored commute buses running from San Francisco to Santa Clara County was unthinkable at that time. In those pre-Craigslist days, would-be renters often focused on the Inner Sunset and the entire Richmond District while poring over the *San Francisco Chronicle*'s real estate listings with their morning coffee and the Herb Caen column.

That was how I found my first apartment at Parkmerced in 1976. As a recent college grad who had just begun working full time as a claims

In the post–World War II years, many couples purchased homes prior to the time they began raising families. Note the ashtray and the cigarette box—popular accessories of the era—on the coffee table of this home on Stratford Drive near Stonestown in 1950. *Courtesy of the Alan and Ruth Mildwurm Family Collection.*

adjuster at Bank of America making $800 a month, my rent was $200, or one-quarter of my gross salary—a standard ratio in those days. Parking, water, gas and garbage collection were all included, leaving me with just a telephone and an electric bill each month—no Internet, cell phones, smart phones, texting, laptops, GPS devices, e-readers or streaming videos—not even a countertop microwave back in those days. Since it was a bit of a hike to the M-Oceanview streetcar or a wait for the 17-Parkmerced bus to West Portal, I often drove to work (at a time when parking downtown cost me exactly $25 per month—just over $1 per workday). Life was good, and with an extra part-time job, I actually managed to save a bit every month.

One college friend was renting a small in-law apartment at the back of a garage in a Richmond District home on 42nd Avenue, complete with a miniature kitchen and bathroom, at a very reasonable rent—far less than mine. There was a problem with smells drifting upward, though, and any time the cooking involved spices stronger than salt and pepper, the landlady was knocking on the door complaining. Likewise, any shower lasting longer than just a few minutes managed to deplete the capacity of the home's

ancient hot-water heater. The unit, directly below the landlady's bedroom, also amplified the sound of her incessant snoring, and when she watched the evening news without her hearing aids, every word spoken by Walter Cronkite was clearly audible in the downstairs unit. My friend quickly realized why the rent was so low on this "great" place.

Couples who married shortly after college graduation in the mid-1970s often seemed to settle near Irving Street in the Inner Sunset. Parking was a regular challenge whenever they had friends over, and invariably, some of the nosier neighbors tended to comment on what had been seen in the trash—"My, Stouffer's for dinner a lot this week…"—to the point that most of these newlyweds wanted to move on to something else very quickly.

Another friend rented a large studio on California Street near Arguello, which gave her a variety of easy MUNI options for getting into downtown. As gasoline prices began to soar in the late 1970s, though, the 1-California, 2-Clement and 38-Geary all became so overcrowded with riders who were leaving their cars at home that the buses were regularly bypassing her and other waiting morning passengers because they were over capacity before ever reaching her stop at Arguello. After several morning hikes to catch the 31-Balboa or the old 5-McAllister on Fulton, my friend began searching for a new apartment closer to the beach so that she would be assured of a seat every morning.

During those same years, one former classmate found a great, though pricey, studio apartment on the north side of Twin Peaks, yet the costlier rent was offset by the fact that he could walk to work near University of San Francisco. It was an easy downhill stroll getting there, though the trip home was significantly harder—all uphill, and with several flights of both exterior and interior stairs before reaching the tiny apartment itself. The place had a spectacular view, though visitors often felt like mountain goats struggling up an Alpine incline and many of his guests gave up long before getting there, since the nearest parking spot was often at one of the public garages near UC Medical Center.

For most baby boomers, the roommate situation—fraught with peril both then and now—was always a fallback position to be avoided if possible. In the past, typical complaints about roomies involved messiness, cigarette smoking or a blaring television or stereo when others were trying to sleep. *Chronicle* articles over the last decade or so have highlighted a whole new series of "roommate-from-hell" issues: sharing a studio apartment with nothing more than a curtain dividing the sleeping areas or roommates running a methamphetamine lab in the kitchen, cultivating marijuana in a

closet, operating a house of prostitution in their bedroom or manufacturing fireworks in the garage (these last few issues apparently being "new" problems in the once-tranquil Sunset District).

For many renters, if things did not work out, they could always move—and "For Rent" signs were once a certain sign of spring in San Francisco. Since 1979, San Francisco's rent-control ordinance has helped many people maintain some affordability in housing, though the downside comes when someone decides that it is time to move but cannot afford to give up a rent-controlled unit and take a chance on what the current market has to offer.

Once MUNI's Market Street subway began operation in 1980, more people began selecting a place to live that was near a streetcar line, thus increasing the popularity of Cole Valley. This invariably led to the same problems experienced by my friend on California Street. After my move from Parkmerced to the Sunset in 1979, I sometimes got onto the N-Judah at 22nd Avenue on a weekday morning, though from 9th Avenue and Judah Street all the way to the Duboce Tunnel entrance at Cole and Carl Streets, waiting passengers were being passed up because the streetcar was packed to the rafters.

Then there were home furnishings—another area where boomers exhibited a strong sense of thrift. Almost all of us had a table and chair set that had been relegated to our parents' basements decades earlier. Whether wood or Formica, these items had seen long, hard years of use, and now they were our standard place for meals, board games, typing grad school term papers and hanging out with friends.

Another item in every single 1970s boomer apartment was the "cinderblock-and-plywood" bookcase, often dressed up with wood-grain contact paper on the shelves. These graced thousands of living rooms, at least until marriage, when a new spouse declared, "Those have got to go…" Old textbooks (remember the Norton Anthologies of English literature?) and paperback novels filled the shelves, along with rows of vinyl record albums in their covers, all standing on end. In those days, a Sony Trinitron television and a stereo receiver with turntable and movable speakers made up all the electronics in the home. A Smith-Corona portable electric typewriter constituted the "home office," and a rubber plant in the bookcase or a hanging fern in the window rounded out the décor.

Mismatched plates and glasses from the kitchen of a deceased grandparent were standard for early kitchens, though sturdy oversized mugs from Cost Plus were the choice for morning coffee rather than tiny cups and saucers. And no matter how scruffy the juice glasses, most of us had a couple of

nice matching wine glasses to grace the dinner table when serving the Carlo Rossi jug wine that had to be kept under the sink because of the large size of its gallon bottle. Pots and pans were often of the mismatched variety, but there was always a large Pyrex baking dish and an enormous round serving bowl for the inevitable lasagna or spaghetti dinners shared with family and friends. For those who found cooking to be too much of a challenge, many nearby restaurants offered substantial meals at moderate prices from late morning through the wee small hours of the next morning.

Grocery shopping in those days might have found us at one of the older, smaller 1950s-era Safeway stores or else one of the many small neighborhood grocery stores that still dotted the western half of San Francisco—Pine Lake Market on Vicente Street, Carriage Market on Noriega Street, Sunset Super

Right: Although "across the line" in Daly City, Joe's of Westlake was popular with thousands of San Franciscans from the day it opened in 1956. *Photograph by John Byrne.*

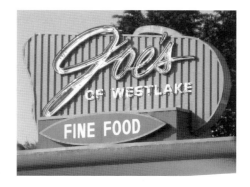

Below: The Coliseum Theatre was damaged by the 1989 Loma Prieta earthquake and forced to close. It sat vacant for years but was eventually revitalized with housing units built inside the shell of the original building, plus new ground-floor retail space. *Jack Tillmany Collection.*

on Irving Street, Lick Supermarket on 6th Avenue in the Richmond, Sutro Super on Point Lobos Avenue in the Outer Richmond—you just had to remember when the weekend was approaching, since most of these places were usually closed on Sundays. There was nothing resembling Costco, Walmart, Sam's Club or Trader Joe's for groceries, and those tiny apartment-sized refrigerators necessitated food shopping every few days.

Sutro Baths, Fleishhacker Pool and Playland all disappeared between 1966 and 1972, yet there were still many low-cost local entertainment options in the mid-1970s. The Alexandria, Bridge, Coronet, Coliseum, El Rey, Parkside and Surf theatres were all still in operation, along with the Mission and Geneva Drive-Ins just over the line in San Mateo County. Date night at any of these places, snacks included, might cost about five dollars per couple.

Front Room Pizza on Clement Street still featured ten-cent beer one night a week. The Hot House was operating on Balboa Street, plus Tien Fu at 21st Avenue and Noriega, with Zim's locations still dotting the city for late-night eats. There were no McDonald's, Jack in the Box or Carl's Jr. outlets in those days, but there was always Beep's on Ocean Avenue near City College for a quick bite to eat.

Many rock music venues were also still in business in those days, and even a couple of tickets to a Giants home game at Candlestick Park on a Saturday afternoon, plus snacks, would yield change from a ten-dollar bill. The iconic S.N.A.C.K. (Students Need Athletics, Culture and Kicks) concert, organized for March 1975 in support of public school programs, offered music in Golden Gate Park by the Doobie Brothers, Jefferson Starship, Jerry Garcia, Joan Baez, Tower of Power, Neal Young and others for a mere five-dollar advance purchase.

Many of us had cars in those days, and the western part of the city was dotted with Volkswagen Beetles (which fit nicely between neighboring driveways), though Toyota was beginning to make

A 1950s-era hamburger stand on Ocean Avenue near City College evokes the *Sputnik* era while still dispensing great hamburgers decades later. *Courtesy of Western Neighborhoods Project.*

Top: As late as 1978, a ticket to a Giants game cost a mere dollar—and on Memorial Day weekend to boot! Times were, indeed, simpler and less costly for residents. *Author's collection.*

Bottom: Grison's operated as popular twin dining houses—steaks and chops served in one building and chicken in the other—at Van Ness Avenue and Pacific from the 1930s until the 1970s. Run by Swiss-born Bob Grison, it was a formal place with tuxedoed waiters. Thanksgiving Day diners were given the boxed remains of their table's entire roast turkey and trimmings to take home. *Author's collection.*

inroads with its new Corolla and Celica models—many of them sporting a crooked "Toyota" decal on the rear window. Gasoline began to creep up in price after the 1973 oil embargo, and it was not unheard of to see prices beyond fifty cents a gallon, though the one-dollar-per-gallon mark was generally not breached until mid-1979.

Today, many of us who grew up in San Francisco, or who lived there in our early adult years, have now settled elsewhere for a variety of good and logical reasons involving family, careers and relative cost. It's easy to remember, though, when we had so many longtime friends and relatives as neighbors, when entertainment and dining out was varied and inexpensive and when local merchants greeted us warmly as we ran our weekly errands. Just like the days of our childhood, the early adult years were also a golden time for many of us—not soon to be forgotten.

14
Down on the Corner

No matter where you lived in San Francisco, there was always a little corner business that opened early, closed late and stocked many different items. It might be a small grocery store, deli, pharmacy, liquor store or candy shop/soda fountain. Whatever the format, these places were invariably the gathering place for young and old alike.

No one had to call, text or send an e-mail to learn what was going on in the neighborhood—you just went to the corner to pick up a loaf of bread, a quart of milk, a sandwich, a newspaper, a bottle of aspirin or a candy bar, and there would always be someone there to fill you in on the news of the day—from around the world and around the block.

Sometimes a parent would hand their child a dollar bill and request a pack of Benson & Hedges Menthol Lights. The corner store clerk would gladly hand the ciggies over to a nine-year-old, and the happy child would get to spend the change on penny candy.

In many areas, there was at least one of these establishments at every single intersection along the commercial streets. You often had credit there, the owners knew you and your entire family (sometimes for generations) and it was truly a home away from home. Sadly, these handy places have been disappearing at a faster pace than ever since the turn of the millennium.

Here are some current and past favorites, remembered by many:

Richmond/Sunset/West of Twin Peaks

Lee's Market at 5th and Balboa

Eddie's on Irving Street in the Inner Sunset

Lincoln Market at 21st and Quintara

Herb's Deli on Taraval—hot meatball sandwiches every Thursday

Amity Market at 44th and Taraval

Pelican Liquors on Vicente—they didn't check ID too much

Sea-Bee Liquors on Taraval—where they carded you until you were at least forty

Johnny's at 18th Avenue and Balboa

Vicente Variety near 24th Avenue—gone since the late 1960s

Your Market on 48th Avenue

John's Richmond Market at 41st and Balboa

George's at 15th and California

P&G (Pete & George's) Market on 4th Avenue and Balboa

Dubayah's on 25th and Taraval

Mo's on Portola Drive in Miraloma Park

Overland Pharmacy at 21st and Taraval, run by Mrs. Corsiglia

The Sweeterie at 21st and California

Appel & Dutch at 22nd and California

Gateview Market on 25th and California

The Royal Rose at 23rd and California

The Village Super at 17th and Irving

Sun Valley Dairy at 24th Avenue and Noriega

Herman's Deli on Geary near 7th Avenue—the wonderful aroma of an old-world delicatessen

Selmi's Market on the corner of Holloway and Ashton for afterschool snacks

Reis' Pharmacy at 18th and Taraval—prescriptions, razor blades, cigarettes, magazines and all the neighborhood news—from the 1930s to the 1970s

Eezy-Freezy on West Portal—opened early and closed late 365 days a year for batteries on Christmas morning, Halloween candy, cranberry sauce on Thanksgiving or that last-minute birthday card

MISSION/EXCELSIOR/CASTRO/ NOE VALLEY/GLEN PARK

Sal's Grocery at 26th and Dolores

Ramirez's (or "Reymos")—Chenery Street near Glen Park. A quarter would get two bags of Jack 'n Jill Popcorn and a Freezie Pop.

The New Bosworth Market at Bosworth and Cuvier

Helen's right across from St. John's Church

Roxie's on San Jose Avenue at San Juan

Len's on Diamond near 24th

Luke Morley's on Chenery in Glen Park

Nick's in Glen Park

Mr. Wong's on Crescent and Andersen in Bernal Heights

Rossi's near Mission and Geneva by the Amazon Theatre

Clara's at 18th Street and South Van Ness. She was the owner who, sadly, was killed during a robbery attempt in the early 1970s.

Dell's on Excelsior Avenue

Jefferson's Market on 23rd and Florida for Italian ice bars

King's Market on 23rd and Bryant for all the candy and especially "saladitos"—dried salted plums

Sunnyside Market

Harrison's Fountain on Geneva Avenue—everyone stopped there after the show at the Amazon (later, the Apollo) Theatre

Del and Emma's on Flood and Detroit Streets

Log Cabin Market on Staples and Edna Streets

Shufat's on 24th and Church

Pete's Grocery at the corner of Peru and Edinburgh

Lam's on 29th and Noe

M&M on Castro and 29th

Nick's (later Margarita's) on Arlington and Miguel and the man who looked like Boris Karloff

The Hong Kong Grocery on the corner of St. Mary's and Marsilly

Golden State Market at 15th and Castro

Joe's on 22nd and Church

Sweeney's at 21st and Castro

Johnson's on the corner of Castro and 20th—Mr. and Mrs. Johnson lived above

Castelli's at 26th and Bryant

St. Francis Candy Store & Soda Fountain, 24th and York—since 1918

Diamond Market on 20th and Diamond

Norman's Liquors on Randall Avenue

Butler's at 26th and Diamond—had a nice deli and allowed charge accounts

Chenery Market on the corner of Chenery and Randall

Ronnie's at Army and Sanchez

St. Clair's Liquors on 24th Street—once owned by Poly High grad and 49ers
football great Bob St. Clair

WESTERN ADDITION/HAYES VALLEY HAIGHT

Goodwin's Grocery on Hayes Street—nice store run by nice people

Fred's at Haight and Divisadero

Little Joe's on the corner of Masonic and Fulton—always a stop for USF
students from the dorms

MARINA/NORTH BEACH/CHINATOWN/RUSSIAN HILL

Mike's grocery store on Greenwich and Grant

Lucca Delicatessen on Chestnut Street—everything Italian

Molinari's on Columbus Avenue

Sherman Market on Union and Franklin

Guidi Brothers on Greenwich—when you want to avoid the "dating game"
at Marina Safeway

Ara's on Washington Street

POTRERO/PORTOLA/VISITACION VALLEY/BAYVIEW

Tom's on 24th Street at Vermont

Potrero Liquors on 24th Street

Lee's Grocery at Silver and Revere

Mary's Grocery at Quesada and Quint in the Bayview

Guttner's on Wilde Avenue

The 7-Mile House on San Bruno Avenue at Wilde

Jiminez on Blanken and Tunnel Avenue—great sourdough-salami sandwiches
 and fresh pomegranates

Mr. Bill's on Scotia

Armanino's Deli on San Bruno Avenue—great sliced meats, cheeses, salads

In addition to the hundreds of small corner stores, San Franciscans had
many other places to shop in the era before the mall. Trips downtown—
particularly to Market Street and the Union Square area—were generally

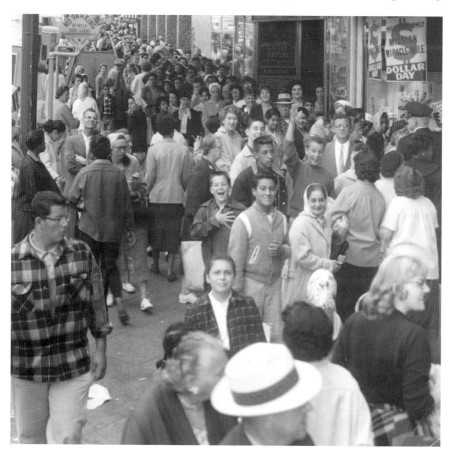

For decades, Mission Street's "Miracle Mile" attracted shoppers from every neighborhood
in San Francisco on "Dollar Day" events sponsored by local merchants. This happy crowd
was bargain-hunting in 1958. *Courtesy of San Francisco History Center, San Francisco Public Library.*

The Crystal Palace, located at 8th and Market Streets, was a shopper's paradise from the early 1920s until its closing in 1959. The location had individual merchants selling everything imaginable under one roof—meats, poultry (feather-plucking cost a bit extra), fish, produce, eggs, cheese, dried fruits, housewares, appliances, tobacco, pets, phonograph records and more. It was demolished for a then state-of-the-art motor lodge, which morphed into apartments in the 1980s, only to be demolished in 2013 and replaced by a new high-rise residential complex. *Courtesy of San Francisco History Center, San Francisco Public Library.*

reserved for large purchases or holiday shopping. Most neighborhoods had retail shopping districts where people found the necessities, but across San Francisco, many people headed to Mission Street's "Mission Miracle Mile" for "Dollar Day" events.

Another spot that attracted shoppers from all neighborhoods was the gigantic seventy-thousand-plus-square-foot Crystal Palace at 8th and Market Streets. Operating from the 1920s until 1959, it was a vast open space, populated by dozens of different merchants in individual stalls—all of them selling a variety of different goods. Easily reached by MUNI, the location also had a vast parking lot facing Mission Street. It was a gathering place for all San Franciscans, regardless of income or neighborhood, with unique items and daily bargains for all.

15

Deck the Halls

Growing up in the San Francisco of the past, Christmas was a civic celebration for everyone in addition to being a religious holiday for many.

Everywhere you went, there were signs of merriment and celebration, from Christmas trees in virtually every residential window to exterior lights on homes in many neighborhoods and the classic department store images—especially the decorated tree in the rotunda of the City of Paris at Stockton and Geary. That store closed in 1972, and the building was demolished in 1979. The new Neiman-Marcus store that was built there managed to save the stained-glass skylight from the original store. The new store has also put up a large tree each year since the early 1980s, but it quite simply does not evoke the same warm feelings as the one at the City of Paris.

A visit to downtown also included checking out the windows of the Emporium, as well as a visit to the carnival "Roof Rides." A stroll through Woolworth's and presto—a child shopping for parents or siblings could find countless stocking stuffers for the entire family for well under a total budget of one dollar. The floral shop Podesta-Baldocchi was yet another entirely free walk-through experience to admire thousands of twinkling lights.

Neighbors banded together in many areas to hold community-wide decorating contests, and in the years just after World War II, San Francisco firehouses joined in the competition. Many families walked block after block after dinner each night just to take in the sights. Public caroling was also a popular pastime, and I have fond memories of being invited to a home on 38th Avenue each year, where participants would enjoy munchies and hot

Each December, Emporium Department Store featured an attraction known as "Roof Rides"—carnival entertainment on the top of its Market Street store and, later, also at the Stonestown location. Santa's arrival at Powell and Market Streets by cable car kicked off the annual holiday shopping season. *Courtesy of San Francisco History Center, San Francisco Public Library.*

cider and then go out "Carrolling with the Carrolls" up and down the local blocks of the Outer Sunset.

Throughout the city, from Twin Peaks with a lighted tree high above Market Street to Fisherman's Wharf and the Marina Green, where boats were strung with colorful lights, the city had a festive air, including a giant Hanukkah menorah in Union Square. Holiday music dominated the radio waves, and across the neighborhoods, smells of holiday baking filled the air. Cookie exchanges proliferated in many schools, office workplaces and community groups, and neighbors also sent paper plates filled with homemade treats to those living across the street or across the backyard fence.

The old red-brick Shriners' Hospital on 19th Avenue joined in by decorating an immense tree that had long been growing in its front lawn with multicolored lights, a beacon for drivers along busy 19th Avenue. A similar decorating theme appeared on an equally large tree in front of McLaren Lodge on the Stanyan Street end of Golden Gate Park near the Panhandle.

Department-store Santas, the retail industry's most seasonal employment position, were always on the visiting list for parents with young children.

Neighbors of Sylvan Drive.

Dear Friends:

Again it is time for Christmas Rejoicing. A fine way to show that there is joy in our hearts is to decorate our homes with outdoor lights and Christmas Trees in our windows.

To the new neighbors of Sylvan Drive, we welcome you to our midst and trust that your residence on this street will be a long and happy one. May we ask that you all enter into the Christmas spirit and cooperate with us by decorating your home with outdoor lights.

No doubt there will be some of you who will need help in putting up your lights, so the committee will assist you on Sunday morning, December 12, 1948. If there are any neighbors who will be out of town or unable to put up their lights, kindly leave lights, extension cord and key to basement with your neighbor and arrangements will be made to put up same.

The following is suggested:

That we have our lights up by Saturday night, December 18th, at 7 o'clock.

That the lights be on every evening between December 18th and January 1st, inclusive, during the hours of 6:00 to 9:30 P.M.

If for some reason you will not be at home on some particular evening, please arrange with a neighbor to turn your lights on and off that night.

Promptly at 7:00 P.M. December 18th, please turn on your outdoor lights and your Christmas tree lights. Please do not turn on lights before the night of December 18th at 7:00 P.M. Christmas Carols will be played on a public address system. Come join with us and let the Yuletide spirit reign supreme.

A children's Christmas party will be held for the children of Sylvan Drive on Tuesday evening, December 21st, at 7:00 P.M. in the basement of Mr. and Mrs. Nemeth, 31 Sylvan Drive.

Wish all of our neighbors on Sylvan Drive a Merry Christmas and a Happy New Year.

Lighting Committee	*Children's Party Committee*
Bert Burman	Margaret Nemeth
Al Michelotti	Corine Kluver
Reginald Manning	Norma Ghiotto
Steve Nemeth	Blanche Michelotti
Paul Grace	Mildred Dittman
Fred Dittman	Mary Grace
Roy Kluver	Ethel Burman

Residents of Sylvan Drive, south of Sloat Boulevard, banded together in 1948 to celebrate the Christmas season. *Courtesy of Christine Meagher Keller.*

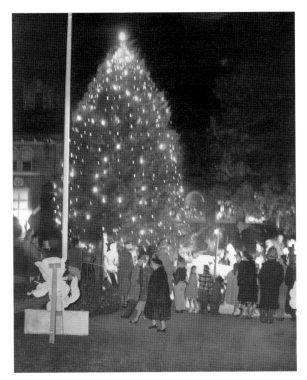

Shriners' Hospital was located on 19th Avenue in the Sunset District from the 1920s until it relocated to the Sacramento area in the 1990s. A crowd gathered annually on the front lawn to celebrate the facility's Christmas tree–lighting ceremony. This was the image viewed by local residents and by thousands of motorists traveling through San Francisco, along the route between San Mateo and Marin Counties. The hospital has been replaced by a senior housing complex and townhouses, with the original brick structure preserved. *Courtesy of San Francisco History Center, San Francisco Public Library.*

Some kids loved the annual visit, while others were afraid of the guy with the white beard and some—whether in fascination or terror—were inclined to "accidents." This author, having had to pinch-hit for more than one AWOL Santa during a quarter-century career in the retail business, knows how important it is to have a spare pair of red velvet pants nearby, along with a sign reading, "Santa is out feeding his reindeer and will be back in 5 minutes."

Even the post office managed to spread good cheer by hiring extra carriers and delivering mail multiple times a day during the month of December, plus adding a new commemorative stamp each year beginning in 1962.

Schoolchildren often pooled their pennies, nickels and dimes to buy a small gift for their teacher—often items along the lines of handkerchiefs, cookies, candy or lotion. Even in the city's public elementary schools, 1950s sing-alongs included religious Christmas carols and Hanukkah songs.

Church groups banded together for many years to put on a "living Nativity scene" in Lindley Meadow of Golden Gate Park—something that many people would visit, bringing children in their jammies, who could ooh and ah while warmly bundled up in the backseat of the family car. In one of the production's final years in the late 1960s, some of the sheep

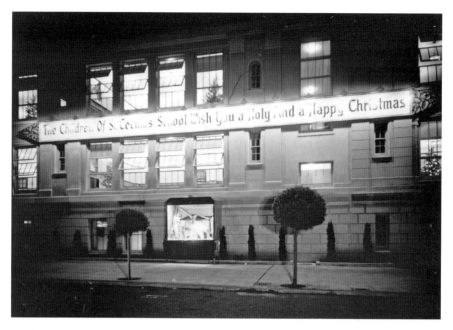

St. Cecilia School at 18th Avenue and Vicente Street in December 1950. The lighted banner reads: "The Children of St. Cecilia's School Wish You a Holy and a Happy Christmas." The adjacent 2600 block of 18th Avenue was equally decked out in holiday lighting in that era. Note the sidewalk Nativity scene and the lighted Christmas trees in each of the classrooms. *Courtesy of Monsignor Michael D. Harriman, parish archives.*

managed to stampede just a bit, providing the actor-shepherds with a real need to display their talents!

The 2600 block of 18th Avenue was fully decorated with trees and outdoor lights every year, from the 1930s when the homes were first built until the dawn of the 1970s—with just a brief "time-out" during the World War II years. On a Saturday night about two weeks before Christmas, Santa would arrive by fire engine, courtesy of the SFFD, sit on his golden throne in the garage entrance of one home and have children (and a couple of moms) sit in his lap and tell him their wishes. Peppermint candy canes from the old Hromada Candy Company near the Embarcadero (picked up by my father and myself a week or so earlier) were dispensed to everyone, as Christmas carols played from rented loudspeakers. Everyone held open houses that night, and all the neighbors mixed like family with one another.

Throughout the city, decorations were strung from MUNI wires by local merchant groups, seeking to bolster both holiday spirit and retail

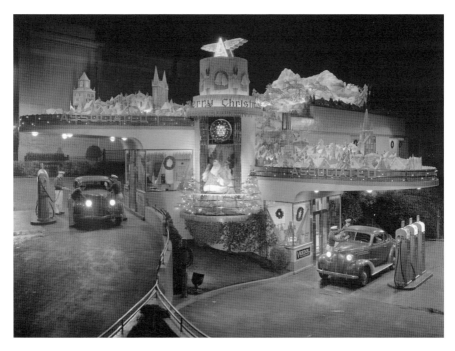

This Flying-A (standing for the firm's corporate name of Associated) service station at the southeast corner of Junipero Serra Boulevard and Ocean Avenue was truly a winter wonderland in 1940. The location was long ago torn down for a bank building. *Photograph by Chas. M. Hiller, Fred Deltorchio Collection, courtesy of Bud Sandkulla.*

sales. Red plastic "mission bells" hung from the wires of the 14-Mission line, while silver scrolls, giant red-and-white-striped plastic candy canes and smiling reindeer heads graced streetlights from the Richmond to the Sunset and from Stonestown to the Excelsior. Buses, streetcars and cable cars often displayed a festive wreath on the front of the vehicle, provided by cheerful MUNI operators. Even the mundane corner gas station took steps to spread cheer to their patrons.

Through it all, the steady bell-ringing of Salvation Army volunteers resounded from shopping areas in the Presidio to Nob Hill, Noe Valley and the Bayview—giving us all a very gentle reminder that the holidays are, indeed, a time to think of others.

16
Savoring the Past

Recent excavations in the Outside Lands have uncovered historical artifacts related to the history of Merrie Way, a one-time amusement village located above the Cliff House and Sutro Baths, near the corner of Point Lobos Avenue and El Camino del Mar. Adolph Sutro filled this area with many attractions that were originally part of the Midwinter Fair of 1894, held in Golden Gate Park, and he operated the spot as the Sutro Pleasure Grounds from 1896 to 1900.

Another nearby archaeological dig, this one organized by a group of San Francisco high school students in 2012, managed to unearth the blue-and-white geometric-patterned interior tile floor of a greenhouse/conservatory that was adjacent to Sutro's residence just across the street from Merrie Way. Sutro's home and the conservatory, built in the 1880s, managed to survive the 1906 earthquake, only to be torn down by the city in 1939 when they were barely fifty years old. The reemergence of the old tile floor was a nice little peek into the past.

Just recently, a bit of sleuthing by this author has managed to uncover yet another popular artifact from this area—one which some people might consider to be the greatest lost treasure of all, perhaps rivaling the Maltese Falcon—the popular but long-gone food of the Hot House restaurant, once located at Playland-at-the-Beach.

The Hot House operated at 750 Great Highway for nearly forty years, from the early 1930s until the closure of Playland on Labor Day weekend 1972. Originally operated by Barney Gavello, the restaurant dispensed

Mexican food to appreciative crowds for decades. It has been estimated that on peak weekends during World War II, the Hot House sold up to twelve thousand tamales to Ocean Beach visitors from both the steamy, fragrant interior—with its cream-color stucco walls and hand-carved dark-wood counter and stools—as well as from the takeaway windows facing the waves.

In a uniquely San Francisco twist, the Hot House, unlike most other purveyors of Mexican food, always served baskets of dark-bake sourdough French bread, with generous quantities of butter alongside, rather than the more authentic stack of tortillas. In addition, spaghetti was a featured menu item for decades. Food from the Hot House still elicits fond memories for thousands of San Franciscans, unlike most other places before or since. On the nostalgia scale, it is right up there with Herman's potato salad, Blum's candies, Larraburu French bread and Herb's meatball sandwiches.

Gavello must have felt the decline of Playland approaching, as he sold his beloved restaurant just a few years before the amusement park breathed its last. New owners Juan Faranda and Jose Robleto took over with enthusiasm, continuing to work with the time-tested recipes that had been pleasing the crowds for decades. Faranda, of Sicilian-Peruvian background, was born in

Popular Playland dining spot from the 1920s through 1972. After Playland closed, the Hot House relocated to Balboa Street and continued in business until the owner retired in 1996. It is now operated by the owner's son on a monthly "pop-up" basis. *Photograph by Dennis O'Rorke.*

Lima, Peru, in the late 1930s and had been living in San Francisco since his teens. As the manager of an adjacent Playland eatery, the Pie Shop, he was well acquainted with the outgoing Gavello and knew that he and his partner could maintain the quality and the atmosphere of the Hot House even after Gavello's retirement.

The new owners took over in the late 1960s, still serving the original 1934 recipes, much to the delight of loyal customers. There continued to be a lively, festive crowd at the Hot House every day of the week—how could it be any other way, when it was surrounded by the excitement of Playland?— and there was seldom an empty seat in the place, right up until the time the wrecking ball struck in 1972.

Once Playland closed, Juan Faranda bought out his partner and moved the restaurant to a new location a few blocks away at 4052 Balboa Street, where it continued as a family business for nearly a quarter of a century, even expanding into an adjacent building that once housed a drugstore. Sadly, though, many of the original loyal customers thought the Hot House had vanished along with the rest of Playland, and perhaps there was too little advertising done in those days. One of my mom's bingo-playing companions tipped her off about the new site in the early 1980s, and it was the first that our family had heard of it, but we soon became regulars.

All throughout the restaurant's long run on Balboa Street, the owner often found himself in the kitchen, ensuring that the staff was preparing the food precisely according to the original recipes and not taking any unauthorized shortcuts to save time or skimp on crucial ingredients. With help from his wife and children, the Hot House continued to thrive, though on a smaller scale. Juan finally decided to retire in 1996 and closed the restaurant after a total run of more than sixty years.

Recently, his forty-three-year-old son Eric was attending a Giants game with friends when the talk turned to classic San Francisco food. Eric was astounded that while so many people his age remembered Doggie Diner, few knew of the Hot House. He decided then and there that a whole new generation of San Franciscans deserved to know exactly why the place was so fondly remembered and what the excitement was all about. Juan, now in his late seventies, agreed to turn those classic recipes over to Eric, but with a clear understanding that they must never be given away.

As a trained chef with a culinary degree, Eric has now resurrected the Hot House menu and started a once-per-month catering business, delivering food orders throughout the Bay Area from his home in San Mateo County for a reasonable price, plus a delivery fee. While the eighty-year-old recipes

remain a family secret (I know—I tried unsuccessfully to get him to share the luscious enchilada sauce recipe with me), he and his family know the powerful draw of both food and nostalgia, and he hopes to bring back some lost memories for many of us.

His toughest challenge was rescaling ingredient proportions to yield a couple of hundred servings, rather than several thousand, because things like salt and spices tend to react differently when proportions are changed— sometimes they are stronger than desired, and sometimes weaker. Eric laughs as he recalls his father's recipes with measurements expressed not in "cups, tablespoons, teaspoons, pinches and dashes" but rather "barrels, sacks, pounds, gallons and potsful." With his parents watching closely over his shoulder, Eric has now mastered the correct measures of ingredients that are required to create the precise taste and texture of the classic dishes, but in manageable quantities—and his customers enthusiastically agree that he has done so to perfection as soon as they take that first bite.

Many of his loyal fans are known to schedule family get-togethers around Eric's once-per-month delivery schedule for enchiladas, tamales, chili con carne, rice and beans, and he is currently working on a business plan to expand the operation to include FedEx overnight deliveries packed in dry ice. Ultimately, this enthusiastic San Francisco native and graduate of Archbishop Riordan High School would like to resurrect the Hot House in a classic San Francisco neighborhood location, complete with some iconic Playland décor and memorabilia.

Just for the record, I recently took along a casserole filled with authentic enchiladas and sauce from the Hot House to share with two different groups of friends for pre- and post-Thanksgiving dinners. As we were eating, I could almost feel the ghosts of the past nudging me as they reached down the long wooden counter for another slice of dark-bake sourdough French bread and a couple of pats of butter. The food and the company were excellent, as we all relived a few precious moments from our neighborhood's beloved culinary past, recalling the sights, sounds and smells of dear old Playland.

Today, Eric Faranda operates the Hot House under a new business model, the "pop-up" restaurant—that is, renting a licensed established restaurant kitchen on a periodic basis, taking orders in advance and then magically transporting his customers back in time with mouth-watering carryout orders, right down to the grated cheese and chopped fresh onions.

For more info, contact Eric Faranda at hot.house28@yahoo.com or via his Facebook page, the Original Hot House From Playland.

A view along Ocean Beach and the Great Highway evokes fond memories of the past for those who remember the fun and excitement of Playland—gone since 1972 and replaced by a rather bland development of homes and apartments. *Photograph by John A. Martini.*

AUTHOR'S COMMENT

So good was the food, and so memorable, that several times over the last few years, the Western Neighborhoods Project (WNP) message boards have carried recipes—all of them identified as being "from The Hot House at Playland." Just for the record, Eric Faranda laughs and responds with an emphatic, "No, not quite," to each of the drastically different versions—only he knows the real secrets behind the sauce. All of those allegedly "authentic" versions that have appeared online in recent years are simply the stuff of urban legend.

17
The City as Backdrop

In the fall of 1972, veteran actor Karl Malden, then sixty years old, was teamed up with the younger Michael Douglas, then twenty-eight, in a new crime series, *The Streets of San Francisco*. It was not the first time that the city was used as the backdrop for a television series. Years earlier, *The Lineup* (known later in syndication as *San Francisco Beat*) teamed up old-time actors Warner Anderson and Tom Tully in similar roles. Sadly, the 1954 series seems to have disappeared from the airwaves, though the 1972 Malden-Douglas series remains in syndication today and offers many nostalgic glimpses of the city as it used to be.

Beginning with season 1, exterior scenes for *The Streets of San Francisco* were shot on location in San Francisco, with interior shots filmed at a motion picture studio in Southern California. By season 2, however, the credits began to indicate, "Filmed completely on location in San Francisco." Among the many settings are a murder victim's house in Sea Cliff with a tremendous view of the Golden Gate Bridge; a would-be arsonist in a large home on Junipero Serra Boulevard near St. Francis Circle; a suspect captured in the wooded area beneath the Mount Davidson Cross; various scenes at multiple locations in Golden Gate Park, including the Japanese Tea Garden and the Music Concourse, with the old de Young Museum in the background; and visits to a smaller San Francisco State University, the old Zim's at 19th and Taraval and a passenger getting onto a green-and-cream MUNI streetcar at 15th Avenue and Ulloa.

The band shell in Golden Gate Park, built in 1899, was donated by sugar baron Claus Spreckels and is still the site of open-air concerts. An underground garage was added to the Music Concourse in 2005 as part of the new de Young Museum project. *Photograph by Michael Fraley.*

From the early days of the film industry, San Francisco has provided an ideal setting for the making of movies, with urban, suburban, rural, mountain and ocean settings all within close proximity. Many locals enjoy pointing out the various spots around town where *Bullitt* careened in one of Hollywood's most famous car chases, the corner above the Stockton Street Tunnel where Brigid O'Shaughnessy shot Miles Archer or the spot where Dirty Harry gunned down the bad guys.

SOME FILMS SET IN SAN FRANCISCO

American Graffiti (1973), Richard Dreyfuss, Ron Howard, Cindy Williams
Basic Instinct (1992), Michael Douglas, Sharon Stone
Bullitt (1968), Steve McQueen, Robert Vaughn, Jacqueline Bisset
Competition, The (1980), Richard Dreyfuss, Lee Remick
Conversation, The (1974), Gene Hackman, John Cazale, Cindy Williams
Dark Passage (1947), Humphrey Bogart, Lauren Bacall
Dirty Harry (1971), Clint Eastwood, Andrew Robinson, Harry Guardino
Escape from Alcatraz (1979), Clint Eastwood, Patrick McGoohan

Fan, The (1996), Robert De Niro, Wesley Snipes, Ellen Barkin

Freebie and the Bean (1974), James Caan, Alan Arkin, Loretta Swit, Valerie Harper

Guess Who's Coming to Dinner? (1967), Spencer Tracy, Sidney Poitier, Katharine Hepburn

Harold and Maude (1971), Ruth Gordon, Bud Cort

Indiana Jones and the Last Crusade (1989), Harrison Ford, River Phoenix

Invasion of the Body Snatchers (1978), Donald Sutherland, Brooke Adams, Leonard Nimoy

I Remember Mama (1948), Irene Dunne, Barbara Bel Geddes, Ellen Corby

Joy Luck Club (1993), Ming-Na Wen, Rosalind Chao, Lauren Tom, France Nguyen

Lineup, The (1958) Eli Wallach, Robert Keith

Love Bug (1968), Dean Jones, Michelle Lee, David Tomlinson, Buddy Hackett

Maltese Falcon, The (1941), Humphrey Bogart, Mary Astor, Peter Lorre

Milk (2008), Sean Penn, Emile Hirsch, Josh Brolin

Mother (1996), Albert Brooks, Debbie Reynolds

Mrs. Doubtfire (1993), Robin Williams, Sally Field

Nine Months (1998), Hugh Grant, Julianne Moore

No Small Affair (1984), Jon Cryer, Demi Moore

Once a Thief (1965), Alain Delon, Ann-Margret, Van Heflin, Jack Palance

Organization, The (1971) Sidney Poitier, Barbara McNair

Pacific Heights (1990), Melanie Griffith, Matthew Modine, Michael Keaton

Parent Trap, The (1998), Lindsay Lohan, Dennis Quaid, Natasha Richardson

Portrait in Black (1960), Lana Turner, Anthony Quinn

Right Stuff, The (1983), Fred Ward, Dennis Quaid

San Francisco (1936), Clark Gable, Jeanette MacDonald, Spencer Tracy

Sister Act (1992), Whoopi Goldberg, Maggie Smith, Harvey Keitel

Star Spangled Girl (1971), Tony Roberts, Todd Susman, Sandy Duncan

Sudden Impact (1983), Clint Eastwood, Sondra Locke

Take the Money and Run (1969), Woody Allen, Janet Margolin, Louise Lasser

They Call Me Mister Tibbs! (1970), Sidney Poitier, Martin Landau, Barbara McNair

Towering Inferno (1974), Paul Newman, Steve McQueen

Vertigo (1958), James Stewart, Kim Novak

View to a Kill, A (1985), Roger Moore, Tanya Roberts

Wedding Planner, The (2001), Jennifer Lopez, Matthew McConaughey

What's Up, Doc? (1972), Barbra Streisand, Ryan O'Neal, Madeline Kahn

Yours, Mine and Ours (1968), Lucille Ball, Henry Fonda

Scene at Candlestick Park in the mid-1960s, prior to the stadium's expansion. *Wikimedia Commons.*

SOME TELEVISION SERIES SET IN SAN FRANCISCO

Though Often with Filming Elsewhere

Amy Prentiss (1974–1975), Jessica Walter, Johnny Seven, Helen Hunt

Barbary Coast (1975–1976), William Shatner, Dennis Cole, Doug McClure

Checkmate (1960–1962), Anthony George, Sebastian Cabot, Carolyn Craig, Doug McClure

Dharma & Greg (1997–2002), Jenna Elfman, Thomas Gibson

Doris Day Show (1968–1973), Doris Day, Denver Pyle

Falcon Crest (1981–1990), Jane Wyman, Robert Foxworth, Abby Dalton, Lorenzo Lamas

Full House (1987–1995), John Stamos, Bob Saget, Dave Coulier

Have Gun—Will Travel (1957–1963), Richard Boone, Kam Tong

Hotel (1983–1988), Anne Baxter, James Brolin

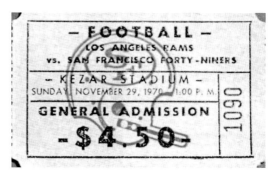

Kezar Stadium, one-time home of the 49ers, has long been a popular backdrop for motion picture and television productions. Note that at $4.50, this ticket was considered to be rather pricey in 1970. *Author's collection.*

Ironside (1967–1975), Raymond Burr, Don Galloway, Don Mitchell, Barbara Anderson

Lineup, aka: San Francisco Beat (1954–1960), Warner Anderson, Tom Tully

Love Is a Many Splendored Thing (1967–1973), Donna Mills, Leslie Charleson, David Birney

McMillan & Wife (1971–1977), Rock Hudson, Susan Saint James

Midnight Caller (1988–1991), Gary Cole, Wendy Kilbourne

Party of Five (1994–2000), Scott Wolf, Matthew Fox, Neve Campbell, Lacey Chabert

Streets of San Francisco (1972–1977), Karl Malden, Michael Douglas/ Richard Hatch

Suddenly Susan (1996–2000), Brooke Shields, Nestor Carbonell, Kathy Griffin

Tales of the City (1993 miniseries), Olympia Dukakis, Donald Moffat

Too Close for Comfort (1980–1986), Ted Knight, Nancy Dussault

Trapper John, M.D. (1979–1986), Pernell Roberts, Gregory Harrison, Madge Sinclair

A Nice Place to Visit

It is now just over 155 years since my great-grandfather David Dunnigan and his cousin Michael stepped off the boat that brought them to San Francisco from our family's original American home in the District of Columbia—an arduous journey around Cape Horn. For a century and a half, hundreds of my relatives called San Francisco home. Today, just one older cousin lives in her longtime home near Duboce Park. All my hundreds of other relatives have picked themselves up and moved to other places— sadly, Holy Cross Cemetery in Colma has been a popular destination for many—but others visit our hometown on a regular basis.

Returning as visitors rather than as permanent residents changes our perception of things a bit. We don't need to rely on MUNI during morning and afternoon rush hours, nor do the heated arguments among members of the city's Board of Supervisors impact us as directly as in the past. We no longer get upset when a favorite hardware store, shoe repair shop or bakery closes, nor do the woes of the public school system any longer have a direct impact on us.

There are things, though, about which we "returning natives" are passionate, including some places that *must* be included in each and every return visit—even if just on a drive-by basis.

On most of my visits, I take MUNI to get around, since I can often be found at the historic old Ocean Park Motel near the zoo, with the L-Taraval beginning and ending its long run right at the front door, thus assuring me of a seat at the start of my daily adventures. It amazes me that the fare is now

$2.25 per ride, though a one-day visitor's pass for $16 and a seven-day pass for $29 represent good value for most visitors. Soon, I'll be able to qualify for MUNI's senior fare of $0.75 per ride, up from the nickel rides that my parents enjoyed in their youth and again as seniors in the early 1980s.

Many places that I enjoyed as a child and as a teen are no longer there—particularly Sutro's (I've seen the ruins many times—no need to revisit), Playland and Candlestick Park.

I still have fond memories of the WPA-inspired zoo, and there have been many improvements there over the years, including more animals in natural habitats, a much larger aviary and insect collection and some improved visitor amenities. Still, I miss Monkey Island, the Pachyderm House with elephants and the *Little Puffer* engine in the Children's Playground area.

Local artists Aileen Barr and Colette Crutcher led the creation of the 163 mosaic panels that were applied in 2005 to an existing public stairway just off 16th Avenue in the Sunset District. Similar installations are being added throughout the city. *Photograph by Mark Roller.*

Fleishhacker Pool is now a paved parking lot for the zoo, which charges ten dollars, over and above the zoo's nineteen-dollar adult admission fee. The late Messrs. Fleishhacker are probably rolling over to think that this once-free amenity is now such a costly excursion for most families.

So what do returning natives want to see? First, I want the age-old experience of riding a streetcar down Market Street to see what is new there—and there is plenty.

Taking the L-Taraval and then switching to the newer F-line at Market and Castro will take you all the way to Fisherman's Wharf—whisking you past trendy new retailers, new apartments and condos on the many corners that were once occupied by gas stations and parking lots, plus providing an up-close look at the pedestrians who make up the city of today. The old Central Freeway from the 1950s is gone,

though the new boulevard on Octavia seemed to be as crowded as 19th Avenue during rush hour.

Once in the downtown area, you will see familiar sights such as the façade of the old Emporium, essentially unchanged since before the earthquake and fire of 1906, but that's where the similarity ends—behind that wall is a dizzying array of eateries, with the refurbished dome now hidden from the street level and placed above an upper floor of the complex. On the opposite side of the street, Woolworth's and its popcorn-candy-pizza aromas are long gone, with a clothing retailer now occupying the space. Across the street at 1 Powell Street, home to Bank of America's day and night branch and its substantial travelers' cheque department, is another ground-floor retailer, with sleek apartments occupying the upper floors where I worked as a claims adjuster back in the 1970s.

As the streetcar ride continues, it's easy to see that the Financial District, once centered on Montgomery Street, has spread its high-rise influence well south of Market and all the way to the waters of the bay. A few years ago, I could still name every skyscraper, but I'd be hard-pressed to do so now—and there are several *dozen* more on the drawing boards for construction later in this decade.

The ride along the Embarcadero still reminds us that this was once a town whose history was based on navigation, but the only clue the day I was there was a sign that a large passenger ship would be arriving the following week. The scenery is much lighter and brighter now that the Embarcadero Freeway is gone—one of the most positive outcomes of the Loma Prieta earthquake more than twenty-five years ago. Many of the old piers have been converted into restaurant or retail outlets, and from Pier 39, all the way through Fisherman's Wharf almost to Van Ness Avenue, is a no-man's land of T-shirt shops, cell phone stores and the same restaurants that might be found in Duluth, Tacoma, Cincinnati or Syracuse. Dear old Sabella's, with fond memories of prom-night dinners and some spectacular wedding receptions, now houses an Applebee's—what can I say?

With my MUNI day pass, I meander around town, silently pleased that so many lines now intersect with others in a way that helps me get to Golden Gate Park and meet a friend in record time. Bypassing the expensive admission to the new de Young Museum, we take an elevator to the rooftop deck for a spectacular 360-degree view of the San Francisco panorama—everything from downtown high-rises to the "timeless twin towers of St. Ignatius" (a Herb Caen phrase) to the park's green swath through the middle of town and some gathering fog all the way out at Ocean Beach.

New (de Young Museum, *left*, built in 2005) meets old (Francis Scott Key monument, *right*, dedicated in 1888) in Golden Gate Park. *Photograph by Alvis Hendley.*

We then take the bus and transfer at Geary for a ride out to the Cliff House for a bite to eat. The new Lands End Visitor Center, now several years old, is a nice contrast to some of the old souvenir shops that once dispensed nothing more than cable car key chains and ceramic ashtrays emblazoned with "Souvenir of San Francisco." I actually find myself doing

The tower of St. Ignatius Church in 1968. The landmark on the city skyline turned one hundred years old in 2014. *Photograph by Keith Forner.*

some holiday shopping there—a great assortment of paperback books on local history, along with educational toys for kids, vintage art posters and the ubiquitous coffee mugs.

Throughout San Francisco's forty-nine square miles, there are hundreds of significant structures, many of them city-designated landmarks, that can make passersby drink in their iconic "only-in-San-Francisco" style. The images in this chapter represent just a few of the places that I see on every single trip "home."

Sutro Tower, constructed in 1972–73, initially faced stiff community opposition. Today it is widely regarded as a civic landmark. *Photograph by P. Eric Dausman.*

As I meander around town on any of my visits, many voices from the past are triggered in my mind by the sight of something familiar along the way. Sometimes it's the one-time home of an old friend or relative, sometimes a repurposed building that once housed a Catholic girls' high school in the 1960s. The ghosts from long-gone businesses still call out, reminders of the times when they were in the forefront of everyone's thoughts. Often, I arrive at my eventual destination still thinking and replaying scenarios from a well-remembered past. The following phrases have resounded with me more than once on my travels:

Nana knew that family from when she went to Presentation.

That man used to work with Grandpa downtown.

I took the streetcar (never "the train" or "the Metro") downtown to meet him for lunch the other day.

She graduated from the old Commerce High School on Van Ness and then walked across the street, got a job at city hall and has been there ever since.

The magnificent Beaux-Arts city hall has been the focal point of the civic center since 1915. *Courtesy of Bigwol.com.*

Daddy always sat with them on Friday nights at temple, and they talked about the old days and the Ukraine Bakery.

We always go to Midnight Mass at St. Ignatius for Christmas and Easter.

They became the next-door neighbors of Grandma's parents right after the Fire.

Your aunt used to date a boy from St. Ignatius.

I miss having a See's Candy store on West Portal (gone since the late 1950s).

Two bits isn't enough for even a few minutes on the parking meter nowadays.

It feels like earthquake weather…

I can still hear calliope music when I drive down Great Highway past the old Playland.

Originally sold only at Playland, where it was invented in 1928, this treat is now widely available in many supermarkets. It is pure pleasure in every bite of rich simplicity—a combination of vanilla ice cream, two oatmeal cookies and chocolate coating. *Author's collection.*

I sure do miss the Star Bakery on Church Street for Irish soda bread.

She lives right down the block from where the Taraval Post Office used to be (moved to new location in 1963).

Now the Cliff House is just full of tourists—we go to Louis's up the street.

On Easter Sunday, we used to go for a walk through the tulip garden at the Dutch Windmill or to the Conservatory of Flowers in the park.

They said the fog should clear to near the coast this afternoon.

The Conservatory of Flowers in Golden Gate Park opened to the public in 1878. *Author's collection.*

Didn't they have a daughter who went to St. Rose (closed in 1990)?

Save those City of Paris and Emporium gift boxes.

We can see the lighted Mount Davidson Cross from our house.

We walked to one of those free concerts at the Conservatory of Music.

We always had Herb's meatball sandwiches on Thursdays.

Someone said they have the recipe for Herman's potato salad.

Really? I have one for the enchilada sauce from the Hot House.

And I have one for Blum's caramel crunch cake.

Let's just go to Joe's of Westlake and have an early dinner.

Mrs. Conroy sent us a loaf of homemade Irish bread for St. Patrick's Day.

Gather up all the leavened items before Passover and we'll send them next door to Mrs. Murphy.

Let's send all these chocolate Easter eggs next door to the Goldmans now that Easter is over.

It's too early to put up the Christmas tree—not until after December 1.

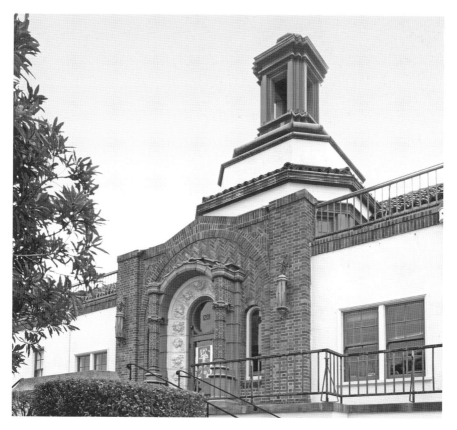

Built before World War II as the San Francisco Infant Shelter, the classic building at 19th Avenue and Moraga Street in the Sunset District later housed the Conservatory of Music for decades. It is now a French-language day school. *Photograph by Alvis Hendley.*

And it stays up until after Epiphany on January 6 (notwithstanding the Catholic Church's revised liturgical calendar).

The wise men cannot be in front of the Nativity scene until January 6.

Now that the children are grown, we celebrate only the first night of Hanukkah.

Any shopping trip downtown in December included looking at the windows of the Emporium, walking through the lighted floral displays inside Podesta-Baldocchi and seeing the tree under the dome at the City of Paris.

Put out the big tablecloth that Grandma bought in the Basement of the Emporium.

We only have a few of Mom's wineglasses from Nathan-Dohrmann left.

Every December, we used to stop at Lindley Meadow in the park and watch the live Nativity scene, and then we'd drive around, looking at the Christmas lights on Sylvan Drive, on 18th Avenue, in St. Francis Wood and along Marina Boulevard.

We know them—they're the cousins of one of Grandma's first cousins on the other side.

Remember how we used to go into the old Hibernia Bank and look up at the stained-glass skylight (building was vacated by the defunct bank in 1985) whenever Grandma went in to cash a check?

We always park in my aunt's driveway on 2nd Avenue whenever we go to a 49er game at Kezar.

Who's going to drive all the way down to Santa Clara to see them play now?

The neighbors were fighting so loudly, you could hear them down at the ferry.

Top: The Hibernia Bank building at 1 Jones Street. The bank ended more than 130 years of operations after being acquired in a 1988 merger, but the grand structure remained, growing derelict over time. It has recently been restored and will soon operate as an event venue. *Photograph by Alvis Hendley.*

Bottom: One of San Francisco's most iconic monuments is the Ferry Building's clock tower, modeled after the Giralda Tower in Seville, Spain. Other than interruptions from an occasional earthquake, the clock has been marking the passage of time for San Franciscans since 1898. *Photograph by Michael Fraley.*

I called to make a reservation for lunch at Caesar's the other day and found out that they went out of business in 2012.

We parked where the El Capitan Theatre used to be when we went to dinner at Bruno's on Mission Street.

We always used to go to four o'clock Mass at St. Edward's on California Street and then out to dinner at the Red Roof down the street (gone since 1998 and 1975, respectively).

She was in the hospital at Presbyterian and then they moved her to Children's and now to Hahnemann for rehab. [Today, all of these hospitals have been merged into a new entity known as California Pacific Medical Center, abbreviated as CPMC.]

I wanted something nice to wear to my daughter's wedding and went to Nordstrom—it was okay, but it's not I. Magnin.

The neighbor's son got caught drinking at the Circle on Saturday night and ended up in Juvi.

Remember when there was a Bufano statue at the entrance to the airport, and everyone used to ask, "What time is blast-off?"

The boys at St. Ignatius (actually coed for more than twenty-five years now) always climb Strawberry Hill to celebrate graduation, but students at Lowell are much more creative—such as the time they planted a full-grown redwood tree on the fifty-yard line of the school's football field.

This thirty-eight-foot-tall granite and stainless-steel sculpture by artist Benny Bufano stood on the main road leading into San Francisco International Airport in the 1950s. It has since been relocated to Brotherhood Way. *Photograph by Michael Fraley.*

I sure do miss the produce and meat departments at Petrini's.

I need to pick up a birthday card and a spool of thread at the dime store.

It always takes two people to buy focaccia at Liguria Bakery in North Beach—one to go in and the other to drive around the block a couple of times.

They had a nice spread at the house after the funeral, including a whole roast turkey sent by the undertaker (Duggan's).

Back in the 1940s, a fun night out was ice skating and hot chocolate at Sutro's.

The longest streetcar ride was the old 40 line from the Ferry Building to the cemeteries in Colma.

The most beautiful streetcar ride was the section of the old 1-California line that ran from 32nd Avenue, along a private right-of-way overlooking the Golden Gate (gone since the tracks washed out back in 1925) to El Camino del Mar and Point Lobos Avenue.

Whenever you were near Herman's Delicatessen on Geary near 7th Avenue, you knew what a delicatessen should smell like.

You could find any kind of food or household item at the Crystal Palace located at 8th and Market (gone since 1959, and so is its replacement, the Del Webb Motor Lodge).

We love MUNI's new senior fare of just a nickel (introduced around 1970 and since raised many times).

Grison's is gone, but at least there is still the House of Prime Rib.

Sometimes we'd just stop in at the de Young Museum to rest after a day in the park—after all, it was free back then.

Juvenile delinquents were always putting dishwashing liquid into public fountains—one of the more serious "crimes" of the 1950s.

Whenever your kids needed a gift for a birthday party, there were three choices: the Emporium's toy department at the back of the fourth floor on Market Street, King Norman's on Clement Street or Toy Village on West Portal Avenue.

We went all out for our daughter's tenth birthday this year—spent almost twenty dollars on the party for a dozen of her little friends.

Everybody went to a place like Sabella's at Fisherman's Wharf for dinner before the junior or senior prom, then to the Tonga Room at the Fairmont afterward and then to Zim's at 19th and Taraval to wrap up the night (or perhaps a stop at the Palace of the Legion of Honor parking lot to "watch the submarine races").

One of these days, we have to visit Mission Dolores, go to the top of Coit Tower and walk across the Golden Gate Bridge.

After three days of a heat wave, our natural air conditioning always kicks in, right on schedule.

Our family will ALWAYS live in San Francisco…

Top: This street fountain at the intersection of St. Francis Boulevard and Santa Ana Way was built as part of the World War I–era residence park known as St. Francis Wood. *Courtesy of a private collector.*

Bottom: Frequently cited as one of the world's most recognizable icons, the Golden Gate Bridge stands tall above the afternoon fog. *Photograph by John A. Martini.*

19

A Timeline of Change

C hange does not take place overnight. In small ways and in large ways, the following dots on the timeline of history have impacted the lives of San Franciscans. Like a tapestry that is woven from thousands of tiny threads, so, too, has the San Francisco of today been formed in countless ways by the history that has preceded us.

A friend once said to me that I was lucky to have had relatives living in San Francisco so long ago. My response was that it was only because life became unbearable in Ireland before it became that bad in many other parts of the world. I have often speculated—out of four sets of my own great-grandparents, are the ones who arrived in 1907 really any different from my other great-grandparents who arrived in 1860, 1875 or in 1890? I think not.

Yet while most change is a gradual thing, sometimes there are a few specific dates that stand out as clear demarcation points when any of us tell stories involving then and now.

By anyone's standards, April 18, 1906, represents a massive turning point in the history of the city of San Francisco, as well as the Bay Area as a region—but there are other watershed events that also marked the beginnings of massive change.

Some longtime residents still remember what they were doing on that ill-fated Sunday morning, December 7, 1941, when their lives and the history of the world began to change forever. Mom always recalled coming home from mass at St. James Church on Guerrero Street to find her parents sitting

at the breakfast table listening intently to the kitchen radio, as her father exclaimed, "My God—Pearl Harbor's been bombed!"

Those of us in younger generations remember where we were and what we were doing on the morning of Friday, November 22, 1963. For this writer, it was sitting in the first row of my sixth grade classroom at St. Cecilia School at 18th and Vicente, working on an addition problem in an arithmetic test. The school's public address system came on, with a garbled radio broadcast that was quickly tuned in. The day went downhill from there, and many of us, as we gather for our fifty-year reunion from elementary school, recall this as a major dividing line between "the good old days" and now.

Early in this millennium, Tuesday, September 11, 2001, became yet another fateful milestone for millions.

Yet, there is another date that marks a stark division in the history of our city—one that has forever separated a beloved past from the stark realities of the present. In my mind, that fateful day occurred fifty-five years ago—Tuesday, November 7, 1961—the day that San Francisco voters went to the polls and overwhelmingly defeated a bond issue, Proposition I, that would have had the city and county acquire ownership of the Market Street land and the magnificent building that housed the Fox Theatre.

Sadly, San Francisco had a poor track record of preserving the past in the 1950s. The Montgomery Block (or Monkey Block in the local parlance) was a large, solid gold rush–era office building in the Financial District that had handily withstood numerous earthquakes, fires and financial panics, only to be torn down in 1959 for a parking lot (the Transamerica Pyramid was built on the site in 1972).

Likewise, magnificent old Victorians had been cleared from the landscape on a wholesale basis during "urban renewal" efforts in post–World War II years. The architectural atrocity of the Embarcadero Freeway was erected in the late 1950s, blocking the cherished image of the Ferry Building—and it took a major earthquake and a vote of the people to get it torn down nearly forty years later. And until the time of the 1950s Freeway Revolt, several neighborhoods were ruined by the demolition of housing for various freeways.

The loss of the Fox Theatre, though, was a sad turning point for the city and its residents. From its opening in June 1929—the absolute heyday of all that was grand and glorious in the film industry—the Fox was San Francisco's largest theatre, with more than 4,600 seats. There were financial difficulties early on, and the movie palace even closed its doors temporarily at the depth of the Great Depression, from the fall of 1932

The Fox was San Francisco's grandest theatre, from its opening in 1929 until the day the wrecking ball struck in 1963. The bland Fox Plaza office-apartment tower has occupied the site since 1965. *Jack Tillmany Collection.*

until the spring of 1933. Business soon rebounded, though, and through the World War II years, movies were the great escape and an affordable luxury for many San Franciscans.

Needing only a simple majority of 50 percent plus 1 vote to pass, the proposition went down to defeat by almost 60 to 40 percent. San Franciscans

were turning their collective backs on a fabled past of glamourous downtown movie theatres in favor of the bland high-rise office/apartment complexes that emerged from the rubble.

More than that vote itself, though, the populace demonstrated that it had somehow bought in to the notion that "bigger is better" and that San Francisco was in some sort of deranged race to transform itself into a West Coast version of New York City. That vote was the final nail in the coffin of the San Francisco that many of us miss and remember so fondly today.

The rise of television in the 1950s began to spell trouble for movie theatres across the nation. In San Francisco, the losses began in the Western Addition and Mission Neighborhoods in the 1950s and then spread to other areas: the State on Mission Street (1950), Midtown on Haight Street (1952), the Noe on 24th Street (1952), the Green Street in North Beach (1955), the New Fillmore (1957) and the American (1959), also on Fillmore Street. The Irving Theatre in the Inner Sunset District was one of the first victims west of Twin Peaks, closing in 1962, a little more than six months after that fateful vote on the Fox, while Mission Street's magnificent El Capitan, closed since 1957, had its interior gutted in 1964 for a parking lot.

Other elements of daily life also began to change drastically at the same time—including the shipping industry along the Embarcadero, manufacturing in the South-of-Market and shipbuilding/maintenance in the Bayview and Hunters Point neighborhoods. These changes wiped out thousands of stable, unionized blue-collar positions that had provided strong economic support to San Franciscans for decades.

San Francisco saw the rise of tourism, convention activities and various forms of shopping. More parking garages were built, and the ghosts of demolished buildings were increasingly paved over with asphalt—ironically, this was the fate that befell the once-grand El Capitan Theatre.

As shipping and manufacturing declined, there was also a declining presence of U.S. military installations all across San Francisco, including the losses of Fort Mason, Hunters Point Naval Shipyard, Presidio of San Francisco and Treasure Island Naval Base. Adjacent cities also saw the closures of Alameda Naval Air Station, Hamilton Field–Novato, Mare Island Naval Shipyard–Vallejo, Moffitt Field–Sunnyvale and Oakland Army Base.

But in February 1963—when the wrecking ball took that first swing at the Fox Theatre—history saw the beginning of the end for the San Francisco that so many of us miss today.

Changing times can confront even modern structures. The Galaxy Theatre was a newer, widescreen multiplex, built in 1984 on Van Ness Avenue. It closed in 2005 and was demolished in 2011 for an apartment tower. *Jack Tillmany Collection.*

San Franciscans woke up to the witty words of columnist Herb Caen in their morning newspapers for nearly sixty years, from 1938 until his death in 1997. *Author's collection.*

Pulitzer Prize–winning columnist Herb Caen, who spent a career writing for the *San Francisco Chronicle*, summed it up best when he said, "I tend to live in the past because most of my life is there."

Many changes, both large and small, take place in our lives every single day. Most are so small that we barely notice. Yet when we review decades of them all at once, we begin to understand how tiny events—in our personal lives and in the life of our hometown—can add up to some very big changes, indeed.

The 1700s

1769 Discovery of San Francisco Bay by the Portolá Expedition, which claimed California for the king of Spain.

1770 Beginning of Russian colonization on the West Coast as far south as present-day Sonoma County.

1776 Founding of the Presidio of San Francisco by the Spanish army and Mission Dolores by Spanish missionaries.

The 1800s

1821 Mexico's independence from Spain shifts control of California to the Mexican government.

1835 Pueblo of Yerba Buena is founded with construction of houses near Portsmouth Plaza.

1845 Beginning of the Great Famine in Ireland, marking the start of massive Irish immigration to America.

1846 Start of Mexican-American War.

1848 Discovery of gold at Sutter's Mill; treaty of Guadalupe Hidalgo ends Mexican-American War, giving ownership of California and other territories to the United States.

1850 California admitted to the Union as the thirty-first state.

1859 Silver discovered in Nevada's Comstock Lode.

1861 Start of the Civil War in the United States.

1865 End of the Civil War; major earthquake strikes the San Francisco Bay Area, causing widespread damage from Santa Cruz to Petaluma.

1868 Second major earthquake in three years, this time centered in Hayward, and also causing widespread damage throughout the Bay Area.

1869 Completion of the transcontinental railroad.

1886 Pine United Methodist Church founded—San Francisco's oldest continuing Methodist congregation—which moved to the Richmond District in 1965.

1894 Midwinter Fair in Golden Gate Park attracts thousands of tourists; construction of St. Paulus Lutheran Church at Gough and Eddy Streets near Jefferson Square, which was a hub of activity for decades until a disastrous fire destroyed the landmark in 1995.

1896 Opening of Sutro Baths on Point Lobos Avenue near the Cliff House.

1898 San Francisco has fewer than a half dozen automobiles, increasing to 25 in 1900, to more than 500 by 1903 and to thousands by the time of the 1906 earthquake/fire. (Today, there are more than 470,000 vehicles registered in San Francisco, plus an additional 35,000 entering during business hours, Monday–Friday.)

THE 1900s

The First Decade

1904 Bank of Italy founded, bringing financial services to the masses.

1906 Great earthquake and fire; St. Paul's Presbyterian Church opens in the Sunset District—a new congregation formed by earthquake refugees.

1907 The most elaborate incarnation of the Cliff House is destroyed by fire; beginning of graft trials that eventually put the mayor and others in jail for bribery.

1909 Portolá Festival celebrates San Francisco's rebirth from disaster of 1906, attracting thousands of tourists.

1910s

1910 Emergence of Van Ness Avenue as San Francisco's "Auto Row."

1913 The last horse-drawn streetcar in regular service runs up Market Street; the *Call* newspaper merges with the *Evening Post* to become the *San Francisco Call & Post*.

1914 Start of World War I in Europe.

1915 Panama-Pacific Exposition in the present-day Marina District attracts thousands of tourists and celebrates opening of the Panama Canal.

1916 Preparedness Day Parade on Market Street, held in anticipation of the United States' entry into World War I, is racked by a suitcase bomb that kills ten and injures forty others; final burial is recorded at Calvary Cemetery at Geary and Masonic, with Holy Cross in Colma, open since 1890, accepting all new Catholic burials.

1917 Congress votes to approve U.S. entry into World War I.

1918 End of World War I; first round of influenza epidemic in the spring spares San Francisco, though in the fall, there are more than 23,000 cases with nearly a 10 percent fatality rate, along with another 5,000 cases in December and more than 3,500 fatalities by year-end.

1920s

1922 Completion of Standard Oil building in downtown San Francisco, leading to decade-long building boom for downtown skyscrapers (Telephone Building, 1925; Russ Building, 1927; Shell Building, 1929; 450 Sutter, 1929; William Taylor Hotel/100 McAllister, 1930; Mills Tower, 1931).

1925 Construction of first homes in the Sunset by Henry Doelger, with prices ranging from $5,000 to $6,000; Temple Emanu-El dedicates its new post-1906 building at Arguello Boulevard and Lake Street.

1929 Start of the Great Depression; the *San Francisco Call & Post* newspaper merges with the *Bulletin* to become the *Call-Bulletin*, leaving the city with only four daily newspapers—*Chronicle* and *Examiner* in the

mornings and *Call-Bulletin* plus *News* in the afternoons—all with slightly different political slants.

1930s

1930 Bank of Italy becomes Bank of America; St. Ignatius College becomes USF.

1931 Removal of bodies from Masonic Cemetery, allowing for expansion of USF.

1932 Fluoridation of drinking water begins in San Francisco's Western Neighborhoods, expanding citywide in 1955.

1933 Removal of bodies from Odd Fellows Cemetery at Geary and Arguello, allowing for commercial development of the area.

1934 General strike begins along San Francisco waterfront.

1935 Beth Sholom, a Conservative Jewish congregation founded in 1904, moves west to 14th Avenue and Clement with construction of a new temple; City College of San Francisco opens as San Francisco Junior College.

1936 Bay Bridge opens.

1937 Golden Gate Bridge opens.

1939 Start of two-year Golden Gate International Exposition on Treasure Island, attracting thousands of tourists.

1940s

1940 Final removal of all bodies from Calvary Cemetery at Geary and Masonic, allowing for commercial development of the area; widening of 19th Avenue approach to Golden Gate Bridge begins.

1941 Start of World War II, with tens of thousands of war workers moving to California; beginning of food/gasoline/supply rationing.

1942 Massive expansion of Hunters Point Naval Shipyard and construction of wartime housing; Executive Order 9066 is put in place, forcing the relocation and incarceration of more than 100,000 Japanese Americans on the West Coast, most of whom are U.S. citizens.

1943 Union Square Garage, built beneath the square with nearly one thousand parking spaces, opens for business.

1944 Opening of Parkmerced garden apartments.

1945 End of World War II; delegates from fifty countries meet in San Francisco to form the United Nations.

1946 San Francisco 49ers win their first All-America Football Conference game against the Chicago Rockets, 34–14, at Kezar Stadium.

1947 Henry Doelger begins construction of homes in suburban Westlake in Daly City; Harold Dobbs and a partner open Mel's Drive-In on South Van Ness Avenue.

1948 Final removal of bodies from Laurel Hill Cemetery, allowing for the commercial development of the area; KPIX goes on the air as Northern California's first television station; ground-breaking for Westlake Shopping Center in Daly City, one of the first malls in the United States, even predating Stonestown.

1949 Opening of Lick Market in the Richmond District, as supermarkets begin replacing small neighborhood grocers; Zim's Hamburgers opens for business; Archbishop Riordan High School opens.

1950s

1950 Construction of Parkmerced tower apartment buildings; construction of Stonestown tower and garden apartments.

1951 Bankruptcy of California Cable Company, leading to eventual ownership by MUNI in 1952, with elimination of several lines by 1954; new Sears Roebuck store, employing fifteen hundred, opens at Geary and Masonic, on the site of the former Calvary Cemetery; Highway 101 freeway opens, linking San Francisco to San Mateo and Santa Clara Counties.

1952 Opening of Stonestown Shopping Center; opening of Mercy High School on 19th Avenue; Broadway Tunnel opens, linking North Beach with Pacific Heights; George Whitney, owner of Playland-at-the-Beach and the Cliff House, buys Sutro Baths.

1953 Relocation of San Francisco State College to 19th Avenue and Holloway; construction of Fireman's Fund Insurance Company (now University of California's Laurel Heights campus) building on former cemetery property; Stanford University votes to move its medical school from San Francisco to Palo Alto.

1954 Major expansion of San Francisco International Airport with new Central Terminal; a thirteen-foot-tall neon-lighted beer glass depicting beer filling and then spilling over the top is installed on

Hamm's Brewery on Bryant Street, remaining in operation until 1974; KQED public broadcasting channel begins operation; Kaiser Foundation Hospital opens on Geary Boulevard; swimming eliminated at Sutro Baths.

1955 New downtown skyscraper building boom commences with completion of Equitable Life Building, followed by Crown Zellerbach Building (1959), Hartford Building (1965), Wells Fargo/44 Montgomery Street Building (1967), Bank of America World Headquarters (1969), Alcoa Building (1970), Embarcadero Center (1971), Hilton Tower (1971), St. Francis Hotel Tower (1971) and the Transamerica Pyramid (1972), continuing until the early 1980s; Crocker First National Bank and Anglo California National Bank announce merger, becoming Crocker-Anglo Bank; Del Martin and Phyllis Lyon found Daughters of Bilitis, the first national lesbian group; George Christopher, first Greek-American and last Republican mayor of San Francisco, is elected; Allen Ginsberg publishes *Howl*, which ushers in the beat generation; beginning of "freeway revolt" in San Francisco's Western Neighborhoods.

1956 Enactment of federal Interstate Highway system; last automobile ferry runs on San Francisco Bay upon completion of Richmond–San Rafael Bridge; last streetcars run along Geary from downtown to Ocean Beach, replaced by diesel buses; first demolition project begins in Western Addition Redevelopment area; George Christopher sworn in as mayor.

1957 National League approves move of Giants baseball team to San Francisco; moderate earthquake, centered near Daly City, strongest since aftershocks of 1906; Soviet Union launches *Sputnik*.

1958 Key System trains end trans-bay service on Bay Bridge; last Southern Pacific passenger ferry between San Francisco and Oakland; Giants baseball team moves from New York to San Francisco.

1959 Seals Stadium demolished; Embarcadero Freeway opens; the *Call-Bulletin* newspaper merges with the *San Francisco News* to form the *News-Call Bulletin*, leaving the city with only three daily newspapers; Bruce Sedley (aka Skipper Sedley as host of KRON's Popeye cartoons and later Sir Sedley on KTVU's the *Three Stooges*) introduces "Trunkey Zoo Key" for talking storybooks at Children's Fairyland in Oakland and at San Francisco's Fleishhacker Zoo.

1960s

1960 Candlestick Park opens; Bank of America opens massive "computer center" at 1 South Van Ness and Market to provide technological support for its new BankAmericard credit card.

1961 USF goes coeducational; construction begins in Diamond Heights Redevelopment area; San Mateo County Board of Supervisors votes to withdraw from BART planning; Father Peyton's Rosary Crusade in Golden Gate Park draws a crowd of 500,000 in San Francisco's largest-ever planned event.

1962 Rare snowfall in San Francisco; Marin County withdraws from BART planning; Relocation of Lowell High School to Eucalyptus Drive; St. Mary's Cathedral destroyed by fire; BART bonds approved by voters in San Francisco, Alameda and Contra Costa Counties; Irving Theatre closed and demolished, replaced with apartments; San Francisco Giants lose to New York Yankees in seventh game of World Series.

1963 Fox Theatre demolished; Alcatraz Prison closes; Crocker-Anglo Bank merges with Los Angeles–based Citizens National Bank to form Crocker-Citizens Bank.

1964 Temple Judea opens on Brotherhood Way, the first new Reform synagogue built in San Francisco in nearly 125 years; Holy Trinity Greek Orthodox Church opens on Brotherhood Way; construction of new Holy Name Church at 40th Avenue and Lawton Street (affectionately referred to as the "circus tent"), the first San Francisco Catholic church built to the new standards adopted by the Second Vatican Council of the 1960s.

1965 Another major expansion of SFO, including a massive parking structure; the White House, a San Francisco department store since 1854, goes out of business; dedication of Holy Virgin Russian Orthodox Cathedral on Geary Boulevard at 26th Avenue; bribery scandal involving long-serving city assessor Russell Wolden, who allegedly received kickbacks for under-assessing commercial properties, dominates the news; afternoon newspaper *News-Call Bulletin* goes out of business; morning newspaper the *Examiner* becomes an afternoon paper and signs a joint operating agreement with the *Chronicle*, leaving the city with only two daily newspapers— one morning and one afternoon; Mary's Help Hospital, operating in the Mission District since 1893, relocates to a new facility in Day City, later changing its name to Seton Medical Center.

1966 Sutro Baths closes and is destroyed by fire; Lowell High School becomes the city's academic college prep school, with a GPA/test-based admission policy.

1967 Summer of Love in the Haight-Ashbury marks beginnings of social change in San Francisco; Security First National Bank merges with Pacific National Bank to form Security-Pacific Bank; Golden Gate Park begins program of vehicle-free portions of certain roadways on Sunday afternoons.

1968 St. Ignatius annual tuition increases from $300 to $400, a 33 percent increase; first killing by "Zodiac," which continued through 1969— officially still unsolved; Mayor Alioto hosts one of the largest-ever predawn celebrations of the anniversary of the 1906 earthquake, with the film *San Francisco* displayed on a giant screen in front of city hall; KBHK-TV begins broadcasting on UHF Channel 44 in San Francisco, opening the way for additional programming.

1969 San Francisco College for Women goes coeducational and is renamed Lone Mountain College; relocation of St. Ignatius College Prep to 37th Avenue; Native American occupation of Alcatraz Island; Beth Israel, a Conservative Jewish congregation, merges with Reform Temple Judea, moving from Geary and Fillmore to Brotherhood Way; basic MUNI adult fare of $0.15, in place since 1961, increases to $0.20, a 33 percent increase—it is now $2.25, a 1,400 percent increase over 1969, or an average of 31 percent per year up to 2014. The fare for cable cars, $0.15 in 1969, is now $6.00—a 3,900 percent increase, or an average 86 percent increase per year from 1969 to 2014.

1970s

1970 San Francisco Zoo initiates admission fee; University of California Regents implement tuition schedule; a horrendous two-car crash on Doyle Drive approach to Golden Gate Bridge leaves ten dead, two seriously injured—mostly teens from the Western Neighborhoods— and leads to calls for construction of safer roadway (on which construction would finally begin a mere thirty-nine years later—in late 2009).

1971 Fleishhacker Pool closes; completion of Interstate 280 between San Francisco and San Jose; the start of busing in the San Francisco

Unified School District; JCPenney store at 5th and Market Streets closes, as the company ceases to do business in San Francisco; San Francisco's largest parade ever, a peace march protesting the war in Vietnam, consisting of 156,000 people, marches from Civic Center out Geary Boulevard to the polo field in Golden Gate Park.

1972 BART begins revenue service; City of Paris goes out of business; Playland closes; voters approve creation of Golden Gate National Recreation Area; Polytechnic High School closes; Sutro Tower begins broadcast transmission from atop Mount Sutro; the last Foster's Cafeteria in San Francisco, part of a chain once numbering two dozen local outlets, goes out of business; Board of Supervisors passes ban on smoking in department stores.

1973 First of twenty-two "Zebra" murders that continue for six months. Suspects were convicted and sentenced to life imprisonment in 1976 in the then-longest criminal trial in California history; McAteer High School opens as replacement for Polytechnic; government closure of the Hunters Point Naval base, with origins dating back to a commercial shipyard founded at the site in 1870.

1974 Liberty House opens a new store at Stockton and O'Farrell, on a portion of the site once occupied by City of Paris.

1975 Assassination attempt is made against President Gerald Ford outside St. Francis Hotel in San Francisco, seventeen days after another unsuccessful attempt on his life in Sacramento; Blum's, a candy and confection maker since the 1870s, with a chain of retail shops and restaurants, goes out of business.

1976 Rare snowfall in San Francisco; Parkside Theatre, built on Taraval Street in 1928, closes and is replaced by a daycare/preschool; Embarcadero Station opens, serving both BART and MUNI, as the system's first additional station since BART service began in 1972.

1977 Golden Dragon massacre in Chinatown, resulting in five deaths and eleven injuries; El Rey Theatre on Ocean Avenue closes and the building is taken over by Voice of Pentecost Church; Harvey Milk elected to the Board of Supervisors as first openly gay member; Bank of America builds a massive data center at 1455 Market Street, replacing various electronics and surplus stores that went out of business.

1978 People's Temple Massacre in Guyana; city hall murders; passage of Proposition 13 to control property tax increases; Lone Mountain College closes, with property acquired by nearby Jesuit-run University of San Francisco and thereafter known as the Lone Mountain Campus of USF.

1979 White-Night Riots; implementation of residential rent control; resales of one-thousand-square-foot homes in the Western Neighborhoods break the $100,000 price point consistently; Carnaval San Francisco debuts in the Mission District.

1980s

1980 MUNI Metro subway opens; first documented AIDS case in San Francisco, resulting in the deaths of more than twenty thousand San Franciscans over the next three decades.

1981 Opening of Moscone Convention Center; British-based Midlands Bank purchases the institution then known as Crocker Bank; Bernstein's Fish Grotto, a Powell Street seafood restaurant with a ship's prow as its façade since 1912, goes out of business; Neiman-Marcus constructs new postmodern building at Stockton and Geary on the site of the old City of Paris, with the old store's stained-glass dome incorporated into the new store's design.

1982 San Francisco 49ers win Super Bowl XVI in January; cable car system shuts down for two years for a major rebuilding of the system and vintage streetcars are returned to Market Street the following year as a substitute for tourists in a "Trolley Festival."

1983 Bank of America expands outside California with acquisition of Seattle First National Bank (Seafirst).

1984 Democratic National Convention is held at Moscone Center; Joseph Magnin goes out of business; Grison's restaurant, located at Van Ness and Pacific since 1936, goes out of business; Liberty House goes out of business.

1985 Mortuary Carew and English, in business since the late 1800s, merges with Halsted-N. Gray, a firm that traces its origins to the gold rush; 49ers win Super Bowl XIX in January.

1986 Star of the Sea Academy closes; Wells Fargo takes over Crocker Bank; the original outdoor Stonestown Mall is rebuilt and expanded as enclosed "Stonestown Galleria"; old SI on Stanyan Street—USF's Loyola Hall since 1969—is demolished for USF's Koret Health and Recreation Center.

1987 Bank of America suffers huge overseas loan losses, eliminates dividend, sells headquarters building, closes nearly two hundred branches, lays off employees for the first time in its eighty-three-year

history and fires President Sam Armacost; Livingston Brothers, a high-end women's clothing store operating in San Francisco since 1876, goes out of business; fiftieth anniversary celebration of the Golden Gate Bridge draws a crowd of 300,000 onto the span, causing it to sag noticeably for several hours under the weight.

1988 Hibernia Bank closes, with customer accounts merged into Security-Pacific National Bank, and while the 1892 building at 1 Jones Street at Market is used temporarily as a police department substation, it remains essentially boarded up for the next twenty-five-plus years until it reopens as an event venue in 2016.

1989 Loma Prieta earthquake; St. Ignatius College Prep goes coeducational; Petrini's, an upscale San Francisco–based grocery chain with anchor stores at Fulton and Masonic and in the Stonestown Shopping Center on 19th Avenue, goes out of business; 49ers win Super Bowl XXIII in January.

1990s

1990 St. Rose Academy closes; Sears Roebuck store at Geary and Masonic closes and company ceases to do business in San Francisco; 49ers win Super Bowl XXIV in January.

1991 Presentation High School closes, property acquired by USF; Embarcadero Freeway demolished; Roos-Atkins, high-end men's clothing store that began operating in 1865, goes out of business.

1992 First major expansion of Moscone Center; Security Pacific National Bank is taken over by Bank of America.

1994 I. Magnin goes out of business.

1995 The Emporium goes out of business; Zim's goes out of business; 49ers win Super Bowl XXIX in January; F-Market streetcar line commences revenue service between Castro Street and the Embarcadero, using a fleet of restored vintage cars.

1996 New Main Library opens in Civic Center.

1997 Herb Caen dies; British Crown Colony of Hong Kong is returned to China, with increasing immigration to the United States; Woolworth's goes out of business.

1998 Bank of America is acquired by North Carolina National Bank, which takes the B of A name and moves the new firm's headquarters to Charlotte, North Carolina; Board of Supervisors creates three-

hundred-acre Mission Bay Redevelopment project on old railroad property adjacent to downtown; Wells Fargo acquires Minneapolis-based Norwest Bank.

1999 Beginning of dot-com bubble; end of previous building restrictions on skyscrapers in downtown area and start of new downtown building boom that will span the next fifteen-plus years.

THE NEW MILLENNIUM

2000s

2000 SFO's International Terminal, costing $1 billion, opens for business; *San Francisco Chronicle* sold to Hearst Corporation, becoming San Francisco's only remaining daily broadsheet newspaper, with the *Examiner* being sold and converted to a free six-day-per-week tabloid; F-line streetcar terminal extended to Fisherman's Wharf area.

2001 End of original dot-com bubble; Giants baseball games move to new SBC (later, PacBell and now AT&T) Park.

2002 McAteer High School closes, replaced by Ruth Asawa School of the Arts at the McAteer campus.

2003 Second major expansion of Moscone Center; BART extension to SFO begins revenue service; Asian Art Museum opens in old Main Library building in the civic center.

2004 Joanne Hayes-White becomes first female chief of a major city fire department, and Heather Fong becomes first female chief of a major city police department. Both women are San Francisco natives who attended school in the Western Neighborhoods; Mayor Gavin Newsom authorizes issuance of marriage licenses to same-sex couples.

2005 New de Young Museum opens in Golden Gate Park; San Francisco State University expands, as it acquires several blocks of the Parkmerced apartment complex and all of the nearby Stonestown apartments, renaming the areas University Park–South and University Park–North; Coronet Theatre on Geary Boulevard, built in 1949, is closed, demolished and replaced by a senior housing complex; the Museum of the African Diaspora opens its doors near the Moscone Convention Center.

2006 Western Neighborhoods Project commemorates the events of 1906 by restoring one of the 5,610 earthquake shacks built to house refugees from the disaster, putting the structure on permanent display at the San Francisco Zoo's Conservation Corner.

2007 T–Third Street MUNI streetcar line begins revenue operations; Mayor Gavin Newsom is reelected mayor that fall with nearly 74 percent of the votes cast.

2008 New California Academy of Sciences opens in Golden Gate Park; Wells Fargo acquires Charlotte-based Wachovia, thus becoming one of the country's "Big 4" banks; Contemporary Jewish Museum moves into the restored Jessie Street Power Substation, a classic 1907 brick building adjacent to St. Patrick's Church on Mission Street; Congregation Beth Sholom builds new ultra-modern synagogue at 14th Avenue and Clement; Ellis Brooks Chevrolet closes its new car showroom on Van Ness Avenue after seventy years in business, leaving only nearby Ford-Lincoln-Mercury as the last San Francisco dealership selling new American-made vehicles.

2009 Reconstruction of the Doyle Drive approach to the Golden Gate Bridge, as a series of tunnels and parkway, commences in December.

2010s

2010 San Francisco population hits a record high of 805,235 residents, but that is only 10 percent of the total Bay Area populations of 8-plus million people; ground-breaking for MUNI's new $1.5 billion Central Subway, a nine-year project that will link Mission Bay to Chinatown, via the existing T–Third Street line with stops at 4th and Brannan, then Moscone Center, then Union Square/Market Street and then on to Stockton and Washington Streets in Chinatown; Giants win their first World Series title since moving to San Francisco in 1958.

2011 Archbishop Riordan High School institutes boarding program for students from overseas; the Ford-Lincoln-Mercury auto dealership on Van Ness Avenue goes out of business, leaving nowhere in San Francisco to buy a new American-made automobile; San Francisco officially has more dogs (120,000) than children (107,000); Doyle Drive rebuilding project begins.

2012 Giants win second World Series title; Caesar's, a North Beach Italian restaurant since 1956, goes out of business; San Francisco joins six other of the country's fifteen largest cities with "minority-majority" populations, including Houston, Los Angeles, New York, San Antonio, San Diego and San Jose; *U.S. News & World Report* indicates that among San Francisco's public high schools, only Lowell has a student pass rate of greater than 50 percent (87.7 percent pass rate for Lowell) in advanced placement courses, a determinant of college-readiness; century-old Chinatown restaurant Sam Wo goes out of business.

2013 Vivian Brown, elder sibling of the famous "San Francisco Twins," dies at eighty-five; the new eastern span of Bay Bridge opens to traffic; Internet company Yelp becomes the primary tenant in the high-rise located at 140 New Montgomery Street, built in 1925 as headquarters for AT&T and popularly known for nearly ninety years as "the telephone company building," which had been sitting vacant for nearly six years; the firm of Freed, Teller & Freed, coffee and tea merchants since 1899, goes out of business.

2014 Marian Brown, younger sibling of the famous "San Francisco Twins," dies at eighty-seven; popular Joe's of Westlake restaurant closes for "remodeling"; Candlestick Park closes and 49er football games move to new Levi's Stadium in Santa Clara; median price (half cost more and half cost less) of San Francisco homes breaks the $1 million price point; the Giants win third World Series title.

2015 Roberts-at-the-Beach Motel closes and is demolished for a new condo-retail complex at Sloat Boulevard and Great Highway, the 1955 motel structure being the last element in a real estate empire owned by "Shorty" Roberts, who began his business in 1897 with a roadhouse known as the Sea Breeze (later, Roberts-at-the-Beach and, under new owners in the 1960s, music venue Donovan's Reef) on Great Highway and Rivera; massive Doyle Drive construction project on the approach to the Golden Gate Bridge is completed nearly forty-five years to the day after the city's most deadly traffic accident on the old approach; demolition work completed on Candlestick Park; MUNI begins weekend revenue service on the new E-Embarcadero streetcar line, featuring a direct route from AT&T Park to Fisherman's Wharf; Sam Wo restaurant reopens in a new location.

2016 St. Mary's Chinese School announces closure—yet another in a long line of Catholic elementary schools to close in recent years, including St. Elizabeth, Corpus Christi, St. Paul, St. Paul of the Shipwreck, All Hallows, Sacred Heart and St. Dominic, with St. Anthony remaining open following a merger with Immaculate Conception; Joe's of Westlake reemerges from a remodel with the new name "Original Joe's–Westlake" to rave reviews as former patrons continue to use the old familiar name; BART acknowledges that much of the system "has reached the end of its useful life," with passenger loads far exceeding planned system capacity.

20
WHATEVER HAPPENED TO...?

W henever San Francisco natives and expatriates gather today, the inevitable question will arise, "Whatever happened to...?" the many restaurants, bakeries, theatres, retail stores and more that we once knew and loved so well. These were the businesses that drew their customers from across the boundaries of their local neighborhoods, and we thought that they would be with us forever. As the saying goes, nothing is certain but death and taxes. Here are some of the places that we flocked to in days gone by:

ADELINE BAKERY. From one shop on West Portal Avenue to a citywide chain supplying morning coffee, pastry, doughnuts and more, the last of them closed early in the new millennium.

AHERN BROTHERS BAKERY. Located on Van Ness Avenue at Jackson from 1938 to 1990, it was everyone's favorite place for a wide variety of freshly baked pies and other treats. I spent many a Thanksgiving morning in line there, picking up dessert for our family's celebrations.

ALEXANDRIA THEATRE. With an Egyptian motif, it anchored the corner of 18th Avenue and Geary beginning in 1923. It was remodeled to Moderne style in 1941, converted to three screens in 1976 and closed in 2004. The property remained vacant for a full decade until it was sold in 2014, and there are now ongoing discussions of possible future uses.

ALHAMBRA THEATRE. The classic Moorish towers have marked this spot in the Polk Gulch business district since 1926. The theatre was converted to

twin screens in 1976, back to a single screen in 1988 and then closed in 1998. It is now a fitness club that still shows movies on the big screen.

ALIOTO'S. Classic Fisherman's Wharf restaurant since 1925 continues to turn out spectacular meals under the leadership of the fourth generation.

ALL STAR DONUTS. This tiny bakery with the big neon sign operated on Chestnut Street in the Marina District for nearly thirty years, from the mid-1980s until 2014, opening early enough each morning to pull in a clientele from all over town.

AMAZON THEATRE. Opened on Geneva Avenue in 1928, it operated until 1969, when it became the Apollo Theatre, and later began showing Filipino films until it closed in 1980. The building remained vacant for some time and has since been converted to a Walgreen's drugstore.

AMERICAN CAN COMPANY. A business that once employed thousands of San Franciscans in manufacturing jobs in a plant at 3^{rd} and 20^{th} Streets, the space now houses office condos.

ANNA'S DANISH COOKIES. A holiday favorite with many San Franciscans since the shop opened on 18^{th} Street between Valencia and Guerrero in 1935. New owners moved the operation to San Mateo in 2003, but the quality is still excellent.

AVENUE THEATRE. Located on San Bruno Avenue between Felton and Paul Avenues in the Portola District, the theatre had a loyal following, particularly during the war years. Succumbing to the expansion of television, a new owner converted it to silent films in the 1960s. Closed as a theatre in 1984, the building now houses a church.

BAGDAD BOWL. Moving from its pre–World War II location at Ellis and Fillmore to 26^{th} Avenue and Noriega in the Sunset District in the late 1940s, it survived longer than many other similar locales but was demolished for a financial services office in 1980.

BANK OF AMERICA. Founded in San Francisco by A.P. Giannini in 1904 and the salvation of many small customers after the 1906 disaster, when money was loaned with little more than a handshake. Many branches remain, but a 1998 merger with North Carolina National Bank saw the closure of many branches with the corporate headquarters moving away to Charlotte, North Carolina—thus eliminating the bank's offices in many iconic buildings, including 550 Montgomery Street, 1 Powell Street, 1 South Van Ness Avenue, 55 Hawthorne Street, 400 Castro, 785 Market, 1455 Market Street and a much-diminished presence at the 555 California Street tower once known as "World Headquarters."

BARONIAL BAKERY. Classic Taraval Street bakery operated for decades by Willie and Wilma Nabbefeld. Following the couple's 1971 retirement,

the shop and its equipment were sold to a new owner, who continued the business for only a short time. A Chinese restaurant now occupies the spot.

BERNSTEIN'S FISH GROTTO. Popular Powell Street restaurant that operated from 1912 to 1981, with the façade of an old sailing ship. Today, a retail store with a bland façade occupies the site.

BLUM'S CANDIES. The firm began making candies at Polk and Sutter Streets in the late 1800s and expanded into a popular chain with stores around San Francisco for decades, including Polk Street, Union Square, Stonestown and other locations, most of which included in-store dining on lunch items and baked goods Their coffee crunch cake still has legions of devoted followers, even though the chain folded in the 1970s.

BRIDGE THEATRE. Opened in the late 1930s with a reference to the nearby Golden Gate Bridge, in later years, it became a spot for international films. It closed in 2014 and became a training facility for San Francisco Baseball Academy.

BRUCE BARY. Iconic prep clothing shop for men and boys that was operated by Willard Segal from the 1950s to the early 1980s, with locations in Stonestown and also near the University of California in Berkeley. Changing times and fashions brought about its closure.

CADILLAC BAR & GRILL. From its beginnings on tiny Holland Court, near 4th and Folsom Streets, in 1982, the concept grew into a well-loved lunchtime and after-work spot. Expansion of the Moscone Convention Center brought about its closure in 1999, though the founder reestablished the business in 2015 at the Twitter Building (formerly Western Furniture Exchange and Merchandise Mart) at 9th and Market Streets.

CAESAR'S ITALIAN RESTAURANT. Opening in 1956 at Bay and Powell Streets in North Beach, there was seldom a quiet day for this restaurant. Changing tastes and a gradual departure of loyal customers from the city—"People who would come in every day for lunch now come in once a month"—brought about its closure in August 2012, and the site remains vacant today.

CANDLESTICK COVE. Small neighborhood apartments and a shopping district constructed during World War II for employees of the nearby shipyards. The area survived until the 1950s, when it was demolished for construction of the new Candlestick Park on nearby landfill. With the park's 2015 demolition, the old neighborhood name is being resurrected by a new housing community in the area.

CANDLESTICK PARK. Opened in April 1960 to mark the San Francisco arrival of the Giants baseball team two years earlier, the new stadium had difficulties early on with weather. Suffering by comparison to other

major-league stadiums, the Giants left after 1999 for improved facilities at SBC Park—later, PacBell Park and now, AT&T Park. The final concert, including an appearance by former Beatle Paul McCartney, took place in 2014, and demolition soon began, with new housing and retail planned for the site.

Carew & English Funeral Directors. An old San Francisco firm that predated the Fire, the firm was located for most of the twentieth century at Masonic and Golden Gate Avenues. It merged with Halsted–N. Gray (also with roots in nineteenth-century San Francisco) in 1989.

Carl's Bakery. Opened at 18th and Guerrero Streets in the Mission District in 1950 by Carl and Mabel Reichmann, Carl's quickly became a citywide destination, especially for cakes. After many years, Mr. and Mrs. Reichmann retired and sold the business to Dick Amondoli, who ran it until 1991, when he sold it to Charles Walter and Roman Michno. The final set of owners supplied breads, pastries and other baked good to appreciative customers until 1998. By then, the triple threat of fewer customers, rising rent and competition from supermarket bakeries brought about the closure of a beloved institution.

Chevy's Mexican Restaurant. Founded in 1981 by San Francisco financier Warren Simmons, the chain grew to thirty-seven locations in California. In 1993, the restaurants were sold to PepsiCo subsidiary Taco Bell, and when PepsiCo decided to exit the restaurant business in 1997, the firm was again sold. The new owners eventually closed several locations, including the popular branch at Stonestown Galleria.

Coca-Cola Bottling Plant. Located at 1500 Mission Street near South Van Ness Avenue, the building was originally constructed for an auto dealer in 1925 and was acquired by Cola-Cola and then remodeled into a Streamline Moderne style in 1941. The company employed hundreds of workers to run the production line, which was visible through the large plate-glass windows to passersby for more than forty years. The property was then owned by Goodwill Industries, which sold it in 2014 for well over $50 million to a high-rise housing developer.

Coliseum Theatre. Opened in November 1918 at 9th Avenue and Clement Street, the location was one of the city's largest neighborhood movie houses, with more than two thousand seats. The 1989 Loma Prieta earthquake severely damaged the building, and it sat vacant for years until it was renovated into housing units with ground-floor retail early in the new millennium.

CORONET THEATRE. One of San Francisco's newer theatres, the Coronet opened in 1949 as a second-run neighborhood house but was later converted to first-run with reserved seating. It hosted such blockbusters as *Oklahoma!*, *Around the World in 80 Days*, *Ben-Hur* and *Funny Girl*. For many San Franciscans who grew up in the 1970s and 1980s, it will always be remembered as the home to *Star Wars*—complete with lines of fans camping out on the sidewalk.

CROCKER BANK. An old-time San Francisco bank with ties to Charles Crocker, one of the "Big Four" of transcontinental railroad fame. By the early 1960s, it was known as Crocker-Anglo, and then after a merger with Los Angeles–based Citizens National Bank, it became Crocker-Citizens. By the early 1970s, it had become known as the "Crocker Bank" with the iconic theme song "We've Only Just Begun." It was eventually acquired by British-based Midland Bank in 1981 and then by Wells Fargo in 1986. The final tie to the past is the Wells Fargo branch at 1 Montgomery Street, known as the Crocker Office branch.

CROWN ZELLERBACH. The Zellerbach Company was established in San Francisco in 1870. In 1928, it merged with Crown Willamette Paper to become Crown Zellerbach, and the new firm continued to grow for most of the twentieth century. In 1959, the firm built one of San Francisco's largest post–World War II office buildings, a twenty-story modern high-rise with a ground-level plaza surrounding it—a new architectural innovation for San Francisco. The firm continued in business until December 1985, when it was announced that it would be split up and sold in a hostile takeover.

DAGO MARY'S. Located at the corner of Donahue Street and Hudson Avenue just inside the entrance gate to the Hunters Point Naval Shipyard, this popular restaurant managed to survive long after the shipyard was closed. Drawing a faithful clientele, including many from city hall for leisurely Friday lunches, the place finally bit the dust in 2007, a full decade after the surrounding area was earmarked for new home construction.

DANCE YOUR ASS OFF!. A well-known Columbus Avenue dance venue in the mid-1970s, the location was memorialized in the Armistead Maupin series "Tales of the City." The crowd was so enthusiastic in various dance moves that broken legs and arms were a fairly frequent outcome on a lively Friday or Saturday night. The dance vibes died down decades ago, and many of the regulars are now Social Security recipients.

DAVID'S DELI. A classic Jewish delicatessen continuously operating on Geary near the city's live theatres since the time Ike was in the White House.

DOGGIE DINER. A Bay Area–based fast-food chain that operated from 1948 to 1986, specializing in hot dogs and fries. So beloved was the iconic image of a seven-foot-tall dachshund head with large eyes, towering over each of the outlets, that one sign was restored, placed in the center median of Sloat Boulevard near the San Francisco Zoo and declared a city landmark in 2006.

EARTHQUAKE SURVIVORS. The last known survivor of the 1906 earthquake and fire, William Del Monte, died in January 2016, just days prior to his 110th birthday.

EL CAPITAN THEATRE. Built in 1928, "The Cap" was one of San Francisco's largest theatres, with elaborate neon signage spelling out the name in bright colors, lighting up one by one. It suffered the usual fate of declining attendance in the the 1950s and closed in 1957. In 1961, the auditorium itself was demolished for a parking lot, but the intricate Spanish Colonial Revival façade facing Mission Street was preserved, though the glow of all that neon is long gone.

ELEPHANT WALK. In 1974, an old pharmacy at 500 Castro Street became the Elephant Walk Bar and Restaurant near Harvey Milk's original camera store. An instant hit, it became the scene of a violent confrontation on the night of May 21, 1979, following the verdict in the city hall killings. The location continued to draw steady crowds until a fire in 1988. Four years later, the building owner reopened the bar as Harvey's.

EL REY THEATRE. Opened in 1931 and surrounded by homes and easy MUNI access, the location thrived for years. However, by 1977, crowds had declined considerably, and it was closed as a movie house. The location soon became the Voice of Pentecost Church, but in 2016, it was announced that the congregation had defaulted on mortgage payments, and the building was sold at auction to a group of investors for just over $1 million—about the price of a nearby single-family home. The future of this neighborhood anchor remains unclear.

EMPORIUM. The once-great department store, located at 835 Market Street, opened for business in 1896, selling everything "from a needle to an anchor." Generations of San Franciscans recall its heyday in the era before branch outlets opened in suburban shopping malls in the 1950s. The store had the city's best Santa, a massive toy department at the back of the fourth floor and a Christmastime attraction known as "Roof Rides"— carnival-style entertainment on the roof of both the downtown and the Stonestown stores. The place vanished into the mists with other long-gone retailers in 1995.

FILLMORE AUDITORIUM. Built in 1912 at the southwest corner of Geary and Fillmore, the Majestic Dance Hall operated as a neighborhood spot for years. Renamed the Fillmore Auditorium in 1954, the site became known as the home of San Francisco rock music under Bill Graham from 1965 to 1968. Owing to encroaching neighborhood demolitions by the San Francisco Redevelopment Agency, Graham relocated his site to Market and South Van Ness, calling the new location Fillmore West. In 1994, the original Fillmore reopened as a music venue.

FLEISHHACKER POOL. A civic improvement donated to the people of San Francisco in 1925 by banker-philanthropist Hubert Fleishhacker. With a capacity of 6.5 million gallons of heated seawater, it was one of the largest outdoor pools in the world—so big that lifeguards patrolled in rowboats! Sadly, other entertainment destinations came along in the post–World War II era, and the city began neglecting maintenance, citing rising costs and declining attendance. After a January 1971 storm damaged pool equipment, it was converted to a freshwater pool for its final year but was closed that fall. The space remained vacant for years, until ownership was granted to the San Francisco Zoo in 1999. The old pool was filled with rock and gravel and paved over for a parking lot. The pool house, once filled with dressing rooms and laundry operations, became an encampment for the homeless until it was destroyed by fire on December 1, 2012. The burned-out shell was demolished, but the ornate arched entrance was saved and is slated to be preserved.

FOX THEATRE. San Francisco's grand movie palace was built on Market Street near the civic center in 1929, just as the "talkies" were sweeping the country. The Fox was the epitome of class and style, a place to get "dressed up" when visiting. Although the place had a tough time in the depths of the Great Depression, closing for a few months in the early years, it came back magnificently later in the 1930s and was a treasured part of the city scene through the late 1950s. Changing tastes and the influx of television started signaling financial troubles. In November 1961, San Francisco voters went to the polls and overwhelmingly rejected a ballot measure that would have had the city take over ownership and management of the site as a convention and an entertainment venue. At that point, the writing was literally on the wall, and the beloved icon met the wrecking ball early in 1963, just as San Franciscans were beginning to understand how the past was slipping away slowly but surely.

FRANCISCAN HOBBIES. Established on Ocean Avenue in the Ingleside just after World War II, it served the needs of model railroad enthusiasts, airplanes, battleships, racecars, action figures and everything else that is

manufactured for collectors. The business was done in by changing times and tastes and the rise of the Internet, which makes finding obscure items much easier than visiting store after store. It was a good sixty-eight-year run for the owners and their loyal customers.

GALAXY THEATRE. One of San Francisco's newer movie houses, a four-plex costing $7 million, built on Van Ness Avenue in 1984 but closed in 2005 and demolished in 2011.

GATEWAY CINEMA. From 1967 to 1998, the Golden Gateway development was home to a small theatre that showcased art, independent, classic and foreign films—always with an April program featuring the 1936 film *San Francisco*. Today, it is home to live performances.

GENEVA DRIVE-IN THEATRE. Operating from 1950 just "over the line" in Daly City, the site was closed and demolished in the late 1990s.

GETs DISCOUNT STORE. "Government Employees Together" was a membership store open to city, state and federal employees that began in the 1950s in the Lakeshore Plaza Shopping Center on Sloat Boulevard. Long gone.

GHIRARDELLI SQUARE. Reconverted factories formed the nucleus of a popular San Francisco attraction beginning in the early 1960s. With many renovations over the years, the site now includes a private residence club.

GILLON LUMBER COMPANY. One of the longest-surviving businesses in the Richmond District, operating at 4th Avenue and Geary, under a handful of different owners, from 1896 to 2002. Competition from "big box" building supply companies spelled the end for this neighborhood merchant.

GINO'S. A small Financial District restaurant once located at the site of today's Transamerica Pyramid. Relocated to 7 Spring Street, a small lane off the 500 block of California Street and opposite the Bank of America building, the warm, club-like atmosphere catered to locals for decades. Sadly, it is now gone.

GOODMAN LUMBER COMPANY. A 100,000-square-foot facility operated on Bayshore Boulevard for a half century but closed in 2000. Controversy over the site raged for a decade, and plans for a Home Depot outlet fell through. In 2010, a Lowe's Home Improvement opened at the site.

GRANADA THEATRE. Operated on Mission Street in the Excelsior District from 1921 until 1982. It later became a video rental store and then a Goodwill store.

GRISON'S. Twin restaurants at Van Ness and Pacific operated by Swiss-born Bob Grison from the 1930s until the 1970s. Today, the nearby House of Prime Rib offers similar food and atmosphere.

GRODINS. Upscale chain of clothing stores in operation from 1955 to 1986.

HALE BROTHER DEPARTMENT STORE. San Francisco–based retail chain that began expanding with branch stores in 1906—including Hale's Mission Store and another in Oakland. Long gone.

HANG AH TEA ROOM. Small Chinatown restaurant that began introducing dim sum to western palates as far back as 1920.

HERMAN'S DELICATESSEN. Classic old-time delicatessen that operated on Geary near 7th Avenue from the 1940s until the 1980s. To this day, when San Franciscans hear the words "potato salad," they think of Herman's.

HIBERNIA BANK. Founded in San Francisco in 1859 and catering to the once-large Irish-American population, the firm was acquired by Security-Pacific Bank in 1988. The Sunset Branch at 22nd Avenue and Noriega will forever be remembered as the site of a 1974 robbery by Patty Hearst and the Symbionese Liberation Army (SLA).

HIPPOPOTAMUS RESTAURANT. Opened by entrepreneur Jack Falvey on Van Ness Avenue in 1950, complete with whimsical hippo characters on the walls, this place was the height of ground beef gourmet (anyone remember the hamburger sundae?) until its closing in 1997.

H. LIEBES. Independent San Francisco–based women's clothing retail store that was in operation from the 1860s until the 1970s.

I. MAGNIN. Old-line San Francisco clothing chain founded by Mary Ann Magnin. Located on Geary, the firm moved a block west after World War II to a classically remodeled, white marble building overlooking Union Square. It was the epitome of gracious elegance until its demise in 1994.

IRVING THEATRE. Opened in 1926 on Irving Street in the Inner Sunset, it was closed and demolished in 1962—one of the early casualties among neighborhood movie houses.

JACK TAR HOTEL. Opened in 1960 at Van Ness and Geary as an ultramodern hotel where guests were able to check in from the garage via closed-circuit TV system with the front desk. Its exterior aqua-pink-white color combination was muted with a more subdued off-white paint job in 1982 when it was renamed Cathedral Hill Hotel, but a fatal fire one year later marked a downturn in popularity. It closed in 2009 and was demolished in 2014 for construction of a new campus of California Pacific Medical Center.

J.J. NEWBERRY. A dime store chain that had a classic San Francisco location on Mission Street, between 22nd and 23rd Streets, behind a 1945 aqua-and-peach building façade designed for a Masonic lodge. The firm has been defunct since the early 1970s, with the site occupied by other retail firms.

JOHN'S GRILL. Classic San Francisco dining establishment once frequented by detective Sam Spade (he ordered the lamb chops), still in business on Ellis Street, near the back of the Flood Building, since 1907.

JOSEPH MAGNIN. Women's and girls' clothing chain founded by the son of Mary Ann Magnin. Joseph's own son, Cyril, refocused the firm on the younger, trendier customer after World War II, and the chain expanded to thirty-two stores before it was acquired. It was closed in 1984.

L&L CASTLE LANES. Geneva Avenue bowling alley near the Cow Palace that enjoyed popularity in the late 1950s and early 1960s when there were more than a dozen similar locales in San Francisco. Most have now disappeared, reflecting changing public interest in the sport, though a few new smaller venues have opened recently.

LACHMAN BROTHERS. Popular Mission District furniture store at 16th and Mission that served customers from across San Francisco. Its location was marked by a clock, held by an enormous uniformed character with the store's then-innovative credit-friendly motto: "Give Time."

LARRABURU FRENCH BREAD. The business was started by two Basque brothers on 3rd Avenue in the Richmond District in 1896. Their product soon became one of San Francisco's most popular edibles for the next seventy-five-plus years. A tragic accident between a delivery van and a young child in the 1970s revealed that the firm was woefully underinsured, and the eventual settlement bankrupted both the bakery and the insurer.

LECYRANO. Popular French-style restaurant in the 1970s and 1980s on Geary in the Richmond District. Low-key and unassuming, the spot packed in happy diners for nearly fifteen years.

LEGG'S ICE SKATING. Popular business located on 11th Street near Market Street in the downtown area and also on Ocean Avenue in the Ingleside neighborhood.

LEON'S BBQ. Popular restaurant, with an outlet on Sloat Boulevard near the zoo and another in the heart of the Fillmore District, dispensing crowd-pleasing food from the early 1970s, until the passing of owner Leon McHenry in 1999. The restaurant's bottled sauces are still available in many local grocery stores.

LICK-WILMERDING HIGH SCHOOL. Dating back to a founding in the 1890s, this private college prep school with five hundred students (coeducational since 1972) has been located on Ocean Avenue near Balboa Park since 1955.

LIVINGSTON BROTHERS. Traditional women's clothing store that operated downtown and then opened a "twig" (smaller than a branch) on Chestnut Street in the Marina District, but the entire chain went out of business in the 1980s.

LUCCA DELICATESSEN. Classic family-owned Italian delicatessen, operating on Chestnut Street in the Marina District since 1929.

MAMA'S AT MACY'S. A spinoff of the popular location on Washington Square in North Beach, the Macy's location opened in the fall of 1972 and operated until 1986. The restaurant chain's expansion in the 1970s and 1980s did not last, and Mama's is back to its original location only, still with a long line of appreciative customers.

MCATEER HIGH SCHOOL. Portola Drive public high school, built in the early 1970s on the site of an old golf driving range. Intended as a replacement for Polytechnic High School, which had just closed, the new school operated until 2002, when it was dissolved. A new school, the Ruth Asawa San Francisco School of the Arts, opened at the McAteer campus in 2005.

MEL'S DRIVE-IN. Opened in 1947 on South Van Ness Avenue, with a later location on Mission Street near Geneva Avenue. The chain was in the 1967 film *Guess Who's Coming to Dinner?* and 1973's *American Graffiti*. The branch on Geary Boulevard in the Richmond District closed to become a stereo store in the 1970s but has since reemerged as a Mel's outlet. The Geary location has been threatened with demolition for new housing, but recent news stories indicate that the location has been spared and will continue in operation.

MISSION DRIVE-IN THEATRE. Technically in Daly City, the Mission Drive-In operated from the 1950s until the early 1980s near Guttenberg and Frankfort Streets. It was demolished, and condominiums now occupy the site.

MOLINARI DELICATESSEN. Dispensing sliced meats, cheeses, salads and other Italian delicacies from its home on Columbus Avenue in North Beach since 1896.

NEW MISSION THEATRE. This classic Mission Street movie theatre opened in 1916 and expanded over the early years to a capacity of more than 2,000 seats. It closed as a movie theatre in the 1980s and was home to a furniture store for the next twenty-five years. There were threats of demolition, but in December 2015, the Alamo Drafthouse–New Mission Cinema opened as a five-plex with a total of 550 seats and is drawing highly favorable reviews.

NIPPON GOLDFISH COMPANY. Founded on Bush Street in the Japantown neighborhood before 1906, it was a vast skylight-covered space with dozens of in-ground marble fish tanks that inspired young and old alike, until urban redevelopment pushed the firm out in the 1960s. Relocated to a standard storefront in the Richmond District, the firm closed many years ago.

NORTHPOINT THEATRE. The last major single-screen theatre to be built in San Francisco (1967) was located at Bay and Powell near Fisherman's Wharf. Big films and crowds were always there, but the lure began to fade, and it was closed in 1997, with the space staring across the intersection at its vacant neighbor, Caesar's Restaurant, for decades.

NOTRE DAME DE NAMUR GIRLS' HIGH SCHOOL. Dolores Street Catholic girls' high school in operation from 1866 to 1981—still with an active alumnae association. The building is now home to a low-income senior community.

NOTRE DAME DE VICTOIRES GIRLS' HIGH SCHOOL. Bush Street Catholic girls' high school closed in the 1970s.

PARK BOWL. Haight Street bowling alley opened in 1950 on the site of an old MUNI car barn; the location closed in 1996 and became a music store.

PARKSIDE THEATRE. Taraval Street movie house opened in 1928, renamed "Fox Parkside" in 1965 and closed in 1976. Today it houses a preschool with the iconic name Parkside School.

PENNEY, J.C. Part of the national department store chain, Penney's operated for decades at 5th and Market Streets. The store survived the most disruptive part of BART construction in the late 1960s and early 1970s but announced in early 1971 that it was closing its sole San Francisco location.

PETRINI'S. A family-owned grocery store chain from 1935 until 1989 that featured the finest in meat, poultry, seafood, fruits and vegetables.

PLANET HOLLYWOOD. Trendy 1990s restaurant opened by a group of investors that included Arnold Schwarzenegger, located in the old Roos-Atkins building at Market and Stockton Streets. The chain once boasted more than one hundred locations worldwide, but today, only a handful still remain open, with none in San Francisco.

PLAYLAND-AT-THE-BEACH. Classic amusement park that operated 365 days a year along Great Highway at Ocean Beach from 1928 to 1972. On a good day, you can still hear calliope music and detect the faint aromas of the Hot House, popcorn and cotton candy in the salty mists.

PLUM, THE. Moderately priced restaurant that originated in the Liberty House Department Store at Stockton and O'Farrell in 1974 and was later operated by Macy's following Liberty House's closure in 1984. Many loyal customers still recall the French onion soup, salade Niçoise and the incredible dessert cart.

POLYTECHNIC HIGH SCHOOL. Beloved Frederick Street public high school that offered a wide range of academic and trade courses to a diverse student body—and had one of the city's winningest football teams for decades, under Coach Milt Axt. Closed in 1972 and eventually demolished, the active

alumni association held a rededication ceremony for the building's 1914 cornerstone in 2014.

PRESENTATION HIGH SCHOOL. Turk Boulevard Catholic girls' high school, in operation since 1864, that closed in 1991, with the property being acquired by the adjacent University of San Francisco (USF) for its School of Education.

QUALITY FOODS, INC. Stonestown grocery store, with operations later taken over by Petrini's.

RED CHIMNEY RESTAURANT. Stonestown restaurant that offered trendy modernity from the 1950s until the early 1980s.

RED ROOF RESTAURANTS. Restaurant–coffee shop chain that included outlets on Ocean Avenue and California Street from the 1950s until the early 1970s.

ROOS-ATKINS. Clothing store chain catering to men and boys. Formed in a 1950s merger between Roos Brothers and Robert S. Atkins, the chain had dozens of stores statewide. A decline began in the 1980s, and the firm reverted to its original name for a short time but was finally closed in the early 1990s.

SABELLA'S. Classic Fisherman's Wharf seafood business, in operation since 1920, closed in 2007, with its space taken over by an outlet of a nationwide chain restaurant.

SACRED HEART HIGH SCHOOL. Catholic boys' high school that was the longtime crosstown rival of St. Ignatius. The school went coed in 1987 when it merged with nearby Cathedral High School to form Sacred Heart Cathedral Prep.

SCHLAGE LOCK. Large manufacturer of doorknob and lock sets, located on Bayshore Boulevard in Visitacion Valley and employing thousands of workers since 1926. Closed in 1999, the site remained vacant for well over a decade and was eventually cleared of old structures except for the Spanish Colonial office building, which will remain as a centerpiece in the new housing development of sixteen-hundred-plus homes that will soon be built.

SEALS STADIUM. Mission District sports venue opened in 1931 that housed the minor-league San Francisco Seals and was the first home to the San Francisco Giants, 1958–1960. It was demolished in 1959, as Candlestick Park was ready to open, and the site became a discount store known as White Front for many years. It has since evolved in a multi-business strip mall. The manager of the Office Depot store has thoughtfully placed a large X in the middle of aisle six to indicate the one-time location of home plate.

SEARS, ROEBUCK. National retailer that once had two stores, Mission-Army and Geary-Masonic, which were booming for decades. The Geary store in particular was well known for appliance salesmen in bold plaid sport coats and the smell of popcorn that permeated the entire building. Both locations have been closed for more than twenty years now.

SECURITY-PACIFIC BANK. Known as Security First National Bank, the Los Angeles–based institution traced its origins to Farmers and Merchants Bank, founded in 1870. By the middle of the twentieth century, it was the fifth largest bank in California. It then acquired Pacific National Bank in 1967 and became known as Security-Pacific, and in 1971, it acquired a controlling interest in Bank of Canton. In 1988, the organization completed the acquisition of the remaining interest in Bank of Canton and renamed itself Security Pacific Asian Bank. In the spring of 1992, the bank was acquired by BankAmerica Corporation.

SELIX FORMAL WEAR RENTAL. One of San Francisco's oldest businesses, visited by virtually every male a couple of times in his life (high school proms and, later, weddings), filed for bankruptcy in early 2015, closing all of its stores.

SKATELAND. Roller rink at Great Highway and Balboa Street, at Ocean Beach, in operation from 1947 to 1972.

SLOANE'S. Founded in New York City in the mid-1800s as an upscale rug and furniture store, W. and J. Sloane expanded to San Francisco in 1875 to furnish the original Palace Hotel. For most of the twentieth century, the company was located in the 200 block of Sutter Street. The firm filed for bankruptcy protection in 1981 and closed in 1985.

STAR BAKERY. Noe Valley bakery that turned out the city's best Irish soda bread. The line snaked out the door, especially around St. Patrick's Day.

STAR OF THE SEA ACADEMY. Longtime Richmond District Catholic girls' school, with comedienne Gracie Allen as one of its best-known graduates. Star of the Sea Parish still maintains a grammar school, but the girls' high school closed in the 1980s.

ST. BRIGID'S GIRLS' HIGH SCHOOL. Catholic girls' high school on Van Ness Avenue that closed down in the 1950s, replaced by a motel.

ST. EDWARD'S CHURCH. One of San Francisco's more modern Catholic churches, built in the 1950s on California Street opposite the Fireman's Fund Insurance complex, was closed in 1998, with the building sold and demolished for the construction of condominiums.

ST. JOHN'S URSULINE GIRLS' HIGH SCHOOL. Longtime Catholic girls' high school on Mission Street near St. Mary's Park that was in operation until the 1980s. Graduates still gather for an annual springtime luncheon.

ST. PAUL'S GIRLS' HIGH SCHOOL. Longtime Catholic girls' high school at 29th and Church Streets in Noe Valley that was established in 1917 and in operation until 1994.

ST. PETER'S ACADEMY. Longtime Mission District Catholic girls' high school that graduated its final class in 1966—still with an active alumnae association.

ST. PETER'S BOYS' HIGH SCHOOL. Long-gone Catholic boys' school affiliated with St. Peter's Academy.

ST. VINCENT'S GIRLS' HIGH SCHOOL. Catholic girls' high school dating back to the 1800s. Located at Gough and Geary since 1938, the school was demolished in 1966 for the new St. Mary's Cathedral on the site. A replacement school named Cathedral High School was built nearby, opening in 1967. It had a long affiliation with Sacred Heart High School, and in 1987, the two institutions merged to form Sacred Heart Cathedral Prep.

SURF THEATRE. Small neighborhood house on Irving Street in the Outer Sunset, well known for showing foreign, art and classic films. Closed in 1985, the building has long housed a church.

SUTRO BATHS. Adolph Sutro's incomparable addition to San Francisco's bygone recreational amenities and to today's open space. A vast complex of swimming pools and artifacts on display, part of the baths was converted to an ice skating rink and a "Tropic Beach" in the 1930s. By early 1954, the swimming facilities were shut down by the San Francisco Health Department because of maintenance difficulties, leaving only the ice rink and the museum (the "Tropic Beach" that remained as part of the signage until the early 1950s was a short-lived 1930s feature). The business had been shut down, and the artifacts already removed, when the structure was destroyed by a "suspicious" fire in June 1966. Planned housing was never built, and the ruins have been part of the Golden Gate National Recreation Area since the early 1970s.

SUTTER'S MILL. Highly popular downtown LGBT bar that catered to workers in the Financial District in the 1980s.

UKRAINE BAKERY. Classic longtime Jewish bakery located on McAllister Street in the Fillmore District—the best place for challah bread. Closed when urban redevelopment overtook the area.

UNITED SHOPPERS EXCLUSIVE (USE) DISCOUNT STORE. A 1950s-era discount store that operated on Alemany Boulevard in the Excelsior District.

VILLA ROMANA. Classic Italian restaurant on Irving Street in the Inner Sunset District from 1956 until it closed when the owners finally retired in 2015.

WHITE HOUSE, THE. San Francisco department store that began operations in 1854 and prospered until 1965. Its former location at Sutter Street and Grant Avenue still retains the classic 1909 façade and signage, while the interior was long ago gutted for a parking facility.

WINTERLAND. Originally the Dreamland Ball Room, built at Post and Steiner Streets in 1928, the venue was renamed Winterland in the late 1930s. Home for decades to the *Ice Follies* for its long run every summer in San Francisco, it was converted to a music venue by rock promoter Bill Graham in 1971. Winterland closed with a farewell concert early in 1979 and was demolished in 1985 and replaced by apartments.

WOOLWORTH. One of San Francisco's most memorable downtown stores occupied the ground floor of the Flood Building from 1952 to 1997, when the chain shut down operations. The last of the bulk candy, pizza slices, sewing notions, parakeets and picture frames were sold at discount prices as the Veg-o-Matic demonstrators packed up their wares for the last time.

YET WAH. The classic Chinese restaurant in the "big purple building" had been operating on Clement Street at 22nd Avenue for decades when it closed suddenly in 2011. It has long since been replaced with another eatery, but thousands of San Franciscans still remember when it was new and cutting edge, complete with a large upstairs banquet facility.

ZIM'S HAMBURGERS. The restaurant phenomenon revolutionized casual dining in San Francisco. Founded by Art Zimmerman, who dreamed of hamburgers and milkshakes during his World War II military service, the chain opened in 1948 and expanded throughout the Bay Area to more than two dozen locations but closed its final outlet in 1995, a victim to the presence of faster, cheaper hamburgers. The location at 19th Avenue and Taraval was seen by thousands every day, its red neon sign glowing like a warm, friendly beacon, welcoming travelers to the culinary delights that were available at the counter there for decades.

Selected Bibliography

Alumni Publications

Genesis, St. Ignatius College Prep.
George Washington High School Alumni Association Newsletter.
Lowell Alumni Association Newsletter.
Perennial Parrott, Polytechnic High School.

Archives

Archdiocese of San Francisco.
Holy Cross Cemetery Archives.
LGBT Historical Society.
Prelinger Library/Archives.
San Francisco History Center.
San Francisco Public Library.
State of California Vital Statistics Index.
St. Cecilia Parish Archives.
Western Neighborhoods Project.

BOOKS

Caen, Herb. *Baghdad by the Bay*. New York: Doubleday, 1949.

Conrad, Barnaby. *The World of Herb Caen 1938–1997*. San Francisco: Chronicle Books, 1997.

Dunnigan, Frank. *Growing Up in San Francisco's Western Neighborhoods*. Charleston, SC: The History Press, 2014.

Gilliam, Harold. *The Face of San Francisco*. New York: Doubleday, 1960.

Hansen, Gladys, and Emmet Condon. *Denial of Disaster*. Petaluma, CA: Cameron & Co., 1989.

Hitz, Anne Evers. *Emporium Department Store*. Charleston, SC: Arcadia Publishing, 2014.

Hooper, Bernadette C. *San Francisco's Mission District*. Charleston, SC: Arcadia Publishing, 2006.

Kamiya, Gary. *Cool Gray City of Love*. New York: Bloomsbury, 2014.

LaBounty, Woody. *Carville-by-the-Sea*. San Francisco: Outside Lands Media, 2009.

Lewis, Oscar. *San Francisco: Mission to Metropolis*. Berkeley, CA: Howell North, 1966.

Lyon, Fred. *San Francisco: Story of a City 1940–1960*. New York: Princeton Architectural Press, 2014.

Martini, John A. *Sutro's Glass Palace: The Story of Sutro Baths*. Bodega Bay, CA: Hole in the Head Press, 2013.

McGloin, John B., SJ. *San Francisco: The Story of a City*. San Francisco: Presidio Press, 1978.

Polk's Crocker-Langley City Directory. Various editions.

Scharlach, Bernice. *Big Alma*. San Francisco: Scottwall Associates, 1990.

Talbot, David. *Season of the Witch*. New York: Free Press, 2012.

Tillmany, Jack. *Theatres of San Francisco*. Charleston, SC: Arcadia Publishing, 2005.

Trimble, Paul C. *Railways of San Francisco*. Charleston, SC: Arcadia Publishing, 2004.

Ungaretti, Lorri. *Legendary Locals of San Francisco's Richmond, Sunset, and Golden Gate Park*. Charleston, SC: Arcadia Publishing, 2014.

INTERNET SITES

Archdiocese of San Francisco. www.sfarchdiocese.org.
Congregation Emanu-El. www.emanuelsf.org.
Curbed SF. www.sf.curbed.com.
Department Store Museum. www.thedepartmentstoremuseum.org.
Legacy. www.legacy.com.
Lick-Wilmerding High School. www.lwhs.edu.
Parkmerced Vision. www.parkmercedvision.com.
Richmond District Blog. www.richmondsfblog.com.
San Francisco Municipal Transportation Agency. www.sfmta.com.
San Francisco Recreation and Parks Department. www.sfrecpark.org.
St. Ignatius College Preparatory. www.siprep.org.
University of San Francisco. www.usfca.edu.
Western Neighborhoods Project. www.outsidelands.org.

NEWSPAPERS

Catholic San Francisco.
J. (Jewish News Weekly).
Noe Valley Voice.
Ocean Beach Bulletin.
Richmond Review.
San Francisco Chronicle.
San Francisco Examiner.
San Francisco History Association Quarterly.
San Francisco News Call-Bulletin.
Sunset Beacon.
Westside Observer.

ABOUT THE AUTHOR

Frank Dunnigan was born during the baby boom years to a family that first settled in San Francisco in 1860. He graduated from St. Ignatius College Prep and the University of San Francisco and spent more than twenty-five years as a bank auditor and corporate trainer in the downtown area. He is now a recent retiree after a career with the federal government.

The author, seated at an IBM word processor at the St. Ignatius High School yearbook office in 1968. Today, only the equipment has become more modern. *Author's collection.*

He is the author of two other books: *Growing Up in San Francisco's Western Neighborhoods: Boomer Memories from Kezar Stadium to Zim's Hamburgers* (The History Press, 2014) and *San Francisco's St. Cecilia Parish: A History* (The History Press, 2016). Since 2009, he has written a monthly column, "Streetwise," for Western Neighborhoods Project (www.outsidelands.org) and has contributed content to the works of other local historians.

The author is grateful for the kind assistance provided by volunteers at Western Neighborhoods Project, founded in 1999 by Woody LaBounty and David Gallagher. Preserving the history of San Francisco's west side was the group's initial goal, and that has now been expanded to include citywide historic preservation. In 2015, WNP launched a new program, OpenSFHistory, created to digitize, catalogue and share with the world more than 100,000 vintage images, donated by an anonymous private collector.

To see images, read articles, hear podcasts, review/comment on posts or join Western Neighborhoods Project, go to www.outsidelands.org.

Western Neighborhoods Project

Visit us at
www.historypress.net
···
This title is also available as an e-book